THINKING AND WRITING
in
THE HUMANITIES

Suzanne Hudson
University of Colorado, Boulder

Molly LeClair
Front Range Community College

Australia • Canada • Mexico • Singapore • Spain
United Kingdom • United States

Publisher: Clark Baxter
Executive Editor: David Tatom
Acquisitions Editor: John R. Swanson
Development Editor: Rebecca F. Green
Assistant Editor: Amy McGaughey
Technology Project Manager: Melinda
 Newfarmer
Marketing Manager: Mark Orr
Advertising Project Manager: Vicky Chao
Project Manager, Editorial Production:
 Kimberly Adams
Print Buyer: Becky Cross
Permissions Editor: Kiely Sexton

Production Service and Compositor:
 G&S Typesetters, Inc.
Photo Researcher: Sandra Lord
Copy Editor: Jan Six
Cover Designer: Preston Thomas
Cover Image: "Red Cube" by Isamu Noguchi,
 © with permission from The Isamu
 Noguchi Foundation, Inc., New York.
Cover Printer: Transcontinental Printing/
 Louiseville
Printer: Transcontinental Printing/
 Louiseville

Printed in Canada
1 2 3 4 5 6 7 07 06 05 04 03

For more information about our products,
contact us at:
Thomson Learning Academic Resource Center
1-800-423-0563

For permission to use material from this text,
contact us by:
Phone: 1-800-730-2214
Fax: 1-800-730-2215
Web: http://www.thomsonrights.com

Library of Congress Control Number:
2002115363

ISBN 0-534-62155-4

Wadsworth/Thomson Learning
10 Davis Drive
Belmont, CA 94002-3098
USA

Asia
Thomson Learning
5 Shenton Way #01-01
UIC Building
Singapore 068808

Australia/New Zealand
Thomson Learning
102 Dodds Street
Southbank, Victoria 3006
Australia

Canada
Nelson
1120 Birchmount Road
Toronto, Ontario M1K 5G4
Canada

Europe/Middle East/Africa
Thomson Learning
High Holborn House
50/51 Bedford Row
London WC1R 4LR
United Kingdom

Latin America
Thomson Learning
Seneca, 53
Colonia Polanco
11560 Mexico D.F.
Mexico

Spain/Portugal
Paraninfo
Calle/Magallanes, 25
28015 Madrid, Spain

CONTENTS

Humanities instructors have, perhaps, the most enviable of all teaching positions. The breadth, depth, and variation of their subject matter render it an endless source of fascination. With the entire scope of human civilization for course content, humanities instructors never lack for material to stimulate class discussion. Humanities courses attract students who engage with the material eagerly and discover a newfound amazement at the accomplishments of humankind and an awareness of their place in the world. These are no small rewards.

Humanities instructors will attest that, as a learning tool, writing is invaluable, as it demands that students pool all their intellectual resources toward the examination of a single idea, which results in ever deeper understanding of the subject and in heightened critical thinking skills. As much as humanities instructors appreciate the advantages that students gain from writing and realize their students' need for guidance, given the breadth of the discipline and the challenges of writing critically, they find precious little time in the classroom to instruct students in the art of writing. We hope that *Thinking and Writing in the Humanities* will fulfill the needs of students who create essays for their humanities courses and of instructors who want to read interesting, insightful student papers.

Writing, of course, requires patience, craftsmanship, information, insight, and practice. Because writing demands the synthesis of so many qualities and skills, students need clear, practical advice on how to gather their thoughts and translate those thoughts into words. *Thinking and Writing in the Humanities* intends to demystify the process of producing critical essays and research papers at every step, from choosing a topic to writing a conclusion. The book places particular emphasis on formulating a thesis and supporting that thesis with points of proof. The composition techniques recommended in this book are classroom tested; in fact, every student essay in this book has resulted from the application of these principles and processes. For this reason, we believe that our student essays are a highlight of *Thinking and Writing in the Humanities*. They come from students who have taken our instruction, and the instruction of teachers like us who teach the composition methods recommended in this book, and have applied it to their own wonderfully individual and ingenious insights.

Another highlight of *Thinking and Writing in the Humanities* is the diverse collection of professionally written samples. The samples span the ages, the humanities disciplines, and the critical approaches—from Aristotle to Montaigne to Joseph Campbell. We find, predictably, that students learn to write

well when they read good writing—writing that communicates the aura of confidence and expertise found in our collection of samples.

Thinking and Writing in the Humanities is organized according to various types of writing assignments, such as writing response papers, analytical essays, arguments, research papers, critical reviews, and essay examinations. Each chapter is enhanced with learning aids such as critical thinking and writing exercises, topic suggestions, templates for planning essays, references to pertinent Web sites, illustrations, and revision checklists. Students who avail themselves of the guidance offered in this textbook are likely to produce sophisticated, organized, focused critical essays.

We thank our reviewers: Paula Bolduc, Salve Regina University; William James Hersh, Salve Regina University; Karen Kaivola, Stetson University; Stuart Noel, Georgia Perimeter College; and Robert M. Woods, Faulkner University.

We thank our publisher and editors: John R. Swanson, Acquisitions Editor; Rebecca F. Green, Editorial Assistant; Kathryn Stewart, Production Project Manager; Gretchen Otto, Production Coordinator; Jan Six, Copy Editor, and Heather Forkos and Sam Hurwitt, Project Editors.

We thank our colleagues—Joan Lord Hall, Linda Jenks Colby, Don Eron, Eleanor A. Hubbard, Charles Esquivel, and John LeClair—for sharing their invaluable suggestions and their students' work with us. We thank the students who allowed us to publish their papers: Nicole Emery, Amanda Michalski, Matt Hoffman, Rebecca Penkoff, Todd Shelton, Trey N. Magee, Liam L. Collyer, Emily O'Connor, Mage Morningstar, Chris Hammett, and Molly Dyson.

We thank the publisher of *Architecture* for permission to reprint Catherine Slessor's essay.

INTRODUCTION

One might argue that the birth of the humanities can be traced to some archaeology of consciousness, when sheer physical prowess and communal security offered an untroubled moment to reflect on our uniquely human abilities. From that moment forward, humankind poured out the fruits of those reflections in art and craft, music and drama, invention in transport and building, and language to suit every purpose, from speaking with deities to ordering and naming every thing on every continent.

Along with the development of language came the need for a means to record and preserve the words that expressed the increasingly complex ideas behind them. And so humans invented writing. Writing, like painting, sculpture, and music, provides us with the means to explore our consciousness—to learn what it is to be human.

In the late third millennium B.C.E., about five thousand years ago, a Sumerian poet cast these words in cuneiform:

> When the gods created man they allotted to him death, but life they retained in their own keeping. As for you, Gilgamesh, fill your belly with good things; day and night, night and day, dance and be merry, feast and rejoice. Let your clothes be fresh, bathe yourself in water, cherish the little child that holds your hand, and make your wife happy in your embrace; for this too is the lot of man.[1]

In the eleventh century C.E., the Persian poet Omar Khayyám echoed the Sumerian poet's sentiment:

> Ah, make the most of what we yet may spend,
> Before we too into the Dust descend;
> Dust into Dust, and under Dust to lie,
> Sans Wine, sans Song, sans Singer, and—sans End![2]

Our desire to read, analyze, and express our thoughts makes us part of the legacy of the power of the written word. Reading and writing in the humanities are means of recapturing the creative journey for us, the living; reading and writing are means of repossessing that original moment of reflection that started our species down the path of wondering.

When we write, we look more closely at the work of art, listen more closely to the music, perceive the historical and philosophical influences on the work more keenly. We notice details that we may not have noticed had we not been looking with writing in mind.

When we write, we record essential information for future generations of historians and lovers of the humanities to assess and consider. We exert our

own influence on the thinking of others. We inform, persuade, enlighten, and entertain. We keep the artist's vision alive—perhaps even enhance it. Writing is one more means of appreciating our diverse cultural heritages.

As a student enrolled in any course in the humanities, you are frequently required to write essays and research papers. It is unlikely that your humanities instructor will use class time to give writing instructions, yet you will be expected to write clear, cogent essays. *Thinking and Writing in the Humanities* will assist you in tailoring your writing to the particular language, style, and organizational patterns one must take into account when approaching a writing assignment in the humanities. This book will assist you in breaking down the writing process into small, manageable tasks, providing numerous examples and writing suggestions. In essence, *Thinking and Writing in the Humanities* will serve as your personal writing tutor, combining two disciplines—the humanities and composition.

PRINCIPLES OF EFFECTIVE WRITING IN THE HUMANITIES

CHAPTER PREVIEW

Clear writing in the humanities demands that you understand your audience and purpose and adjust your tone and style accordingly. You must be knowledgeable about your subject and the elements that constitute it. You must

understand certain principles, such as the difference between objective and subjective writing, the qualities of a workable thesis, and the concept of development. Finally, clear writing depends on careful planning, drafting, revising, and editing. The purpose of this chapter is to explain the terms, concepts, and methods that will be mentioned throughout this book and that, through familiarity, you will use to your advantage in the creation of clear, effective essays and research papers in the humanities.

TYPES OF ESSAYS

As a student, you will be called upon to write about the humanities, primarily in the form of essays and research papers. **Essay** is a widely used term for many kinds of writing, but essentially it is a prose, nonfiction literary composition. The invention of the essay is attributed to Michel de Montaigne, a sixteenth-century French writer. Montaigne considered his own experiences and opinions worthy of study in his search for the truth, believing that to study himself was to study humankind. "Every man bears the whole stamp of the human condition," he wrote.[1] Your own experiences, responses, and ideas, like Montaigne's, are worthy subjects for writing.

An essay consists of more than one paragraph, and it is shorter than a book, but within those parameters, an essay may be any length. An essay may make use of sources, but not to the extent that a research paper does. An essay may be objective or subjective. An **objective** essay divulges information without offering commentary, opinion, or interpretation. A **subjective** essay, on the other hand, does offer an opinion or interpretation. For example, a newspaper article that informs the reader that the University Theater and Dance Department will perform the ballet *Swan Lake* during the spring semester is objective. An article that reviews the performance or evaluates it is subjective.

A **critical** essay is subjective. The purpose of the critical essay is not, as the term may imply, to criticize, but rather to critique. To *criticize* is to denounce or find fault; to *critique* is to exercise careful judgment, including scholarly interpretation. Critical essays are either analytical or argumentative.

To *analyze* means, literally, to take a thing apart to discover how the pieces work together to create a whole. An **analytical** essay examines various pieces of a whole in order to evaluate, interpret, or speculate about causes and effects. Analytical writing differs from objective writing in that inference is at its core. An **inference** is a conclusion derived from facts, but it is not itself a fact. It is a guess or a theory, albeit an educated one. Read, for example, Jonathan Swift's famous essay, "A Modest Proposal." Was Swift being serious? Did he really advocate that the Irish eat their children as a solution to their poverty? Or was he being ironic? What evidence can you offer for the inference you have made? To answer the question, you will have to take Swift's essay apart and examine the individual pieces.

An **argument** essay assumes a contrary audience, one that is predisposed to disagree with the writer but is not irrational or ignorant. When you write an argument essay, your task is not only to defend your position, but also to refute your opponent's position.

Remember that the word *argument* is often used broadly to mean "main point" or "thesis." Your professors may speak of your "central argument" with regard to the thesis or main point of your paper, even if the paper is purely analytical and does not engage in refutation at all. Be sure that you understand the meaning of the word *argument* as it pertains to your assignment.

ELEMENTS OF THE HUMANITIES DISCIPLINES

Students preparing to write essays in the humanities may choose from various disciplines: literature, poetry, drama, dance, film, art, architecture, music, or other subjects. A **discipline** refers to a branch of knowledge or instruction. An early use of the term appears in Chaucer's "Canon's Yeoman's Tale" when the yeoman reveals his master's crafty *disciplyne:* alchemy. Each discipline is composed of **elements,** basic principles of the subject, or individual parts that make up a composite entity, such as a novel, a poem, a play, a painting, or a symphony. Reviewing the elements of a particular discipline is a necessary step in planning an approach, or angle, for your essay. Although a humanities essay may touch on one or more elements, a single element usually predominates. Following are some of the more common elements discussed in humanities essays.

LITERATURE

When you are casually enjoying a novel or short story, taking it apart piece by piece is not usually the objective. Yet when you write about literature, the elements of the story are crucial to its understanding. For example, a close look at the narrator's voice, or point of view, in F. Scott Fitzgerald's *The Great Gatsby* sheds light on the novel's meaning. The narrator, Nick Carraway, is Gatsby's next-door neighbor. How much does he know? How much can we trust his perceptions? Is Gatsby really the person Nick says he is, or are there other elements in the story to suggest that there is another man behind the image Gatsby projects? When you begin taking the story apart, you begin formulating ideas about its meaning.

Plot is the action—the events, incidents, and circumstances as the author organizes them. The choice and ordering of the action in a story results in its structure. Most plots involve a **conflict,** a struggle between opposing forces, such as between the hero and his or her nemesis. The plot falls into five parts: (1) the **exposition** introduces the characters, situation, time, and place; (2) the **rising action** develops the story, usually intensifying and complicating the conflict; (3) the **turning point,** or **climax,** signals a change in the action or

the sudden discovery, recognition, or revelation of a character; (4) the **falling action** begins the unknotting of the story; and (5) the **conclusion,** or **denouement,** offers a resolution.

Characters bring the story to life—their daily manner of living, their occupations, their aspirations and fears. The quality of the character may range from the **flat,** or caricature, to the **round,** or realistically complex. In the following essay, Martha Chew compares female characters from two of Flannery O'Connor's short stories.

> Flannery O'Connor's works often suggest a double-edged satire of Southern traditions and attitudes. Her characterization of Southern women, in particular, reveals this complex satirical perspective. That O'Connor's satire can cut both ways is perhaps most clearly illustrated by her contrasting portraits of the daughters in "The Life You Save May Be Your Own" and "Good Country People." In Lucynell Crater, the idiot daughter in "The Life You Save," O'Connor parodies conformity to the traditional role of the Southern woman; in Hulga Hopewell, the lady Ph.D. in "Good Country People," she satirizes ineffective rebellion against that role. O'Connor's counterpointing of the two daughters suggests that she sees Lucynell and Hulga as representing two different but equally futile responses to the role of women in the South.[2]

In this introductory paragraph, Chew not only lets the reader know which characters she intends to compare, but *how* she intends to compare them. The final sentence in the paragraph is a thesis statement around which the entire essay will revolve.

Setting is the physical background against which the action of a story takes place: geographical location, topography, scenery, even the location of doors and windows in a room. Setting also establishes the time: the historical era in which the action occurs, the season of the year, or the religious, social, or emotional environment in which the characters move. The setting may have symbolic meaning or suggest the theme of a story.

Point of view lets the reader know who is telling the story and what relationship that person has to the story. A writer has five viewpoint choices. In **first person,** *I* tells the story, and the reader is confined to the thoughts, feelings, memories, and perceptions of *I*. The **observer-narrator** is a witness to the action, telling a story about someone else. In **limited third person,** the narrator employs the pronoun *he* or *she* to tell the story, and the reader is privy to what that particular character knows, thinks, and remembers. The **involved,** or **omniscient,** narrator peers into the minds of any and all characters, making observations or predictions that only an all-knowing storyteller can make. The **detached,** or **objective,** narrator is not central to the action and remains neutral, describing and reporting only what can be seen and heard.

Symbols are generally figurative, or nonliteral, putting two unlike things together. People, places, or objects may signify meanings beyond themselves. For example, in Edgar Allan Poe's "The Cask of Amontillado," Fortunato's fool's garb represents his gullibility, which is the cause of his grisly entrapment in the end.

Theme is the central or dominating idea in any literary work, including prose fiction, poetry, and drama. Students should be careful not to oversimplify the theme by confusing it with the **moral** of the story. For instance, the moral of Gabriel García Márquez's "A Very Old Man with Enormous Wings" might be that what appears to be a burden may be a blessing in disguise. The more complex questions of why a community acts in conformity to violate a stranger, why all the wise people and religious counselors at the community's disposal are powerless to understand the old man, and how silence and solitude can erode human values—these are the materials of the theme.

POETRY

Reading, and more so interpreting, poetry presents special challenges because the language of poetry is compressed. Poets concentrate on the sound of language, the development of rhythms, and the refined use of images. Usually, more is implied than is stated directly. For example, when Maura Stanton writes in her poem "Childhood" that "I must have turned down the wrong hall, / Or opened a door that locked shut behind me, / For I live on the ceiling now, not the floor," the reader does not take the words literally. The implication is that this child is sadly disconnected from her family.

Imagery is the heart of poetry—pictures created with words that stir our emotions. An image can be seen, heard, smelled, tasted, touched, or otherwise sensually represented. It may be as palpable as Hart Crane's "burnt match skating in a urinal" in "The Bridge" or as psychologically penetrating as Shakespeare's "damn'd spot" in *Macbeth.*

Figurative language refers to words used in a nonliteral way to heighten an effect. For example, a **metaphor** involves the direct comparison of two objects. In John Donne's "Meditation 17," human beings are compared to chapters in a vast book designed by God: "All mankind is of one author, and is one volume." A **simile** is an indirect comparison, using the connective *like* or *as.* In "On a Maine Beach," Robley Wilson compares tide pools and coins: "Look, in these pools, how rocks are like worn change / Keeping the ocean's mintmark." A *symbol* is something that stands for something else, such as a flag to represent a nation. A symbol can be as brief as a lily to signify purity, or as extended as an **allegory,** in which an abstraction is made concrete for the purpose of communicating a moral. For example, Christian's journey in John Bunyan's *Pilgrim's Progress* is allegorical. Poets may use **hyperbole** (exaggeration), **personification** (endowing something inanimate with human characteristics), puns, ethnic dialect, slang, or any manner of nonliteral language to express ideas. And critics may focus on one or more figures of speech to glean meaning from the poem.

Structure refers to a poem's rhythm, rhyme, and direction. You might study **line length,** the specific duration of a unit of words, or **meter,** a poem's stressed and unstressed syllables, to answer a question about the poem's meaning. Whether you are reading a **fixed form** poem that follows a strict and formal

pattern, such as a sonnet or a sestina, or a **free verse** poem that has no regular metrical or rhyming pattern but relies instead upon the cadences of normal speech, the structure will reflect the poem's content. At first glance, "Silent Poem" by Robert Francis looks like words simply strung together to describe New England. On closer examination, one sees a clear direction in the poem, from inside "candlestick ragrug firedog brownbread" to outside "hilltop outcrop cowbell buttercup."

Style is the arrangement of words that expresses the idea and intent in the author's mind. Style includes the qualities of diction, line, imagery, rhythm, and arrangement of ideas.

In the following review, poet and critic Ezra Pound focuses on Robert Frost's distinctly American style:

> Mr Frost is an honest writer, writing from himself, from his own knowledge and emotion, not simply picking up the manner which magazines are accepting at the moment, and applying it to topics in vogue. He is quite consciously and definitely putting New England rural life into verse. He is not using themes that anybody could have cribbed out of Ovid. . . . Mr Frost has humor, but he is not its victim. *The Code* has a pervasive humor, the humor of things as they are, not that of an author trying to be funny, or trying to 'bring out' the ludicrous phase of some incident or character because he dares not rely on sheer presentation. It is a great comfort to find someone who tries to give life, the life of the rural district, as a whole, evenly, and not merely as a hook to hang jokes on.[3]

THEATER AND DANCE

Theater and dance are visual arts in which the actors or dancers, stage sets, projected images, costumes, makeup, and props all share the spotlight. The challenge of writing about theater or dance is that you, the critic, are carried along at someone else's pace. You cannot linger, as you might at an art exhibition, or flip back a few pages, as you might when reading a novel, to reflect on a detail. Still, while seeing a performance, you can take notes and capture your immediate reactions on paper. And while writing about a play, you can refer to a written copy of it.

Like prose fiction, dramatic literature contains the elements of plot, setting, point of view, symbol, and theme. However, because dramas are performed, they contain other elements as well.

Irony, which occurs in prose fiction as well as in drama, refers to a dramatic condition that is the reverse of what the participants think, or a speech or action more fully understood by the spectators than by the characters. In Aeschylus's *Agamemnon*, Clytemnestra's welcome home speech to her husband, just back from the Trojan War, is darkly ironic because she has been meticulously plotting his murder with her lover.

Characters are the *dramatis personae*, persons listed in the play program whose lives are to be presented dramatically. Characters may be flat or round. Flat, or **stock,** characters represent a single trait or quality whose behavior is predictable, such as the intractable father, the faithful wife, the rebellious son,

or the genial drunk. Round characters have many traits, often behaving un-expectedly. If the playwright wants us to identify with a character, we will more likely see a round one; but if the playwright wants us to focus on the situation, a flat character may better serve the purpose.

Conflict is inherent in drama. It is is the struggle, the interplay of two op-posing forces in the plot. The protagonist may be struggling against the forces of nature, against another person, the antagonist, or against society; or two emotions within the protagonist may be struggling for mastery. A feigned character, device, or event, called *deus ex machina,* might be introduced in an unexpected way to resolve a conflict.

Dialogue is talking, conversation, the interchange of ideas. Dialogue serves many purposes; it provides background information, reveals charac-ter, creates a sense of time and place, and moves the story forward. A **con-vention** is a device that the audience agrees to tolerate, such as an **aside,** when a character expresses thoughts in words audible to the audience but supposedly unheard by the other actors on stage. In a **soliloquy,** a character speaks to himself aloud, alone or unaware of the presence of other characters. In a **direct address,** a character turns from the stage and speaks directly to the audience. Dialogue is at the heart of drama, although silence on stage can have as much impact on the spectator as a ruckus.

Choreography is the art of creating and arranging dances or ballets. The choreographer develops the steps or movements of a dance. In the following review, dance critic Ann Barzel critiques a piece choreographed by Antony Tudor and performed by the Joffrey Ballet of Chicago:

> Tudor's *Lilac Garden* (or as he insisted it be referred to, *Jardin aux Lilas*) displays a masterly use of the classical vocabulary. The extensions, the jumps (which are often merely decorative or performed for virtuosic thrills) are used by the chore-ographer as means to express psychologically inspired feelings. In the thwarted meeting of *Lilac Garden's* lovers, an arabesque expresses yearning, a pirouette is a warning to turn away. The Tudor masterpiece can be merely pictorial, as it of-ten has been in hurried productions. However, the Joffrey production was as clear as spoken words, every movement motivated and tellingly simple.[4]

Staging/set design/lighting create a dramatic illusion—suggesting lo-cales, establishing time, evoking a mood—in which spectators accept that the world on stage is real, all the while fully aware that they are looking at per-formers and scenery. Staging may be realistic—characters eat actual food, speak with their backs to the audience, and so on—or fanciful, as in *The Fan-tasticks,* during which props are pulled out of a chest on the stage as needed.

FILM

Film invites interpretation, and so it is not surprising to read reviews of a particular film that bear little resemblance to one another. Fortunately for critics, objectivity in a film review is not what readers expect, or even desire. A thoughtful critique allows the reader to compare his or her values with

the critic in order to understand how the subject looks from a different perspective.

In the following paragraph, film critic Lee Siegel defends Kubrick's *Eyes Wide Shut* against critics who either missed its message or, worse yet, made no effort "to understand the film on its own artistic terms,"[5] but instead responded to the publicity hype *about* the film:

> Our tame middle-class critics so wanted Kubrick's orgy to be dark and dangerous and full of sexual energy, but Kubrick wanted to show that sex without emotion is ritualistic, contrived, and in thrall to authority and fear. He was too wild for them. Everyone droned on about how unerotic Kubrick's orgy is, but no one talked about how intensely erotic is Bill's fantasy of Alice making love with the naval officer. It is so erotic because Alice is the object not only of Bill's desire but also of his love.[6]

Like prose fiction and drama, films contain the elements of plot, character, setting, point of view, symbol, and theme. Certain elements, however, are particular to film.

Direction refers to the vision and techniques of the film's artistic leader, although it is sometimes difficult to know what elements to ascribe to the director, because filmmaking is a collaborative business. For example, if an actor gives a particularly convincing performance, to what degree are camera angles, lighting, sound, gestures, and voice inflections responsible? And how much of that responsibility did the film director assume? It is difficult to know. Generally, though, the director receives the largest portion of the credit or blame for a film's success or failure.

Cinematography is movie photography, featuring the camera angles, framing, fast- and slow-motion, and lighting of the cinematographer or director of photography. Look for coherence, continuity, and variety. Critics of the 1957 film *The Sweet Smell of Success* invariably cite James Wong Howe's handheld camera and deep focus techniques in capturing the fast pace and seamy side of New York.

Music and sound can be discussed in terms of their intrinsic quality and appropriateness to the situation in which they are used. You must ask yourself if the music or sound adds to or detracts from the suspense, the tension, or the romance. Imagine David Lean's *Lawrence of Arabia* without Maurice Jarre's music, or James Cameron's *Terminator 2: Judgment Day* without the clamor of crunching metal, to appreciate how music and sound enhance a motion picture.

ART AND ARCHITECTURE

Writing about painting, sculpture, photography, or architecture requires training the eye as much as learning the basic vocabulary of art. For example, at first glance, Velázquez's *Las Meninas* may look like another seventeenth-century court scene with women in full skirts posed for their portrait. Looking more closely, however, one finds that Velázquez has extended the spatial

field to include the viewer (us) exchanging glances with him, a large canvas whose subject is hidden, a mirror that reflects the alleged subjects of the painting, and so on. In the case of art, familiarity breeds admiration and delight, or at least sufficient reason for dislike.

Subject matter refers to the content and iconographic references in a work of art, whether that art is **representational,** recognizable from real life, or **abstract (nonobjective),** without reference to reality or reliance on imitation of nature.

Formal elements might be thought of as the artist's toolbox, the basic components from which an artist can choose to convey an idea. **Line** is versatile and expressive, a mark used to define a shape or contour. **Shape** is a two-dimensional area with discernible boundaries. **Space** refers to the dimensionality of a work and the devices used to achieve it, such as linear perspective, aerial perspective, and foreshortening. **Texture** refers to the dimensional quality or tactile aspect of the surface of a work. **Value** is the gradation of tones from light to dark to give the appearance of three-dimensionality. **Color** involves hues, lightness, and saturation, varying in warmth or coolness, with each color having its opposite or complementary color. **Time** is a relatively new formal element in art, featured especially in photography, film, and computer media.

Principles of design refer to the comprehensive scheme or composition of the formal elements. **Balance** has to do with the equilibrium or symmetry of contrasting or interacting forms, darker shapes often appearing heavier than lighter shapes. **Rhythm** deals with the relationship between formal elements to establish unity and continuity, perhaps through a repetition of lines, shapes, or colors. **Proportion** is the relation of one part to another or each part to the whole in regard to size, height, width, length, or depth. **Scale** is the size of an object in relation to a given measurement. **Unity** and **variety** together give a work of art its power and vitality.

In the following paragraph, artist Bridget Riley writes about principles of design in one of Piet Mondrian's later paintings:

> In 1937—the year before he [Mondrian] left France for England and New York—he made *Composition of Lines and Color, III (Composition with Blue),* a most beautiful painting that reconciles the increasing role he was giving to rhythm with a new sense of scale and tectonic strength. Generated by black verticals and their intervals, the movement sweeps across the painting and is brought to a complex rhythmic close on the right. A subtle countermovement of horizontal intervals modifies and harmonizes the drive and tempo of the painting. As a finishing stroke an implied diagonal descending from the top left is pulled up for attention by the deep blue rectangle it carries, the only color plane in the painting.[7]

Medium (plural *media* or *mediums*) is the material used by the artist, such as paint, ink, clay, stone, glass, metal, or film, each having its distinctive features and subcategories.

Style refers to attributes in art that identify it with a country, a period, a group of artists, or a particular artist. An essay might examine the influence of

one country's style on another, say, Russian constructivism on *de Stijl* in Holland, or explore the dadaists' response to mechanized war, or investigate the invention of cubism by Braque and Picasso and its philosophical implications.

Theme is the main subject of a work of art or an art exhibition. An art exhibition might feature any theme, such as transportation or medical oddities or revival architecture.

MUSIC

Music is pervasive in our culture, from concert halls to waiting rooms, ballet stages to ballparks, on radio, on television, and on sound systems in our homes. Sometimes called the purest art form, music is liberated from the constraints of space; as such, writing about music, whether symphonic, operatic, jazz, or hip-hop, requires training the ear as well as learning some musical terminology.

Sound is transmitted vibrations, a distinctive component of music that combines tone and silence, the basic building materials of music. The properties of pitch, dynamics, duration, and tone color are all included in this element of music. **Pitch** depends on the number of vibrations per second emanating from the sound source and indicates the relative highness or lowness of a tone. **Dynamics** refers to contrasting degrees of loudness or softness, the increasing or decreasing of intensity. **Duration** is the relative length of a tone or rest, established by conventions called notation, the expression of music in writing. **Tone color** refers to the **timbre** (tone quality), dynamics, and duration that make up the melodic and harmonic elements of a musical work.

In his book, *The Symphony*, Michael Steinberg discusses musical properties in the **finale,** or final movement, of Beethoven's *Symphony No. 7 in A Major, Opus 92*. (**Scherzo** refers to a lighthearted and fast-moving musical melody. **Coda** literally means "tailpiece" or the ending of a passage.)

> The finale is fast, too, but the sense of pace is quite different. The scherzo, sharply defined, moves like a superbly controlled machine; the finale carries to an extreme point, unimagined before Beethoven's day and rarely reached since, the sense of a truly wild and swirling motion adumbrated in the first movement. Here, too, Beethoven builds the coda upon an obsessively repeated bass—just a pair of notes grinding away, G-sharp/A at first, then working its way down through chromatic degrees until the dominant, E, and its neighbor, D-sharp, are reached. The whole inspired and mad process is spread across fifty-nine measures. Of course, to sound wild it must be orderly. Here, as in the notoriously difficult first movement, rhythmic definition is everything.[8]

Rhythm is the pulse of music, consisting of **beats** that mark divisions of time, **meter** that comprises note values and accents, and **tempo** that establishes the pace or rate of speed of a composition.

Melody is an organized succession of sounds. A **tune** or **air** is a melody, often sung. A **theme** is a central musical idea that may be restated and developed throughout a piece.

Harmony is the simultaneous sound of two or more tones, the art of combining sounds into chords that are either **consonant** (agreeable) or **dissonant** (disagreeable). Of course, these terms are relative because what may sound cacophonous to one person may sound mellifluous to another.

Interpretation is the act of conceptualizing and presenting a musical performance. In writing about music, you might examine a conductor's interpretation of the slow movement in a symphony, evaluate a tenor's interpretation of an aria, or compare the way two cellists interpret a partita or suite.

PLANNING YOUR ESSAY

The process for writing essays and research papers about the humanities is the same as the process for writing about any topic: plan, draft, revise, and edit.

PREWRITING

Planning your essay involves any of several prewriting strategies. You might begin by **brainstorming.** Many people use a **mind map,** which is a diagram of connecting words and ideas. The purpose of such a diagram is to free-associate ideas and begin the process of seeing the relationships among ideas.

Another brainstorming device is **freewriting.** Set a timer for a certain number of minutes, say ten, and write for that length of time without stopping, without lifting pen from paper, and without correcting grammar or spelling errors. Your words will be garbled and incoherent; you'll repeat yourself. That's fine. The only requirement is that you don't stop. You can edit later. The idea is to allow your thoughts to flow freely, resulting in the discovery of your interests and ideas, which, while they were locked inside your head, were intangible. Now that you can see them on paper, however, they acquire tangibility, and you can begin to shape them.

CHOOSING AND NARROWING YOUR TOPIC

Your **topic** is the subject matter of your paper. It can be stated broadly in a few words, such as Homer's *Odyssey* or Da Vinci's *Mona Lisa* or Mozart's *The Magic Flute.* You will need to narrow your focus, however, to some particular aspect, such as Odysseus's ability to use language, the significance of the background in *Mona Lisa,* or fantasy and freemasonry in Mozart's *The Magic Flute.*

Many students make the mistake of thinking that the goal of an essay is to cover as much territory as possible—to show how much they know. The result is a paper that can be described as shallow and wide. Many topics are touched on generally, but none are pursued in depth. In fact, most instructors prefer papers that are narrow and deep—that explore one idea thoroughly.

POSING A RESEARCH QUESTION

Your **research question** is the question about the topic that the thesis will answer. Posing a proper research question is a crucial step in the design of your essay because some research questions will lead you to an objective essay, and some will lead you to a subjective (analytical or argumentative) one.

For example, "How does Poseidon delay Odysseus's return from Troy to Ithaca?" is a research question that will inevitably lead to an objective paper. To answer the question, you will merely summarize the plot of the story.

On the other hand, the question, "Why do writers continually resurrect the character of Odysseus?" will probably lead to an analytical paper, because no definite answer to that question exists. One can only speculate about the causes of this fascination with Odysseus through the ages.

The question, "Should the *Odyssey* be required reading in middle school?" will lead to an argument essay. No matter what your answer, there will be an intelligent, informed consortium of scholars predisposed to disagree with you. You will have to anticipate their objections to your position and address their concerns if you want to write an effective argument.

Be sure to ask only one research question. Asking more than one will lead to a disunified paper. Also, remember that a research question will not serve as a thesis. You will try to prove the truth of your thesis; you cannot prove the truth of a question.

RESEARCHING YOUR TOPIC AND TAKING NOTES

Hardly anyone can write an academic paper without **sources**—books and articles that relate to the topic—so you will probably need to collect some sources for your paper. Chapter Seven, "Writing the Research Paper," offers detailed information on finding sources through your campus library or the Internet.

After you have collected your sources, read them with your pen and highlighter. That is, highlight the interesting passages and write your reactions and thoughts in the margins as you read. If you are using borrowed books, use sticky notes to call out the interesting passages. Take notes on index cards, one note per card. On each card, write a fact or a quote that you may want to include in your paper. Be sure to note on each card the source from which you obtained the information, including the page number. Later, you will find that the index cards are easily shuffled and reorganized as your paper takes shape.

FORMULATING YOUR THESIS

Your **thesis** is the *answer* to your research question. It articulates the main point of your essay and is, therefore, the most important sentence in the essay. Chapters Three and Four offer specific criteria for a workable thesis.

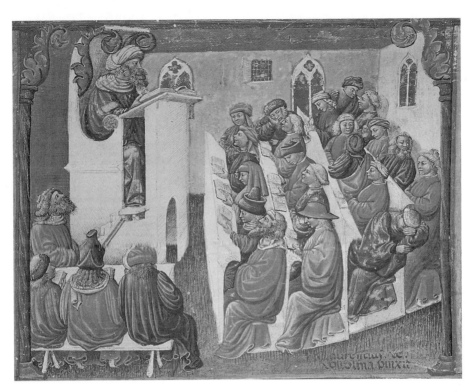

1.1 *"Do we *have* to take notes?"* Laurencius de Voltolina, *Lecture of Henricus de Alemania*, 14th century. Manuscript illumination. Bildarchiv Preussischer Kulturbesitz, Berlin.

Your thesis statement is also important because it determines your paper's **mode of discourse.** The modes of discourse are generally classified as narration, description, analysis, and argument. A narrative thesis will lead to a narrative essay, a descriptive thesis will lead to a descriptive essay, and so forth. Consider the following examples:

Narrative Thesis: Poseidon is angry that Odysseus has been set free and delays the hero's return home as long as possible. [What follows will recount the details of Odysseus's adventure.]

Descriptive Thesis: The *Odyssey* is a literary classic. [What follows will illustrate and corroborate a thesis that is a generally accepted fact.]

Analytical Thesis: Writers continually resurrect Odysseus because he gives voice to our own impulse to adventure. [Most readers would need to read support for this statement before they would accept it as true.]

Argumentative Thesis: The *Odyssey* contains too much violence to be appropriate reading for middle school children. [A rational, educated person might disagree with this statement.]

IDENTIFYING THE COUNTERARGUMENTS

If your essay is argumentative, you must articulate your opponents' arguments. Your opponents' arguments are your **counterarguments.** Like your own argument, they are controlled by a thesis and points of proof, which you will regard as the *counterthesis* and *counterpoints.* Your paper will *refute* the counterarguments. Identify what you believe to be the strongest arguments against the side that you will take.

ASKING THE PROOF QUESTION

After you have found a thesis, you must support or *prove* it. How does one do that? What constitutes support? One way to ascertain what sort of information will support your thesis is to ask a **proof question.** A proof question simply converts the thesis statement into a question, beginning usually with *how* or *why.* For example, if your thesis is, "Odysseus gives voice to our impulse to adventure," a new question arises naturally in response to that statement: *"How* does Odysseus give voice to our impulse to adventure?" This is your proof question, and answers to this question will support, or prove, your thesis. Although the proof question rarely appears in written form in the final version of your essay, it is a critical step in planning your essay because it provides a good test of whether you have a workable thesis. If you cannot answer the proof question, you need to rethink your thesis.

DESIGNING YOUR POINTS OF PROOF

Your **points of proof** answer your proof question. They are the reasons why you think your thesis is true. Each point of proof must be general enough to require one, two, or several paragraphs' worth of supporting facts, details, and examples, depending on the size of the essay you are writing; but the point of proof should not be so general that an entire essay would be required to support it adequately. Each point of proof should directly answer the proof question, but it will not, by itself, provide a complete answer. For example, if the proof question is, "How does Odysseus give voice to our impulse to adventure?" one answer could be that "Like us, Odysseus yearns for the safety and comfort of home, yet he relishes his adventures as they unfold." This is not a complete answer to the proof question, but a partial one— one point of proof. Collectively, your points of proof will fully support your thesis.

Be sure that each point of proof addresses the proof question. In this way, you can be sure that each point of proof supports the thesis and not some other idea. Sentences like, "First, we shall examine the character of Odysseus," and, "Then we shall observe his use of language," are not points of proof. Rather than answering the proof question, they delay the task and digress from the thesis.

OUTLINING YOUR ESSAY

Most writers find it helpful to organize their ideas in the form of an outline like the one that follows. The number of points of proof and supporting facts and examples will, of course, vary according to your paper's needs.

OUTLINE FOR ESSAY

 I. Introduction
 A. Identify topic
 B. State thesis
 C. List points of proof
 1. Point 1
 2. Point 2
 3. Point 3
 4. Point 4
 II. Body (developed points of proof)
 A. Point 1
 a. Supporting fact
 b. Supporting example
 B. Point 2
 a. Supporting fact
 b. Supporting fact
 c. Supporting example
 C. Point 3
 a. Supporting example
 D. Point 4
 a. Supporting fact
 b. Supporting example
 III. Conclusion

DRAFTING YOUR ESSAY

Now that you have planned your essay, the next step is to begin writing. Remember that you will probably need to revise your essay several times before you arrive at a final version.

WRITING THE INTRODUCTION

The type of introductory paragraph that we recommend for critical essays comprises three parts: introductory remarks, thesis, and points of proof.

Introductory remarks are difficult to write because they must strike just the right balance. They must orient the reader without simply telling what the reader already knows. Introductions must begin somewhat generally, but not too generally. Introductions must engage the topic directly, but not abruptly. It helps some writers to remember the journalistic formula: *who, what, when,* and *where.* The *why* will come later. Stick to the facts. Do not begin with a platitude or with an overly general expression, such as, "Throughout history . . ." or, "Humankind has always. . . ."

In a literary, theatrical, or film analysis, often the introductory remarks briefly summarize the plot objectively or, more likely, the small part of the plot with which the essay is concerned. In an analysis of art, very often the introductory remarks describe the work objectively, so that the reader sees an image of the work in her mind's eye and can therefore follow the ensuing analysis of the work. If the essay will analyze not the work but some issue surrounding it, the introductory remarks will probably explain objectively the issue or perhaps the issue's status quo. In other words, introductory remarks should provide the reader with the information he or she needs to be able to understand the thesis, which comes next.

Do not allow yourself to labor too long over the introductory remarks. If you are struggling with the first few sentences or are stalled altogether, proceed directly to the writing of your thesis and return to the introductory remarks later.

Your *thesis statement* is the most important sentence in the entire essay, so you want to construct it carefully. As a rule, let your thesis be the first general statement that you make. If the thesis is preceded by several generalizations, it is difficult to spot as the thesis. Be sure that the thesis is written in the appropriate mode of discourse to let your reader know if you plan to narrate, describe, analyze, or argue.

Some introductory paragraphs end with the thesis statement; others go on to list *points of proof.* If you intend to list your points of proof after your thesis, use transitional expressions, such as *first, second,* and *finally,* to help your reader see the relationship of the points of proof to the thesis and to each other. Without such clues, the reader will feel that he is reading several unrelated claims and will not understand that these claims are subordinate to the thesis and coordinate with each other. End the introductory paragraph with the final point of proof.

ORGANIZING THE EVIDENCE

Before you begin writing the body paragraphs, gather the index cards on which you took notes from your sources. Write your points of proof on separate index cards, one complete statement per index card, and lay them out side by side. Place each index card containing a fact beneath the point of proof that it supports. Continue to compile the evidence until you have enough to support each point of proof adequately. You may find, if you are like most writers, that some of your notes are not usable and that you need others that

better illustrate and support your points of proof. Having to go back to your sources and look for new evidence is typically part of the process.

WRITING THE BODY PARAGRAPHS

Well-written body paragraphs generally contain four qualities: unity, adequate development, organization, and coherence.

Unity in paragraphs is the quality of having only one main idea. Unity is best achieved by the use of a **topic sentence** that makes a general claim. This claim will have to be supported by the evidence presented in the rest of the paragraph. The topic sentence is often the first sentence of the paragraph.

The following paragraph from an essay titled "Who Killed King Kong?" by X. J. Kennedy demonstrates the concept of paragraph unity. In the essay, Kennedy analyzes audience identification with King Kong, the giant ape of the perennial film classic produced in 1933. Notice that every sentence in the paragraph illustrates the topic sentence, which is the first sentence.

> Yet however violent his acts, Kong remains a gentleman. Remarkable in his sense of chivalry. Whenever a fresh boa constrictor threatens Fay, Kong first sees that the lady is safely parked, then manfully thrashes her attacker. (And she, the ingrate, runs away every time his back is turned.) Atop the Empire State Building, ignoring his pursuers, Kong places Fay on a ledge as tenderly as if she were a dozen eggs. He fondles her, then turns to face the Army Air Force. And Kong is perhaps the most disinterested lover since Cyrano: his attentions to the lady are utterly without hope of reward. After all, between a five-foot blonde and a fifty-foot ape, love can hardly be more than an intellectual flirtation. In his simian way King Kong is the hopelessly yearning lover of Petrarchan convention. His forced exit from his jungle, in chains, results directly from his single-minded pursuit of Fay. He smashes a Broadway theater when the notion enters his dull brain that the flashbulbs of photographers somehow endanger the lady. His perilous shinnying up a skyscraper to pluck Fay from her boudoir is an act of the kindliest of hearts. He's impossible to discourage even though the love of his life can't lay eyes on him without shrieking murder.[9]

Another type of paragraph, called the **topic-restriction-illustration (TRI)** paragraph, begins with a topic sentence that is too broad for development in a single paragraph. It may be intended to govern several succeeding paragraphs. Next comes a statement that restricts the topic to a manageable size. Then come the facts and examples that support the restriction sentence. The following paragraph by Roger Shattuck from his book *Forbidden Knowledge: From Prometheus to Pornography* demonstrates the TRI construction:

> Another haunting cluster of ancient stories from both Hebrew Scripture and pagan myth concerns a similar prohibition laid upon the human faculty of sight. In these tales, sight stands for the human need for evidence of the senses to bolster a flagging faith. The results are often fatal. Lot's wife, escaping the destruction of Sodom, hears the injunction, "Look not behind thee" (Genesis 19:17). When she turns to look at the horrible scene of fire and brimstone, "She became a pillar of salt" (Genesis 19:26). Her weakness of will closely parallels that of

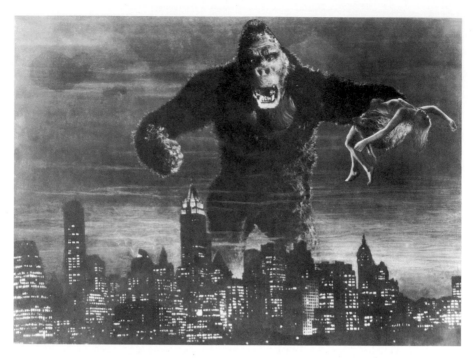

1.2 Simian chivalry. *King Kong* movie still. Photographed 1933. © Bettmann/Corbis

Orpheus leading Eurydice out of the underworld. In spite of instructions to the contrary, he must verify with his eyes that his wife has not faltered along the way. That failure of faith deprives him of Eurydice for the second time and for good.[10]

In some cases, writers find the topic sentence best placed at the *end* of the paragraph, as in the following example. The paragraph is excerpted from Jim Frederick's essay titled "We Are, Like, Poets," written when he was a student at Columbia University. The essay defends, humorously, the propensity of people of Frederick's age to pepper their conversations with the word *like:*

Take the sentence, "I can't drive you to the mall because, like, my mom took the car to get her hair frosted." Here, *like* is a crucial phonic punctuation mark that indicates, "Important information ahead!" In our frenetic society, where silence is no longer powerful but completely alien, the dramatic pause doesn't carry much rhetorical clout. We employ *like* to replace that now-obsolete device.[11]

Sometimes a **concluding sentence** for the paragraph is in order. This sentence might restate the assertion made in the topic sentence, or it might speak of the broader implications of the evidence offered in the paragraph and its connection to the thesis. A paragraph from Robert MacNeil's essay "Word-struck" demonstrates:

In the *Just So Stories* and *The Jungle Books,* which we read in the same years, Kipling pushed his language right in front of me; I couldn't ignore it, the exotic Indian words, like *Bandarlog* and *dhak* tree, that seemed to have a taste as well as

a sound; the strong names for the characters like Tabaqui the jackal, Nag the cobra, and Rikki-Tikki-Tavi, the mongoose. There were also his rhetorical devices, borrowed from the oral storytellers, repetitions like *the great grey-green, greasy Limpopo River, all set about with fever trees.* They are funny to a child and they grow hypnotic like magic incantations. The repetitions, the sing-song rhythms, and the exotic vocabulary were so suggestive that I imagined I could smell things like the perfumed smoke from the dung fire or the mysterious odour of sandalwood.[12]

Adequate development is achieved by providing sufficient evidence for the assertion you have stated in the topic sentence. **Evidence** consists of specific details, facts, and examples. Assume that your audience is not going to believe a word you say unless you present specific supporting evidence.

Paragraph **organization** is achieved simply by giving the details in a logical order. Sometimes the logical order of details is *chronological*. If you are describing something tangible, such as a sculpture or a painting, you might begin at the top and progress downward, or you might begin at the bottom and progress upward, or begin on the left and move to the right. In other words, the organization of your paragraph is *spatial*. The following paragraphs, excerpted from myth critic Joseph Campbell's book *Mythic Image,* describe the famous bronze Hindu statue of *Shiva Nataraja,* spatially.

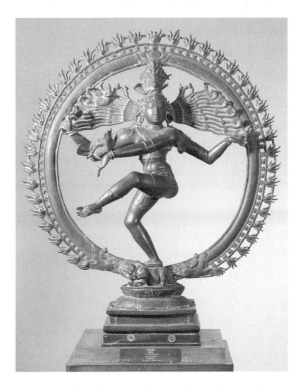

1.3 Lord of the Cosmic Dance. Chola Bronze Shiva Nataraja from Tamil Nadu. © Angelo Hornak / Corbis

The upper right hand of the dancing god holds a little drum shaped like an hourglass, the rhythm of which is the world-creating beat of time, which draws a veil across the face of eternity, projecting temporality and thereby the temporal world. The extended left hand holds the flame of spiritual light that burns the veil away, thus annihilating the world and revealing the void of eternity. The second right hand is in the "fear-dispelling" posture, and the second left, lifted across the chest, pointing to the raised left foot, is in a position known as "elephant hand," signifying "teaching"; for where an elephant has gone through jungles all animals can follow, and where a teacher leads the way disciples follow. The left foot, to which the "teaching hand" points, is lifted to symbolize "release," while the right stamping on the back of a dwarf named "forgetfulness" drives souls into the vortex of rebirth. The dwarf is gazing in fascination at the poisonous world-serpent, representing thus man's psychological attraction to the realm of his bondage in unending birth, suffering, and death.

The god's head, meanwhile, is poised, serene and still, in the midst of all the movement of creation and destruction represented in the rhythm of the rocking arms and slowly stamping right heel. His right earring is a man's, his left a woman's; for he includes and transcends opposites. His streaming hair is that of a yogi, flying now however in a dance of life. Among its strands is tucked a skull, but also a crescent moon; a datura flower, from the plant of which an intoxicant is distilled; and finally, a tiny image of the goddess Ganges—for it is Shiva, we are told, who receives on his head the first impact of that heavenly stream as it falls to earth from on high.[13]

Another typical organizational pattern is the *question-answer pattern*, demonstrated in the following paragraph by author and editor Justin Kaplan.

What is an essay, and what, if anything, is it about? "Formal" and "informal," "personal," "familiar," "review-essay," "article-essay," "critical essay," essays literary, biographical, polemic, and historical—the standard lit-crit lexicon and similar attempts at genre definition and subclassification in the end simply tell you how like an eel this essay creature is. It wriggles between narcissism and detachment, opinion and fact, the private party and the public meeting, omphalos and brain, analysis and polemics, confession and reportage, persuasion and provocation. All you can safely say is that it's not poetry and it's not fiction.[14]

Because comparison is a valuable tool in the study of art, it is particularly important to be able to organize a **comparison paragraph.** You might proceed in one of two ways, using either the block method or the point-by-point method. The **block method** divides the paragraph roughly into halves, or blocks, and discusses the first item thoroughly before going on to the second item. The **point-by-point method,** on the other hand, makes a point about the first item and then a corresponding point about the second item, then a second point about the first item and a corresponding point about the second item, and so forth.

The paragraph that follows, borrowed from a treatise by drama critic Walter Kerr titled *Tragedy and Comedy,* uses the block method to compare the two dramatic forms. The first half of the paragraph discusses tragedy; the second half discusses comedy. The concluding statement generalizes about the difference.

The tragic statement is the original and fundamental statement, the mother statement, because it coincides exactly with the intention of drama as a whole. If drama's impulse is to display an action, tragedy is the form that sees man free enough to act, to act extensively, even to act absolutely. When the tragic hero says "I *will*," he is doing drama's work without reserve. Comedy, which we feel in our bones to be the lesser form, is indeed the lesser form because it comes into existence as a comment upon tragedy, and in fact upon drama. It is a species of criticism and, hence, parasitical. It does not initiate action; its desires are all passive. Rather it derides action for the inhibited and otherwise oppressed thing it is. "Oh, no, you won't," it says, pointing to the stone wall just ahead. Comedy could not create drama of its own power; its feet are too sore, its burdens too heavy, for it to cross the circle unaided. Comedy will cross the circle when it is kicked across or chased across or carried across; left to its own devices it will simply run in circles forever, or until it is tired enough to lie down. Comedy is dependent. It requires tragedy to budge it into its characteristic posture of dragging its feet while thumbing its nose. Tragedy is the thought of drama, and comedy the afterthought.[15]

The following comparison paragraph, by Virginia Woolf, is excerpted from *A Room of One's Own.* Woolf imagines the life that Shakespeare's sister, if he had had one, might have led, supposing that the siblings were equally talented, and she expounds on the conspicuous presence of women in literature and their conspicuous absence from historical records in England during the seventeenth century. The paragraph is organized point by point:

A very queer, composite being thus emerges. Imaginatively she is of the highest importance; practically she is completely insignificant. She pervades poetry from cover to cover; she is all but absent from history. She dominates the lives of kings and conquerors in fiction; in fact she was the slave of any boy whose parents forced a ring upon her finger. Some of the most inspired words, some of the most profound thoughts in literature fall from her lips; in real life she could hardly read, could scarcely spell, and was the property of her husband.[16]

Coherence in paragraphs is the smooth progression from one idea to the next. One way that coherence is achieved is by the use of **transitional expressions,** such as *for example, nevertheless,* and *however.* These expressions keep the reader from becoming lost in the maze of evidence you are presenting. Some useful transitional expressions are listed here:

Additional idea: *and, also, in addition, too, indeed more important, furthermore, moreover, or*

Comparison: *similarly, likewise, neither/nor, either/or*

Contrast: *but, yet, however, on the other hand, conversely, rather*

Numbered ideas: *first, second, third, finally*

Result: *so, hence, therefore, consequently, thus, then*

Exemplification: *for example, for instance, in fact*

Summary: *in short, on the whole, to sum up, in other words*

WRITING THE CONCLUSION

The conclusion is your last chance to evoke a nod of approval from your reader as you reinforce your main idea. Do not waste the opportunity by merely repeating your thesis and points of proof. The reader has already read and been convinced of these points. On the other hand, the conclusion must not raise a new issue. How do writers, under these restrictions, reiterate their main ideas without repeating themselves? Conclusions need a controlling idea. Following are some ideas you might develop in your conclusion:

- Return to a detail or anecdote written in the introductory remarks.
- Use a quotation.
- Predict the future of the situation or issue.
- Tell the current status of the issue.
- Discuss the broader implications of the topic.
- Call your readers to action.

Conclusions are closely connected to introductions and cannot be fully appreciated unless the essay's main point is understood. Following is a concluding paragraph of an essay by George Orwell on Charles Dickens. The essay argues that attempts to appropriate Dickens as a Marxist, a socialist, or a champion of the proletariat, as certain critics have done, are misguided.

> When one reads any strongly individual piece of writing, one has the impression of seeing a face somewhere behind the page. It is not necessarily the actual face of the writer. I feel this very strongly with Swift, with Defoe, with Fielding, Stendhal, Thackeray, Flaubert, though in several cases I do not know what these people looked like and do not want to know. What one sees is the face that the writer *ought* to have. Well, in the case of Dickens I see a face that is not quite the face of Dickens's photographs, though it resembles it. It is the face of a man of about forty, with a small beard and a high colour. He is laughing, with a touch of anger in his laughter, but no triumph, no malignity. It is the face of a man who is always fighting against something, but who fights in the open and is not frightened, the face of a man who is *generously* angry—in other words, of a nineteenth-century liberal, a free intelligence, a type hated with equal hatred by all the smelly little orthodoxies which are now contending for our souls.[17]

Notice the *concrete image* of a photograph of Dickens in this conclusion. Abstractions are easily forgotten. Your conclusion will be more memorable if it contains concrete images.

CITING YOUR SOURCES

If you have used sources in your essay in a way that obligates you to credit them, you must document the necessary passages and create a list of *works cited* or a *bibliography,* depending on which documentation style your instructor requires. Chapter Seven gives detailed information on this step in the process.

INVENTING A TITLE

Some writers create a title for their essay early in the process, saying it helps them narrow their topic and focus on the task. Others wait until they have finished the essay to compose a title. Your title may be an indication of the topic, like Matt Hoffman's essay title in Chapter Three, "Bach's Enduring Influence." Or it may indicate the thesis, like the title of Todd Shelton's essay in Chapter Four, "Claggart Was Just Doing His Job." Or you might mine your own essay for a particularly apt turn of phrase or ask a question. Do give your essay its own title, not the title of the work it discusses. For example, "The Birth of Venus" will not do as a title for an essay about Botticelli's *The Birth of Venus,* although you might include the name of the work of art in the title, such as "Neoplatonism in *The Birth of Venus.*"

REVISING YOUR ESSAY

Good writing usually entails extensive *revision.* Ernest Hemingway once told an interviewer that he rewrote the ending of *A Farewell to Arms* thirty-nine times. When the interviewer asked him what the problem was, he replied, "Getting the words right."[18] Hemingway's answer may seem obvious, but most of us do not know when we have reached the point where our words are "right."

Most of us benefit greatly from having others read our writing and comment on it. Usually the person who reviews your writing will be a friend, roommate, or classmate—in other words, your peer. At times, peer review can be helpful; at other times not. Generally, peer review goes more smoothly and is more beneficial not only for the author but also for the reader (whose own writing and critical thinking skills will improve as a result of the process) if you have guidelines. The following guidelines for peer review, much of which summarize the advice of Peter Elbow, author of *Writing Without Teachers,*[19] will provide you with a procedure for productive peer review and for the revision that results from it. Realize that there are two kinds of feedback: **reader-based** feedback and **criterion-based** feedback. The first type, all readers are qualified to give. The second type is only for readers who have been trained to judge writing based on the same criteria that your instructor will use to grade your essay.

GUIDELINES FOR PEER REVIEW

AUTHOR

- If your peer group consists of more than one person, give assignments: pointing, summarizing, and telling, as explained hereafter. It is your responsibility to decide what kind of feedback you want and from whom.

- Have a peer read your essay aloud, one section at a time. Hearing your words will give you an auditory sense of the work, which until now you have probably been lacking. You will hear the rough spots.

- Be quiet and listen. Do not, by gesture or facial expression, express disapproval or disagreement with your peers' comments, or your peers will stop commenting.

- Do not make any decisions yet as to which comments you will take seriously and which ones you will reject. For now, take all comments indiscriminately. Sometimes, later, you will find that a comment that seemed "off" was actually an indicator of a real problem or a chance for real improvement.

- Do not ask your peers to fix your essay.

- Know that ultimately you are responsible for your essay. It is up to you to decide what to do with the feedback you receive.

READERS GIVING READER-BASED FEEDBACK

- Know that you do not have to be an English teacher to give valuable feedback to your peer. You have been reading most of your life and are perfectly qualified, as a reader, to respond to writing.

- Remember throughout the process that you do not have to justify any of your reactions. They are what they are. It is the author's task to solve the essay's problems, not yours.

- Never quarrel with someone else's reaction.

- Be specific. If you say, "This paper keeps saying the same thing over and over," the writer may simply feel judged. If you say, "Paragraph five makes the same point as paragraph three," the writer will have a clearer sense of direction.

- With your finger or a pen, *point* at the places in the text where you feel satisfied and comfortable. Point to the places that make you dissatisfied or uncomfortable.

- *Summarize* the main point of the section you have just read, and tell the dominant mood.

- *Tell* what happened to you during the reading. Mark the places where you smiled, where your brow wrinkled, where you thought, "Huh?" How did you feel at the end? Concentrate on conveying your responses to the writing.

- Do not discuss grammar, punctuation, spelling, or mechanics.

- Do not fix the essay. That is the author's job.

READERS GIVING CRITERION-BASED FEEDBACK

- Find the thesis, or what you believe to be the intended thesis. Are there other statements that could be mistaken for the thesis? Is the thesis

written in the proper mode of discourse? Does it fulfill the criteria for a workable thesis as set out on pages 50 and 97 of this textbook?

■ What question does the thesis provoke? In other words, what is the proof question?

■ Where are the points of proof? Do they follow the thesis directly? If not, is there a good reason? Are they explicit in the body of the essay?

■ Do the points of proof fulfill the criteria for workable points of proof as set out on page 52 of this textbook?

■ Do the introductory remarks (the material preceding the thesis) contain specifics, such as *who, what, when,* and *where?*

■ Do the introductory remarks lead directly to the thesis? Or does there seem to be some lack of continuity between the introductory remarks and the thesis?

■ Do the body paragraphs exhibit the qualities of unity, adequate development, organization, and coherence?

■ Is the evidence presented in the body convincing?

■ Does the conclusion reiterate the main point without simply repeating the thesis and points of proof? Does the conclusion have the qualities of unity, adequate development, organization, and coherence?

■ What suggestions for improvement do you have for the author?

After peer review, the author must make decisions as to which comments and suggestions to act on. Remember that the author, not his or her peers, is responsible for the essay.

If review by your peers is not an option, put yourself in the place of a reader who is reading the essay for the first time and answer the questions for reader-based and criterion-based feedback.

EDITING AND PROOFREADING YOUR ESSAY

William Strunk, coauthor of the renowned *The Elements of Style,* writes, "Vigorous writing is concise. A sentence should contain no unnecessary words, a paragraph no unnecessary sentences, for the same reason that a drawing should have no unnecessary lines and a machine no unnecessary parts."[20] Such economy is rarely achieved without extensive editing.

Like the procedure for revision, the procedure for editing is rarely linear. A word change in one place in the paper may create a need to reconstruct a sentence or reorganize a paragraph somewhere else. Still, it makes sense to start with the larger issues in editing, and work toward the smaller ones.

■ Examine your sentences individually. Each sentence should be solidly constructed. *Run-ons* and *fragments* are very serious errors. Try reading your sentences in reverse order, the last sentence first. This way, you are reading each sentence out of context and can concentrate on its

structure rather than its content. This is also the time to consider sentence punctuation, especially of quoted material. Consult the Handbook at the end of this textbook for advice on sentence construction and punctuation.

■ Look at your words individually. Is each word chosen carefully in terms of meaning and tone? Are you using upper- and lowercase correctly? Is each word spelled correctly? Your computer's grammar and spell-check functions are useful, but they will not catch every error, particularly with homonymic words. If, for example, you have written *medal* where you should have written *mettle* or *where as* instead of *whereas,* your computer, being only a machine, is of no help. Use a dictionary! Consult the Handbook at the end of this textbook for advice on word choice and ways to avoid wordiness.

■ Review your source citations and works cited page or bibliography. Are they presented correctly?

FORMATTING YOUR ESSAY

See the sample essays in this book for a generally accepted, MLA-recommended format for college papers. You probably do not need a title page because title pages are generally for book-length papers with multiple chapters. If you need one, or if your professor prefers one, center the information on the page, as follows:

Title

Student Name

Course Number

Professor's Name

Date

Finally, check with your professor for any special requests in the handling and packaging of your paper.

WRITING THE SHORT RESPONSE

Responding Objectively	*Paraphrase*
	Summarize
Responding Subjectively	*React*
	Compare
	Evaluate
	Infer

CHAPTER PREVIEW

Art, whether visual or performing art, evokes a response in us. Michelangelo's *David,* for example, was greeted so enthusiastically by the people of Florence that they compelled him not to place the sculpture in the Cathedral of Florence, as he had planned, but to place it instead in the middle of town, where they could admire it conveniently. His paintings on the ceiling of the Sistine Chapel, on the other hand, incurred the wrath of Pope Paul IV, who very nearly destroyed the paintings by commissioning the artist Daniel da Volterra (the *braghettone* or "pants putter on") to cover up the most critical parts of the nudes. Our responses to art matter. They define us and our culture. The examples and exercises in this chapter are intended to provide you with the opportunity to respond *informally* to the arts through the practice of certain skills such as paraphrasing and summarizing ideas, to record your emotional responses, to compare and evaluate works, and to draw inferences from them. Often, such informal responses will provide the basis for fuller, more formal critical essays.

RESPONDING OBJECTIVELY

PARAPHRASE

To **paraphrase** is to restate another's speech, either written or spoken, in your own words and style. Paraphrasing is an important academic skill; it allows you to develop and demonstrate your understanding of ideas that have influenced cultures and civilizations.

Following are some points to remember when paraphrasing:

- You must completely recast the original passage. If your paraphrase resembles the original too closely, you have, perhaps unwittingly, committed an act of **plagiarism,** which is the illegitimate use of another's words. Simple substitution of synonyms or rearranging of word order is insufficient; you must use your own words, your own style, and your own sentence structure.

- Your paraphrase must accurately convey what the original passage *says*, not what you believe it *means*.

- Your paraphrase must not be colored by your own ideas or opinions.

- When you are paraphrasing a sentence that contains information that is *widely available,* there is no need to cite or acknowledge your source. Still, you cannot copy another writer's sentence, no matter how innocuous the content.

- If the words you are paraphrasing convey factual information that is *not* widely available, you must place a source citation at the end of your sentence.

- If you are paraphrasing someone's ideas, as opposed to facts, you must introduce the paraphrase with an **acknowledgment phrase,** such as "According to so and so . . . " or "So and so has observed that " You may also need a source citation at the end of your paraphrase, if the original source is not widely available.

Exercise 2-1

Read the following poem by A. E. Housman and the paraphrases that follow. Which paraphrase of Housman's poem most completely fulfills the preceding criteria?

Loveliest of Trees, the Cherry Now

Loveliest of trees, the cherry now
Is hung with bloom along the bough,
And stands about the woodland ride
Wearing white for Eastertide.

Now, of my threescore years and ten,
Twenty will not come again,
And take from seventy springs a score,
It only leaves me fifty more.

And since to look at things in bloom
Fifty springs are little room,
About the woodlands I will go
To see the cherry hung with snow.

Paraphrase #1: Life is too short. We must make the most of what little time we have.

Paraphrase #2: The cherry trees look very pretty in the spring, hung with bloom. I am seventy years old and feel that life is slipping away. I must make the best possible use of my time. So I will keep going about the woodlands every spring for as long as I live to look at the cherry trees hung with snow.

Paraphrase #3: The narrator of A. E. Housman's poem, "Loveliest of Trees, the Cherry Now," is saying that the cherry tree looks very pretty in the spring covered with white flowers. The narrator figures he can expect to live seventy years. He is twenty years old now, so that leaves him only fifty years more. He feels that fifty springs are not enough to fully enjoy the cherry trees, so he plans to see them in wintertime as well, when they are covered with snow.

SUMMARIZE

Whereas a paraphrase offers a literal translation of the original passage, including most of the details of the original, a **summary** offers the original passage's main idea, often without the supporting details. Therefore, a summary is usually shorter than a paraphrase. A summary of Housman's poem might be the following: "The twenty-year-old narrator of A. E. Housman's 'Loveliest of Trees, the Cherry Now' intends to look at the cherry trees both in the spring and in the winter for the rest of his life." Otherwise, the criteria for summarizing are essentially the same as those for paraphrasing.

The following guidelines provide an efficient method for summarizing longer prose passages:

- First, read the passage carefully.
- Find the *thesis* of the passage. Underline it.
- Find and underline the *topic sentence* of each paragraph. This sentence summarizes the contents of the paragraph. If the paragraph has no topic sentence, compose one of your own in the margin.
- Draft a summary. *Paraphrase* the thesis in writing. Then paraphrase the topic sentence of each paragraph, adding whatever connecting material is necessary for coherence.
- Paraphrase the summary you have written, as an added measure against plagiarism.
- Check the summary against the original passage to ensure that your summary does not too closely match the original.
- Make it clear to your reader throughout your summary that these are someone else's ideas, not yours.

EXERCISE 2-2

Read the following excerpt from an essay titled "Of the Art of Discussion" by sixteenth-century French writer Michel de Montaigne. Then read the summaries that follow. Which summary of Montaigne's essay best fulfills the preceding criteria?

THE ART OF DISCUSSION

The most fruitful and natural exercise of our mind, in my opinion, is discussion. I find it sweeter than any other action of our life; and that is the reason why, if I were right now forced to choose, I believe I would rather consent to lose my sight than my hearing or speech. The Athenians, and the Romans too, preserved this practice in great honor in their academies. In our time, the Italians retain some vestiges of it, to their great advantage, as is seen by a comparison of our intelligence with theirs.

The study of books is a languishing and feeble activity that gives no heat, whereas discussion teaches and exercises us at the same time. If I discuss with a strong mind and a stiff jouster, he presses on my flanks, prods me right and left; his ideas launch mine. Rivalry, glory, competition, push me and lift me above myself. And unison is an altogether boring quality in discussion.

As our mind is strengthened by communication with vigorous and orderly minds, so it is impossible to say how much it loses and degenerates by our continual association and frequentation with mean and sickly minds. There is no contagion that spreads like that one. I know by enough experience how much it is worth per yard. I love to argue and discuss, but in a small group and for my own sake. For to serve as a spectacle to the great and make a competitive parade of one's wit and chatter is an occupation that I find very unbecoming to a man of honor.

Stupidity is a bad quality; but to be unable to endure it, to be irritated and chafed by it, as happens to me, is another sort of malady which is scarcely less troublesome than stupidity; and that is what I now wish to accuse in myself.

I enter into discussion and argument with great freedom and ease, inasmuch as opinion finds in me a bad soil to penetrate and take deep roots in. No propositions astonish me, no belief offends me, whatever contrast it offers with my own. There is no fancy so frivolous and so extravagant that it does not seem to be quite suitable to the production of the human mind. We who deprive our judgment of the right to make decisions look mildly on opinions different from ours; and if we do not lend them our judgment, we easily lend them our ears.[1]

Summary #1: Engaging in discussion is a worthy use of our time. Through discussion, especially with a stiff jouster, our intelligence

grows. We shouldn't associate with people who have "mean and sickly" minds, however; their stupidity is contagious. We shouldn't be astonished by any proposition or offended by any beliefs. All ideas have equal validity. We should listen with an open mind to all ideas.

Summary #2: In his essay "Of the Art of Discussion," Montaigne claims that the best thing we can do with our minds is to engage in discussion. Discussion of ideas with someone who disagrees with us pushes us to higher levels of thinking, whereas the opposite happens when we associate with stupid people. Also, according to Montaigne, it is not good manners to show off our wit and intelligence in public, so we should conduct our discussions in small groups. Montaigne goes on to say that it is bad enough to be stupid, but to tolerate our own stupidity, to do nothing about it, is even worse. Montaigne says he tries to keep an open mind to unusual ideas. He says we should withhold our judgment and listen.

Summary #3: Montaigne believes that it's important to discuss things because through discussion we may someday arrive at the truth. Reading is useless; we are much more enlightened by talking with an enemy. It's better not to have opinions; that way, we remain flexible.

RESPONDING SUBJECTIVELY

How we respond to art depends largely on the guidance the artist has given us. The artist has made certain choices in theme and composition, and we must note those choices, discern as much as possible about the artist's intended meaning. But our own educations and backgrounds contribute to our responses.

Following are some questions that may help you to define and assess your responses to the arts. It is important that you *write* your responses; doing so will allow you to capitalize on your responses, leading to ever deeper ones. Unwritten responses are fleeting; you are not likely to remember them or be able to use them to launch further inquiry.

QUESTIONS TO GUIDE YOUR RESPONSES TO THE ARTS

1. What is the overall subject matter?
2. What are the larger components?
3. What are the smaller details?
4. What is the predominant mood?
5. What details contribute to the predominant mood? What details contradict it?

6. Do any details strike you as symbolic?

7. What does the title of the work tell you?

8. What is the style of the work? Why would the artist have chosen this style?

9. What is the historical setting of the work—its place, time, and political influences?

10. What critical strategies could you apply to the work? (Refer to Chapter Eight.)

11. What do you "hear" when you view the work (even if the work has no actual sound)?

12. What do you believe the artist intended you to feel?

13. Do your feelings coincide with what you perceive the artist's intentions to be?

14. Does the work confirm or challenge your experiences? your values? your beliefs? your assumptions? Explain why or why not.

15. How is the work like or unlike comparable works?

16. What accounts for the work's similarities and differences?

17. Has your response to the work changed from your initial reaction, now that you have examined the work in more detail?

18. What questions do you have about the work?

REACT

When we read a work of literature, listen to music, or view a work of art, we respond both intellectually and emotionally. We may laugh or cry, gasp in admiration, shake our heads in anger or disbelief, or scratch our heads in bafflement. All reactions are valid initially, but to engage with the work, we must invest some time and effort in assessing our reactions. In other words, we must ask not only *how* the work makes us feel but also *why* it makes us feel the way it does.

Consider, for example, William Carlos Williams's famous poem, "The Red Wheelbarrow," published in 1923:

The Red Wheelbarrow

so much depends
upon

a red wheel
barrow

glazed with rain
water

beside the white
chickens.

Many readers, on first encountering "The Red Wheelbarrow," are baffled. Others are moved. Still others are angered that the poem merits publication, let alone praise. All of these reactions are valid up to a point, but we must stretch our imaginations, reach into our experiences, and exercise our intelligence if our opinions are to transcend mere reaction.

EXERCISE 2-3

Look at Walker Evans's photograph below. The black and white photograph was taken in Alabama in 1935. Answer the preceding Questions to Guide Your Responses to the Arts. Do your impressions and opinions of the work deepen as you engage more intimately with it?

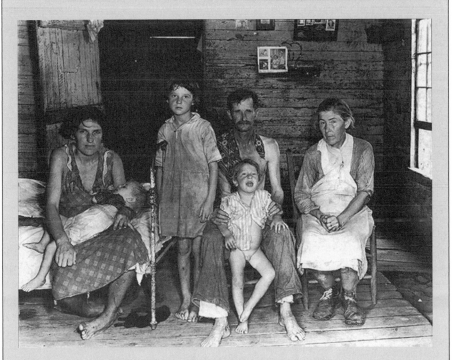

2.1 Walker Evans, *Sharecropper Bud Fields and his family at home*, 1935. Black and white photograph. Library of Congress.

COMPARE

Often, comparing two works of art heightens our awareness of both works. The attempt to compare compels us to look at the works more closely and sharpens our observations.

EXERCISE 2-4

Following are two sonnets by William Shakespeare. Answer the Questions to Guide Your Responses to the Arts set out in the previous section for each work, paying particular attention to questions 15 and 16.

MY MISTRESS' EYES ARE NOTHING LIKE THE SUN

My mistress' eyes are nothing like the sun;
Coral is far more red than her lips' red;
If snow be white, why then her breasts are dun;
If hairs be wires, black wires grow on her head.
I have seen roses damasked red and white,
But no such roses see I in her cheeks;
And in some perfumes is there more delight
Than in the breath that from my mistress reeks.
I love to hear her speak, yet well I know
That music hath a far more pleasing sound;
I grant I never saw a goddess go;
My mistress, when she walks, treads on the ground.
And yet, by heaven, I think my love as rare
As any she belied with false compare.

SHALL I COMPARE THEE TO A SUMMER'S DAY?

Shall I compare thee to a summer's day?
Thou are more lovely and more temperate.
Rough winds do shake the darling buds of May,
And summer's lease hath all too short a date.
Sometime too hot the eye of heaven shines,
And often is his gold complexion dimmed;
And every fair from fair sometime declines,
By Chance or nature's changing course untrimmed.
But thy eternal summer shall not fade,
Nor lose possession of that fair thou ow'st,
Nor shall Death brag thou wand'rest in his shade,
When in eternal lines to time thou grow'st.
 So long as men can breathe or eyes can see,
 So long lives this, and this gives life to thee.

EVALUATE

One of our most common responses to art is to consider its worth. After we have seen a film, for example, our first question to our fellow viewers is, "Did you like it?" or, "What did you think of it?" We may find ourselves in a lively discussion about the film's merits or lack of them. Or we may find our own

reactions confused, as when we feel we should like a film, but some nagging, as yet unidentifiable, doubt prevents us from proclaiming a definitive judgment. Such friendly disagreements help us, ultimately, to focus our thinking and solidify our opinions. At times, we even succeed in persuading others to accept our evaluations as worthy, if not completely agreeable.

Evaluations are usually based on a set of elements that break the work into smaller pieces. For example, you could evaluate a film according to the quality of the acting, cinematography, sound track, story line, theme, or emotional impact. What you will emphasize in your evaluation will depend on what is emphasized in the film itself and on your own sense of what is important. Various elements for evaluating and analyzing literature, poetry, drama, film, art, music, and dance are discussed in Chapters One, Six, and Eight of this textbook. In order to kick-start your own responses, you may want to refer to those sections.

The following is an informal evaluation of Stanley Kubrick's *Dr. Strangelove; or, How I Learned to Stop Worrying and Love the Bomb.* Notice the various elements of the film that Chris Hammett has chosen to emphasize. Notice, also, the aspects of this response that mark it as informal; for example, Hammett's mention of the fact that she had viewed the film twice, once in class and again with her mother. Typically, such information would not appear in a formal essay, but here such prompts are not only permissible but encouraged.

A Post-Cold War Response to *Dr. Strangelove*

by Chris Hammett

Produced in 1964, *Dr. Strangelove* is a perfect example of "you had to be there" to fully understand its implications. Today's younger generation might view it as pure slapstick—obvious, overstated, and even boring; but Baby Boomers, members of the "Sixties Generation," having grown to adulthood via the McCarthy years and with a vision of "The Bomb" hanging over their heads every waking moment, saw this film when it first came out as a strong statement reflecting their increasing distrust of both the military and politicians.

After having viewed this film in the classroom, I saw it a second time in the company of my mother, who was born in 1946. Her comments and insights gave me an entirely different perspective of the film. Unlike me, she did not at all think that either the plot or Kubrick's portrayal of the characters was farfetched. In fact, throughout our viewing of the film, she noted themes and characterizations that had completely escaped me the first time.

For instance, whereas I saw both Generals Jack D. Ripper (Jack da Ripper?) and Buck Turgidson (turgid: pompous and bombastic) as highly unrealistic characters, the two men reminded my mother of the U.S. generals who went so far as to lie to the President (possibly) and to the nation (certainly) about the need for a U.S. military presence in Vietnam. In other words, both in the film and in reality, the military needs, even wants, wars.

In another example of our different perspectives, I felt that President Muffley (muff: blunder) appeared simple and altogether spineless. My mother, on the other hand, saw him as a caricature of Harry Truman, not only in appearance, but as the man who authorized the use of the first atomic bomb, especially when Muffley says, "I will not go down in history as the greatest mass murderer since Adolf Hitler."

Both my mother and I found wry humor in the dual meanings of the characters' names: "King" Kong, "Bat" Guano (*guano:* bat excrement), Premier Kisov (kiss off?) and, of course, Dr. Strangelove, "a Kraut by any name," according to Turgidson.

More subtle than the use of their names, however, was Kubrick's casting of the actors. George C. Scott, for instance, portrays a semi-parody of his role as General Patton (I use the term "semi-parody" because the role of Patton was somewhat of a parody itself). In this film, Slim Pickens, who previously had acted only in Westerns, is a flying cowboy, donning his Stetson upon reading his war orders, making constant references to horses ("no horsin' around," "more holes in us than a horse trader's mule") and, finally, riding off into the sunset in his last appearance in the film, astride his bomb and waving his hat, shouting, "Yahoo," as if aboard a bucking bronco at a rodeo.

As a woman, I was particularly aware of Kubrick's portrayal of these sorry leaders' views of the female sex. The only woman to appear was cast as a total bimbo ("I told you never to call me here," says Turgidson, and "Of course I respect you like a human being. Buckie will be back as soon as he can. Don't forget to say your prayers"). At the film's end we watched the reactions of the men when

Dr. Strangelove proposes his deep mine shaft survival program. First, he suggests ten females to each male, and then, in response to a question by Turgidson, goes on to say that regrettably, a "sacrifice will be required of the men," each being "required to do his service."

Stanley Kubrick directed a film that initially bored me, but ultimately gave me greater insight into the Cold War and what life was like for those who experienced that era. Although the film initially appeared to be pure slapstick to me, after viewing the movie a second time, accompanied by my mother, a member of the "Sixties Generation," I came to see its subtleties and thus its satire.

EXERCISE 2-5

View with a friend or a group of friends a work of art, literature, film, music, or dance that has received mixed reviews—one that is likely to generate a lively discussion. Discuss the work based on the elements set out in Chapters One, Six, and Eight of this textbook. Tape-record your discussion, and then distill your individual evaluations into separate written responses.

INFER

To *infer* is to interpret information, to draw a conclusion from it. Valid inferences rely on careful examination of the smaller pieces, or elements, that constitute the whole. In literature, for example, one looks at the plot, characters, setting, symbols, and other elements that make up the whole short story or novel in order to infer the author's meaning. In art, one examines such elements as the subject matter, medium, and palette to infer the artist's meaning or mood.

EXERCISE 2-6

Read the following story, handed down from the oral tradition of Kalandar dervishes (wandering Sufis), especially in light of the Questions to Guide Your Responses to the Arts. What inferences can you draw from the story? Why, for example, do you think the "matter was never referred to again"?

THE ANCIENT COFFER OF NURI BEY

Nuri Bey was a reflective and respected Albanian, who had married a wife much younger than himself.

One evening when he had returned home earlier than usual, a faithful servant came to him and said,

'Your wife, our mistress, is acting suspiciously.

'She is in her apartments with a huge chest, large enough to hold a man, which belonged to your grandmother.

'It should contain only a few ancient embroideries.

'I believe that there may now be much more in it.

'She will not allow me, your oldest retainer, to look inside.'

Nuri went to his wife's room, and found her sitting disconsolately beside the massive wooden box.

'Will you show me what is in the chest?' he asked.

'Because of the suspicion of a servant, or because you do not trust me?'

'Would it not be easier just to open it, without thinking about the undertones?' asked Nuri.

'I do not think it possible.'

'Is it locked?'

'Yes.'

'Where is the key?'

She held it up. 'Dismiss the servant and I will give it to you.'

The servant was dismissed. The woman handed over the key and herself withdrew, obviously troubled in mind.

Nuri Bey thought for a long time. Then he called four gardeners from his estate. Together they carried the chest by night unopened to a distant part of the grounds, and buried it.

The matter was never referred to again.[2]

EXERCISE 2-7

Look at the following engraving titled *Melancolia I*. The engraving was produced in 1514 by Albrecht Dürer. Examine, perhaps even list, the details of the picture. What inferences about the artist's meaning can you draw from the details?

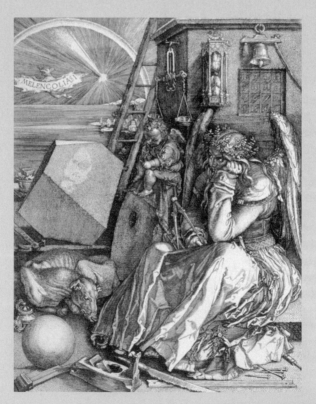

2.2 Albrecht Dürer, Burstein Collection, *Melancolia I*, 1514 © Corbis

EXERCISE 2-8

Look again at Walker Evans's photograph titled *Sharecropper Bud Fields and his family at home* on page 33. What can you infer about Evans's message from the photograph? Which critical approaches listed in Chapter Eight could you apply in your assessment of the photograph?

All formal essays and research papers in the humanities begin with a response to the arts. In this chapter, you have become acquainted with some methods for catalyzing and cataloguing your responses. You have also practiced many of the skills that will come into play as you write formal essays and research papers in the humanities and as you continue to enjoy the visual and performing arts beyond college and throughout your life. The subsequent chapters will guide you toward shaping the ideas that spring from your responses into formal critical essays and research papers.

WRITING THE ANALYTICAL ESSAY

CHAPTER PREVIEW

Most people find writing analytically to be simultaneously liberating and constricting. In analytical writing, you are free to interpret what you have seen or read, to draw your own conclusions from it, and to express an opinion. You are encouraged to take a chance, to posit a theory, or to speculate. However, you are also expected to limit the scope of your opinion and to validate it. You must offer support for your theory. This chapter will explain the concepts inherent in analysis and guide you through the process of writing an analytical essay, from choosing a topic to supporting a thesis to editing and proofreading.

THE NATURE OF ANALYSIS

When you write an analytical essay, you attempt to convey your own perspective on a work of art. The analytical essay might focus on some particular symbol or image and discuss its implications. For example, you might discuss Shakespeare's use of the moon in *A Midsummer Night's Dream*. Sometimes it is a "silver bow"; other times it is "cold" or "wat'ry." Sometimes it "gracious, golden, glittering gleams"; other times it is the "governess of floods, / Pale in her anger." What moods, what themes, what messages are implied by this ever-changing object? The analytical essay might employ a fresh critical approach. For example, you might apply Marxist criticism (see Chapter Eight) to Chaucer's "The Wife of Bath's Tale" by discussing the influence of economy and labor on the characters in the tale. Your analytical essay might explain the theory of deconstruction, using as an extended example John Coltrane's groundbreaking free-form jazz saxophone rendition of "My Favorite Things," that fetching tune about "whiskers on kittens" originally from *The Sound of Music*. There truly is no end to the possible ways in which the arts can be analyzed.

DRAWING INFERENCES

At the heart of the analytical essay is an *inference*. In other words, the writer examines a fact, or perhaps a collection of facts, and from them draws a conclusion or an inference. Take, for a brief example, Shirley Jackson's short story, "The Lottery." The Hutchinsons, who draw from the wooden box the scrap of paper with the dreaded black dot, occupy center stage of this tightly woven drama, but several times the reader's attention is diverted toward another family, the Dunbars: "'Dunbar,' several people said, 'Dunbar, Dunbar.'" When the name Dunbar is repeated three times, the astute reader might infer that the narrator is signaling that the Dunbars deserve our attention. Indeed, if you look closely at the Dunbars, your understanding of the story could acquire a whole new dimension. An analytical paper might explore the importance of the Dunbars to Jackson's theme of obedience to authority.

FORMAL ANALYSIS

You may be asked, at times, to write a type of essay called the **formal analysis.** Here, *formal* means "pertaining to shape or structure," not "in accordance with the rules of etiquette." To *analyze* means, literally, to take a thing apart to discover how the pieces work together to create a whole. A formal analysis of an artwork, then, would discuss the ways in which the artwork's *subject matter, formal elements, principles of design,* and *medium* work together to create an overall impression. The following paragraph, from an essay titled "Hopper: The Loneliness Factor," by Mark Strand, describes two of Edward Hopper's paintings in terms of the impression created by geometric forms:

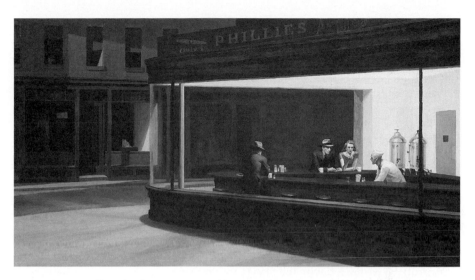

3.1 American all-night diner expressed in geometric forms. Edward Hopper, *Nighthawks*, 1942. Oil on canvas. The Art Institute of Chicago (Friends of American Art Collection).

In *Nighthawks* loneliness depends on the dominant form of an isosceles trapezoid. The trapezoid moves from the right-hand side of the painting and stops two-thirds of the way across. It alone establishes the emphatic directional pull of the painting to a vanishing point that cannot be witnessed but must be imagined, for the simple reason that it is not situated on the canvas but beyond it in an unreal and unrealizable place from which the viewer is forever excluded. The long sides of the trapezoid slant towards each other, but never join, leaving him midway in their trajectory. It is this element of passage that is constantly emphasized by Hopper, contributing to the general condition of loneliness in his work. . . . *Approaching the City* (1946), also composed around an isosceles trapezoid, provides the most unsettling example of the nonexistent vanishing point. The trapezoid is a bleak, featureless wall of concrete that gradually darkens as it heads underground. There are no verticals to slow its disappearance as it is hurried along by the foreground tracks. Above and behind the wall are some buildings whose windows suggest vertical movement, but these, along with two truncated smokestacks that run through a patch of half-clouded sky, hardly relieve the picture's atmosphere of gloom, its determination to disappear into itself even before a geometrical vanishing point can be indicated. It is a work that invites the viewer in only to bury him. It is the most remorseless and sinister of Hopper's paintings.[1]

APPROACHES TO ANALYSIS

There are three primary approaches to analysis: *interpretation, speculation* about causes or effects, and *evaluation*. In all three approaches, you will be making inferences about meaning, causes, effects, or value.

In his *Poetics,* a treatise on art, poetry, and tragedy, the Greek philosopher Aristotle speculated about what causes theatergoers to react to tragedy with pity and fear:

> Following the proper order, the next subject to discuss after this would be: What one should aim at and beware of in plotting fables; that is to say, What will produce the tragic effect. Since, then, tragedy, to be at its finest, requires a complex, not a simple structure, and its structure should also imitate fearful and pitiful events (for that is the peculiarity of this sort of imitation), it is clear: first, that decent people just not be shown passing from good fortune to misfortune (for that is not fearful or pitiful but disgusting); again, vicious people must not be shown passing from misfortune to good fortune (for that is the most untragic situation possible—it has none of the requisites, it is neither humane, nor pitiful, nor fearful); nor again should an utterly evil man fall from good fortune into misfortune (for though a plot of that kind would be humane, it would not induce pity or fear—pity is induced by undeserved misfortune, and fear by the misfortunes of normal people so that this situation will be neither pitiful nor fearful). So we are left with the man between these extremes: that is to say, the kind of man who neither is distinguished for excellence and virtue, nor comes to grief on account of baseness and vice, but on account of some error; a man of great reputation and prosperity, like Oedipus and Thyestes and conspicuous people of such families as theirs. So, to be well informed, a fable must be single rather than (as some say) double—there must be no change from misfortune to good fortune, but only the opposite, from good fortune to misfortune; the cause must be not vice, but a great error; and the man must be either of the type specified or better, rather than worse.[2]

Aristotle was theorizing, of course; the causes of the tragic effect cannot be identified absolutely. One can only speculate. One's speculation, however, must have *validity* to be convincing. Aristotle's work seems to have validity, for even now, twenty-five centuries after publication of the *Poetics,* theater critics continue to use Aristotle's theories to aid their understanding and evaluation of drama.

PLANNING AND DRAFTING YOUR ANALYTICAL ESSAY

Before you draft your analytical essay, spend some time planning and outlining. A general process for planning essays is described in Chapter One. The following section is a further description of the process, more specifically as it applies to writing the analytical essay.

CHOOSING A TOPIC

Isolate one remarkable element of the work (of art, literature, drama, music, dance, etc.) that intrigues you. Consider the length of the essay, and narrow

your topic accordingly. A two- or three-page essay cannot discuss classical literature in depth. Nor would that amount of space allow for a deep discussion of Homer's work, or even of one epic poem such as the *Odyssey*. An essay presented later in this chapter discusses just one aspect of the *Odyssey*— Odysseus's universal appeal, which has resulted in his repeated resurrection in subsequent literary works.

POSING A RESEARCH QUESTION

Your task, in writing the analytical essay, is to answer a research question; therefore, a properly posed research question is essential to the process of composition. It is almost always a wise decision to focus on some small element of the work, such as a particular object in a painting or a set piece in a play, and plan to discuss its broader implications, rather than to begin with the broader elements, such as theme or plot, and plan to discuss them in their entirety. Following are six generally stated research questions, each of which stands a good chance of leading to an analytical essay on the humanities:

- What does the work mean?
- What is the appeal of the work (or artist)?
- How does this work (or artist) compare to another?
- How do certain elements of the work contribute to a larger concept?
- Why did the artist make certain choices?
- What is the cause or effect of some element of the work (or the work as a whole)?

There are many other possible research questions that will lead you into analysis. If you are in need of guidance, however, avail yourself of the preceding suggestions, keeping in mind the necessity of converting each question into a more specific one. In the following section, those same six general questions are repeated in revised and narrowed form. These narrowed questions could provide you with a topic for your own analytical essay on the humanities, or they may spark ideas for other topics. Or you may use them simply as models of the sort of question you should devise for your own project.

Keep in mind that in analysis, no definitive answer to your research question is available. You are expected to support an inference, not a fact. If an answer to your research question is readily available, you will be writing an objective, not an analytical paper.

SAMPLE RESEARCH QUESTIONS

WHAT DOES THE WORK MEAN?

- What is the meaning of the tree in Samuel Beckett's *Waiting for Godot*?
- What is the meaning of the bull in Picasso's *Guernica*?

- What is the political analogy being drawn in the character of the pig Napoleon in George Orwell's *Animal Farm*?
- What is the meaning of the fly in Emily Dickinson's "I Heard a Fly Buzz When I Died"?
- What is the meaning of the recurring image of roses in the film *American Beauty*?

WHAT IS THE APPEAL OF THE WORK OR ARTIST?

- What is the appeal of Thelonius Monk's minimalist approach to jazz?
- What is the appeal of the "Saber Dance" in Aram Khachaturian's ballet *Gayaneh* to the Soviet Republic?
- What is the appeal of the film *Citizen Kane*?
- What is the appeal of the Beatles?
- What is the appeal of Castiglione's ideal courtier and court lady in the *Book of the Courtier*?
- What is the appeal of the Taj Mahal?
- What is the appeal of Satan in Milton's *Paradise Lost*?
- What is the appeal of Richard in Shakespeare's *King Richard III*? Iago in *Othello*?
- Considering that the postimpressionists were maligned in their own time, what is the appeal of their art today?

HOW DOES ONE WORK OR ARTIST COMPARE TO ANOTHER?

- How do Ros and Guil's attitude toward death in *Rosencrantz and Guildenstern Are Dead* compare to that of Vladimir and Estragon in *Waiting for Godot*?
- How does the Hindu pursuit of escaping the wheel of rebirth compare to the Christian pursuit of eternal life in heaven?
- How does the ancient Greek attitude toward displaying violence on stage compare with our attitudes toward contemporary stage violence?
- How do Gilgamesh and Achilles compare as epic heroes? Roland and Lancelot?
- How do Seneca and Cicero's views compare concerning the role of the individual in society?
- How does the architecture of the early Christian Church compare with the Buddhist *stupa* in form and in function?
- How do the lyrics of female troubadours compare with those of male troubadours?
- How do medieval conceptions and representations of the Madonna compare with those of the Earth Mother from ancient civilizations?

- How do Constable's landscape paintings compare with Wordsworth's nature poetry?
- How does Le Corbusier's Notre Dame du Holut compare to Notre Dame cathedral in Paris?

How do certain elements of the work contribute to larger concepts?

- How does the existence of the cave art at Lascaux, France, demonstrate Jung's theory of the collective unconscious?
- How does the quest of Gilgamesh represent the basic human search for truth?
- How does *The Law Code of Hammurabi* apply to contemporary notions of justice?
- How does the architecture of the Palace of Knossos contribute to our understanding of Minoan culture?
- How does the black and white imagery in Shakespeare's *Othello* contribute to the idea of racism?
- How does opera contribute to the baroque taste for theatricality?
- How does the science fiction of Ursula Le Guin contribute to contemporary concerns? H. G. Wells? Kurt Vonnegut?

Why did the artist make certain choices?

- Why did Boccaccio represent a realistic and liberated woman in his "Tale of Filippa"?
- Why did Raphael place Diogenes on the stairs in a such a pose in *The School of Athens*?
- Why did Van Gogh use the painterly method?
- Why do the women in *Thelma and Louise* drive their car into the Grand Canyon?
- Why did Goya present nonrealistic figures in his painting *The Third of May, 1808*?

What is the cause or effect of some element of the artwork (or the artwork as a whole)?

- What is the effect of removing African masks and fetishes from their cultural context and placing them in museums of fine art?
- What is the effect of harmoniously proportioned buildings on the idea of citizenship?
- What was the effect of the Lutheran chorale on the spirit of the Protestant Reformation?

- What is the effect of African music on today's rap, hip-hop, etc.?
- What is the effect of the music in the film *Easy Rider*?
- How do the long horseback riding scenes in Kurosawa's film *Ran* affect the viewer?

FORMULATING A THESIS

Your *thesis* is a declarative statement of your main point. It is the statement that the whole essay will prove. A workable thesis usually possesses the following qualities:

- answers the research question
- is one complete, unified statement about the work or the artist
- is precise enough to limit the material
- is general enough to need support
- is defensible
- is not too obvious

EXERCISE 3-1: FAULTY ANALYTICAL THESES

All of the following theses are faulty. Imagine that the writer has observed in her introductory remarks that Odysseus has been a central figure in many literary and artistic works since Homer recorded his adventures in the *Odyssey*. The research question that arises from this observation is, "Why has Odysseus gotten so much attention?" or, in other words, "What is the appeal of Odysseus?" The thesis should answer the research question.

Use the preceding guidelines for a workable thesis to determine the problem(s) with all of the following analytical theses. After you have determined the problems, compare your answers to those on the next page.

1. Odysseus is an appealing figure.

2. This paper will analyze the appeal of Odysseus.

3. Odysseus is an appealing figure for three reasons.

4. Odysseus is appealing because of his abilities to use language, play tricks, and tell stories in order to survive.

5. The sustained attention paid to Odysseus lies in his enormous appeal.

6. The appeal of Odysseus can be understood through careful analysis.

7. Odysseus symbolizes the concerns of humanity.

8. Odysseus devised a way to hear the Sirens' song without being dashed against the jagged rocks of the shoreline.

9. Homer's epic poem, the *Odyssey,* was drawn from the songs and chants of oral poets who accompanied themselves with stringed instruments.

10. The *Odyssey* is the greatest story ever told.

ANSWERS TO EXERCISE 3-1: FAULTY ANALYTICAL THESES

1. The thesis does not answer the research question. It merely repeats what has already been observed in the introduction.

2. This thesis does not state a main point. It is not really a thesis but rather a statement of purpose, which is usually unnecessary. If a statement of purpose is necessary, it should not replace the thesis.

3. This thesis exemplifies a typical fault. The first half of the sentence repeats the mistake of thesis #1. The second half of the sentence merely anticipates the points of proof. The effect is that the thesis has been skipped, and the writer has moved straight from the research question to the points of proof. The result will be an essay that develops three disparate ideas without a stated common bond. Furthermore, the thesis is indefensible in that there are many more than three reasons for Odysseus's appeal.

4. Essentially, this thesis makes the same error as thesis #3. It repeats what has already been observed in the introduction and lists ostensible points of proof, but the thesis itself, an assertion in its own right, is missing. Also, the thesis is not unified; it gives the writer three assertions to prove instead of one.

5. The reasoning in the thesis is circular. It gives the effect as a cause. It says, essentially, that Odysseus is popular because he is popular.

6. The thesis does not state a main point. It is also imprecise. What understanding will we come to after we have analyzed the work? Answer that, and you will have a workable analytical thesis.

7. The thesis is too broad. The concerns of humanity are too numerous to be developed in one essay. The thesis promises more than the paper can deliver.

8. The thesis is too specific; it needs no proving; it is a fact. And it is too obvious, as any reader of the *Odyssey* will already know this fact.

9. The thesis is descriptive, not analytical, in that it states a fact. The thesis is general enough to warrant illustration, but it needs no proving.

10. The thesis may well be true and yet is indefensible. To defend such a statement, one would have to compare the *Odyssey* to every other story, both written and oral, and define the extremely vague term *great*—an impossible task.

FORMULATING THE POINTS OF PROOF

In order to begin formulating your points of proof, if is often helpful to articulate a *proof question.* Convert the thesis into a question beginning with *how* or *why.* For example, if your thesis is "Odysseus gives voice to our own impulse for adventure," the proof question becomes "*How* does Odysseus give voice to our own impulse for adventure?" If you can answer this question, you can prove your thesis.

Give as many answers to the proof question as are needed to answer it adequately. These will be your *points of proof.* There must be at least two points of proof. Workable points of proof usually possess the following qualities:

- answer the proof question
- exhibit a clear connection to the thesis
- are stated in complete sentences
- are general enough to need support
- are precise enough to be supportable in one, two, or several paragraphs each (depending on the length of the paper)
- state reasons for the thesis, not examples that illustrate it

Think of the points of proof as topic sentences for your body paragraphs, as that is how they will ultimately serve you.

EXERCISE 3-2: FAULTY POINTS OF PROOF

Imagine that the writer has stated the following thesis: "Certainly one source of Odysseus's appeal is that he gives voice to our impulse for adventure." The proof question, then, is *"How* does Odysseus give voice to our impulse for adventure?" The points of proof should answer that question.

Use the preceding guidelines for workable points of proof to determine the problems with all of the following points of proof. After you have determined the problems, compare your answers to those on the next page.

1. We shall examine Odysseus's words and actions to better understand his impulse for adventure.

2. Like us, Odysseus loves adventure.

3. Odysseus has himself tied to the mast so that he can hear the Sirens' song.

4. Odysseus loves to tell the stories of his adventures.

5. The *Odyssey* makes us want to experience adventure.

ANSWERS TO EXERCISE 3-2: FAULTY POINTS OF PROOF

1. The sentence contains two points of proof, ostensibly: "words" and "actions." However, neither is developed into a point. What point will the writer make about Odysseus's words? What point will the writer make about Odysseus's actions? The writer who cannot answer that question has not yet thought through the paper in enough detail.

2. This point of proof ignores the proof question. It does not tell *how* Odysseus gives voice to our impulse for adventure.

3. This point of proof promises a plot summary, but not a reason for the thesis. It may be used to *illustrate* a point, but it does not *state* a point.

4. The connection between this point of proof and the thesis is not clear. How does the fact that Odysseus loves to tell stories give voice to our own impulse for adventure? The writer may see the connection, but the task is to put that connection into writing so that the reader of the essay may see it as well.

5. This point of proof acknowledges our own relationship with adventure, but does not tell how Odysseus gives voice to it. Also, it shifts focus from Odysseus, the character, to the *Odyssey*, the epic poem. In other words, it does not answer the proof question.

A few codicils regarding points of proof are in order:

■ To begin with, some instructors and students do not like to see a list of points of proof accompanying the thesis. Many essays end the introductory paragraph with the thesis statement. Such a form is, of course, perfectly acceptable, and sometimes more graceful than the one that includes the points of proof. Other instructors believe that including the points of proof in the thesis paragraph results in superior essays. We encourage students, whether they plan to include points of proof in their thesis paragraphs or not, to use the strategy explained here for devising points of proof while planning their essays. In other words, construct the paper to include the points of proof. It is an easy matter to delete them when printing the final version of your essay, and they will have served their purpose.

■ Another way in which your essay may deviate from the form prescribed in this book is to offer the points of proof before instead of after the thesis. Mage Morningstar makes use of this option in her research paper in Chapter Seven.

■ Finally, we have suggested that the points of proof be stated in separate, complete sentences; however, sometimes they can be offered as separate items in a series without loss of clarity. See, for example, Amanda Michalski's paper on *Othello* beginning on page 72.

Constructing an Outline

You may want to construct an outline for your essay, now that you have assembled the thesis and supporting points. An outline of the essay on Odysseus, as planned in the preceding box, follows. Notice that the outline of the body lists details to be covered in each section.

OUTLINE FOR ANALYTICAL ESSAY
ODYSSEUS

I. Introduction

 A. Introductory remarks: The figure of Odysseus recurs throughout literary and artistic history. He is a very popular figure.

 B. Thesis: One reason Odysseus appeals to us is that he gives voice to our own impulse for adventure.

 C. Points of Proof:

 1. Like us, Odysseus yearns for the safety and comfort of home, yet he relishes his adventures as they unfold.

 2. We further identify with Odysseus in that his character is multidimensional; he has both noble and not-so-noble qualities, all of which he puts to use in his struggle to survive.

 3. Finally, we identify with Odysseus as a storyteller who, in accepting the adventure of his life and living to tell about it, excites our desire to leave a measure of ourselves behind.

II. Body: develop each point of proof

 A. Like us, Odysseus yearns for the safety and comfort of home, even as he relishes his adventures.

 1. Reluctant to leave family

 2. Relishes adventure

 a. Cyclops

 b. Sirens

 c. Calypso

 d. Land of the Dead

 B. We further identify with Odysseus in that his character is multidimensional; he has both noble and not-so-noble qualities, all of which he puts to use in his struggle to survive.

 1. Philoctetes

 2. Wooden horse

 3. Ajax

 4. Penelope's letter

5. Palladium

6. Counselors of Fraud

7. Troilus and Cressida

C. Finally, we identify with Odysseus as a storyteller who, in accepting the adventure of his life and living to tell about it, excites our desire to leave a measure of ourselves behind.

1. Tells Alcinous about adventures

2. Cyclops story

3. Regales Dante

III. Conclusion: other versions of Odysseus's adventure

A. Ezra Pound

B. Dante

C. James Joyce

D. Nikos Kazantzakis

E. Wallace Stevens

F. Alfred Lord Tennyson

G. Coen brothers

Following is an essay that developed as a result of using the process presented in the preceding section of this chapter. Notice that in this essay, the research question ("What is the appeal of Odysseus?") marks the transition between the introductory remarks and the thesis. The proof question ("How does Odysseus give voice to our impulse for adventure?"), although necessary to the planning process, is not physically present in the final version of the essay.

Odysseus: I Am Become a Name

MOLLY LECLAIR

A man begins his long journey home, companions at his side, suffering every calamity and indignity along the way. He is a leader and a strategist, an artful deceiver "endowed with the gift of gab" (Coen 54). He tells stories that leave his listeners wide-eyed and rapt. He is Ulysses Everett McGill, hero of the Coen brothers' 2000 film, *O Brother, Where Art Thou?*, yet another in a long line of Odyssean tales. When we first meet Odysseus in

Book II of Homer's *Iliad,* he is "standing still" (80), an exceptional attitude, because all the other Greeks are kicking up dust and running to their ships, giving up and going home. When Hera, wife of Zeus, asks Athena to rectify this ignominious retreat from Troy, Athena knows just the man to put things right, the one she hails "the equal of Zeus in counsel" (80). Odysseus wastes no time admonishing and marshaling the men back into the assembly. Although the story of the *Iliad* revolves around the tragedy of Achilles, Homer's *other* epic is about resourceful Odysseus and his ten-year voyage back to Ithaca and kingship, wife and son. If Homer could not get enough of this intrepid hero, neither could other writers resist the salty soldier and resilient rememberer. What, one wonders, is the appeal of Odysseus, whom writers from antiquity to modernity have revived and reshaped? Certainly one source of his appeal is that he gives voice to our impulse for adventure. Like us, Odysseus yearns for the safety and comfort of home, yet he relishes his adventures as they unfold. We further identify with Odysseus in that his character is multidimensional; he has both noble and not-so-noble qualities, all of which he puts to use in his struggle to survive. Finally, we identify with Odysseus as a storyteller who, in accepting the adventure of his life and living to tell about it, excites our desire to leave a measure of ourselves behind.

Odysseus is not on a mission to die for cause and country, as Achilles dies beside the Scaean gates at Troy. Odysseus is reluctant to leave his family and the good life in Ithaca and sail for Troy in the first place. In fact, he feigns madness to avoid it, although the ruse is discovered by another cunning Greek, Palamedes, one of Agamemnon's envoys. His plan after the ten-year war is to return home, enjoy the kisses of his steadfast wife, raise his young son, and taste the bright wine of his island kingdom. The wrathful Poseidon, however, has other plans for him, and Odysseus is tested mercilessly, his strength against the forces of nature and his will against the capricious gods. Yet for all of Odysseus's propitiation to Zeus and Athena for smooth sailing and safe homecoming, we sense that he relishes every adventure. Having escaped the Cyclops's blood-drenched cave, Odysseus exults in his own cleverness by taunting the blinded Polyphemus with self-aggrandizing banter. He not only survives the Sirens' song, he revels in it by having his men tie him to the mast, then ordering them to plug their own ears with wax. While he is stranded on Ogygia, the island of the nymph Calypso, he alternately weeps for home and drinks, dines, and makes love with the ageless enchantress. In the Land of the

Thesis

Points of Proof

Point of Proof #1

Dead, unassisted by gods or companions, he not only speaks to Tiresias, the only contact he really needs to make to find his way home, but engages and questions a host of other shades, waiting there in case more spirits of interest should show up. Odysseus, yearning for home, nonetheless lingers to take in the ideas and customs of his exotic captors, rescuers, and diviners. The fact that he truly is trying to get home, even as he dallies, assuages our guilt for wanting to be like him, to go off exploring when we really should be home taking care of business.

Point of Proof #2 Later Greek and Latin writings about Odysseus offer a more duplicitous, morally ambiguous, and complex character. His craftiness is presented as cunning, his way with words as demagoguery. In Sophocle's *Philoctetes,* an ignoble Odysseus devises a trick to induce the sick and abandoned Philoctetes to return to Troy. The Greeks have learned that they cannot take Troy without the bow and arrow of Philoctetes, given to him by Heracles. Odysseus goes to Lemnos to make sure the job gets done, walking the thin line between cunning and treachery, compromising his Homeric virtues. Virgil's Aeneas recounts Odysseus's nefarious hand in the trick of the wooden horse and the sacking and torching of Troy. And Ovid relates the argument between Ajax and Ulysses (Latin for Odysseus) to win Achilles's armor, Ajax being no match for the ruthless debater. Ulysses boastfully invokes his ancestors, lists his accomplishments as chieftain and ambassador, exhibits his war wounds, and demonstrates his unique understanding of the significance of Achilles's shield and the fine art of Hephaestus. Of course, he wins the prize, and Ajax, mortified, kills himself. In the *Heroides* of Ovid, a collection of fictitious letters written by legendary women, Penelope gives her letter addressed to Ulysses to every passerby in Ithaca, hoping that he might happen to meet her husband. Her first line introduces Ulysses with the adjective *lento,* slow to return, denoting deliberate tardiness. The tone of the letter is sarcastic and bitter, suggesting an aspect of Odysseus that counters his image of conjugal devotion.

Dante casts Ulysses as the unprincipled stealer of the Palladium, sacred image of Pallas Athena, and mastermind of the wooden horse, destroying all that is sacred in the city of Troy. In *The Divine Comedy,* Virgil and Dante encounter Ulysses among the Counselors of Fraud, engulfed in a tongue of flame, fitting punishment for a man who uses his gift of speech for trickery. In *Troilus and Cressida,* Shakespeare casts Ulysses as an idealist and a pragmatist who, embroiled in a war for a worthless cause, issues earnest but erroneous judgments. His attempt to persuade Achilles to return to battle effectively ends in his promot-

ing a rivalry between Ajax and Achilles. He judges Cressida too harshly, Diomedes too highly, and Troilus without appraising the young Trojan's delusions as a lover and a warrior. His Homeric wisdom and sense of fairness fall flat in the depraved world of the play, which suggests that the established strongholds of personal honor and reputation, military glory and eternal love, may still exist but are corruptible. He is not the immutable hero whose greatest feat, or whose very life, ends with a single and selfless act of valor. Our own identification with Odysseus is only heightened by versions of his story that show him as an imperfect being, sometimes rash, wrong, and misunderstood. When we wonder how much we can endure, what our limits are, we find in Odysseus the best of all flawed, mortal men for clinging to life—the archsurvivor.

Odysseus, maybe foremost, is a supreme raconteur, a talent that puts him in good stead with strangers, wins him the admiration of gods, gets him out of trouble, and also belies his desire to end an adventure for safe harbors. In Book VIII of the *Odyssey*, in the palace of the Phaeacian king Alcinous, Odysseus gives a full account of his life and misfortunes, which earns him highest praise when the king tells him he could "hold out until the bright dawn" (177) if Odysseus could only bear to continue his story. Odysseus's ability to dazzle with words is clear, too, from the approbation he receives from the gods. Athena praises him, saying, "You are far the best of all mortal men for counsel and stories" (206). The story of the Cyclops itself contains a story. Odysseus tricks Polyphemus by telling him his name is "Nobody." After Odysseus and his men blind the man-eating giant with a fiery timber, Polyphemus cries out for help, "Good friends, Nobody is killing me by force or treachery" (147). Odysseus and his men make it to their ships and are as good as gone when Odysseus again enrages Polyphemus who, this time, hurls the top of a mountain peak at his foes, threatening lives and, of course, dashing dreams of home. Even Dante, so eager to speak with Odysseus in spite of Virgil's misgivings, is regaled with a colorful story about the venerable wanderer's last sailing adventure. Unable to settle down in peaceful, well-ordered Ithaca, Odysseus sails out beyond the boundaries of the world, accepting the adventure of his life and telling about it. Odysseus is a reminder to us that if we do not take the journey, we cannot tell the story, and if we cannot tell the story, we may be lost to the world and leave no measure of ourselves behind.

Point of Proof #3

Ezra Pound saw in Odysseus the ultimate poet-hero who offers blood to the shadows so that they may speak and tell their stories. We must have stories, else why would we have mythol-

Conclusion

ogy, literature, and theater? So we resurrect and reincarnate Odysseus repeatedly, continuously throughout the millennia, in every storytelling medium. And in virtually every version, Odysseus survives, at least to the extent that he can speak. Dante cranes on tiptoe to admire the famed orator, insisting to Virgil, "Deny me not to tarry a moment here / Until the horned flame come; how much I long / And lean to it I think thee well aware" (235). In James Joyce's *Ulysses,* Leopold Bloom survives the day, and to cap it off, his wife says "yes." Kazantzakis's modern Odysseus accepts the abyss with jubilation and song. Wallace Stevens's Ulysses, crossing by night the giant sea, reminds us of a time when man *was* the measure of all things, "As he is, the discipline of his scope / Observed as an absolute, himself" (390). In Tennyson, he is become a name, "To strive, to seek, to find, and not to yield" (89). Odysseus survives because he has things to do, an impulse for adventure, as indeed we do, even as we cling to safety. Odysseus journeys through the centuries, admired and maligned, questing for life, wisdom, old age—and an audience. And Ulysses Everett McGill, one of our hero's latest incarnations, echoes the centuries: "We're adventurers, sir, currently pursuin' a certain opportunity but open to others as well" (Coen 54).

Works Cited

Coen, Ethan, and Joel Coen. *O Brother, Where Art Thou?* New York: Faber, 2000.

Dante Alighieri. *The Divine Comedy: Hell.* trans. Dorothy Sayers. Baltimore: Penguin, 1974.

Homer. *Iliad.* trans. Richard Lattimore. Chicago: Chicago UP, 1951.

———. *Odyssey.* trans. Richard Lattimore. New York: Harper, 1965.

Stevens, Wallace. *The Palm at the End of the Mind.* New York: Random, 1972.

Tennyson, Alfred. *The Poetical Works of Tennyson.* ed. G. Robert Stange. Boston: Houghton, 1974.

ORGANIZING THE COMPARISON-CONTRAST ESSAY

Some special considerations are necessary when you are planning a comparison-contrast essay. The process for thinking through the essay remains the same: observation, research question, thesis, proof question, and

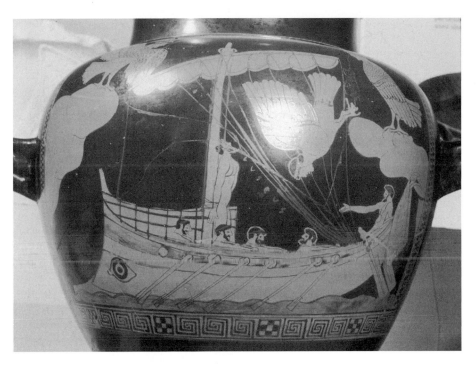

3.2 Odysseus alone hears the Sirens' song. Ancient Greek vase, *Odysseus and the Sirens*, 5th c. B.C.E., *stamnos* by the Siren Painter. Copyright Werner Forman/Art Resource, NY. British Museum, London.

points of proof. The nature of comparison, however, creates the need for some organizational and conceptual adjustments.

First, when using the comparison-contrast approach, be specific about the elements you are comparing. For example, the question "How does *Othello* compare to *Macbeth*?" is too open-ended. Everything there is to say about both plays could appear in an essay that asks such a broad, vague question. One purpose of the research question is to help you narrow, focus, and eliminate material. "How do Iago's motives in *Othello* compare to those of Lady Macbeth in *Macbeth*?" is a more specific question and will lead to a more focused paper.

For a comparison-contrast essay to be successful, you must point out the differences in things that appear similar, or the similarities in things that appear different. For example, if you write an essay that shows that a ballet is different from a tap dance, you have wasted your time. Your audience already knows they are different. If you write an essay showing that Picasso's cubism is similar to Braque's cubism, you have made the obverse mistake. Of course the two are similar. The more interesting question here would be, "How are they different?"

Comparison-contrast essays usually fall into one of two organizational patterns: the block pattern or the point-by-point pattern. The **block pattern** would discuss one of the two items being compared, and then the other. The **point-by-point pattern** would discuss one point of comparison between the two items, then the next point of comparison, and so forth. Following are examples of the two organizational patterns, using, for demonstration purposes, the subject matter of Nicole Emery's essay, "The Perfect Woman."

Standard Block Pattern	**Standard Point-by-Point Pattern**
I. Opening Paragraph	I. Opening Paragraph
A. Occasion	A. Occasion
B. Thesis	B. Thesis
C. Projected Organization	C. Projected Organization
1. Botticelli	1. Modest vs. Immodest
2. Manet	2. Passive vs. Confrontational
II. Body	3. Ethereal vs. Earthly
A. Historical Context and Description of Painting	II. Body
B. Botticelli's *Venus*	A. Historical Context and Description of Painting
1. Modest	B. Modest vs. Immodest
2. Passive	1. Botticelli's *Venus*
3. Ethereal	2. Manet's *Olympia*
C. Manet's *Olympia*	C. Passive vs. Confrontational
1. Immodest	1. Botticelli's *Venus*
2. Confrontational	2. Manet's *Olympia*
3. Earthly	D. Ethereal vs. Earthly
III. Conclusion	1. Botticelli's *Venus*
	2. Manet's *Olympia*
	III. Conclusion

TEMPLATES FOR ORGANIZING YOUR ESSAY

Now that you have chosen and narrowed your topic, begin organizing your ideas. Use one of the following templates to assist you in outlining your essay. Each template must be tailored to suit the needs of your own essay, as the number of points of proof and supporting details is variable.

ANALYTICAL ESSAY OUTLINE

I. Introduction

 A. Introductory remarks (briefly) ⎯⎯⎯⎯⎯⎯⎯⎯⎯⎯⎯⎯

 ⎯⎯⎯⎯⎯⎯⎯⎯⎯⎯⎯⎯⎯⎯⎯⎯⎯⎯⎯⎯⎯⎯⎯⎯⎯⎯

 B. Thesis ⎯⎯⎯⎯⎯⎯⎯⎯⎯⎯⎯⎯⎯⎯⎯⎯⎯⎯⎯⎯⎯

 C. Points of proof (Fill in at least two blanks with complete sentences.)

1. ———————————————————————————
2. ———————————————————————————
3. ———————————————————————————
4. ———————————————————————————

II. Body (Develop each point of proof. Copy your points of proof from C above; there should be at least two. If your notes are assembled, you may opt to fill in details that will illustrate or support each point. The number of details will vary from point to point. You must tailor the template to suit your own needs.)

 A. Point 1 ———————————————————————

 a. Detail ———————————————————————

 b. Detail ———————————————————————

 c. Detail ———————————————————————

 B. Point 2 ———————————————————————

 a. Detail ———————————————————————

 b. Detail ———————————————————————

 c. Detail ———————————————————————

 C. Point 3 ———————————————————————

 a. Detail ———————————————————————

 b. Detail ———————————————————————

 D. Point 4 ———————————————————————

 a. Detail ———————————————————————

 b. Detail ———————————————————————

III. Conclusion (briefly) ———————————————————

———————————————————————————

If your essay will be comparison-contrast, block method, use the following template to outline your essay. If you will be using the point-by-point method, use the next template.

ANALYTICAL ESSAY OUTLINE
COMPARISON-CONTRAST: BLOCK METHOD

I. Introduction

 A. Introductory remarks (briefly) ———————————————

 B. Thesis ———————————————————————

C. Projected organization
 1. Item one
 a. Point #1 _____
 b. Point #2 _____
 c. Point #3 _____
 2. Item two
 a. Point #1 _____
 b. Point #2 _____
 c. Point #3 _____

II. Body
 A. Item one
 1. Point #1 _____
 2. Point #2 _____
 3. Point #3 _____
 B. Item two
 1. Point #1 _____
 2. Point #2 _____
 3. Point #3 _____

III. Conclusion _____

ANALYTICAL ESSAY OUTLINE
COMPARISON-CONTRAST: POINT-BY-POINT METHOD

I. Introduction
 A. Introductory remarks (briefly) _____
 B. Thesis _____
 C. Projected organization _____
 1. Point one
 a. Item #1 _____
 b. Item #2 _____
 2. Point two
 a. Item #1 _____
 b. Item #2 _____

 3. Point three
 a. Item #1 _____
 b. Item #2 _____
 II. Body
 A. Point one
 1. Item #1 _____
 2. Item #2 _____
 B. Point two
 1. Item #1 _____
 2. Item #2 _____
 C. Point three
 1. Item #1 _____
 2. Item #2 _____
 III. Conclusion _____

STUDENT ESSAYS

Following are three essays written by college students. All three exemplify an analytical mode of discourse as well as the organizational patterns recommended throughout this book.

Nicole Emery, the author of the first essay, has noticed that Sandro Botticelli's *The Birth of Venus* and Édouard Manet's *Olympia* are similar in that they both depict female nudes as beautiful. But how are the artists' attitudes toward their subjects different from each other? That is the question that Emery answers in "The Perfect Woman."

EXERCISE 3-3

Determine which comparison-contrast pattern—the block or the point-by-point—Nicole Emery uses in the following essay.

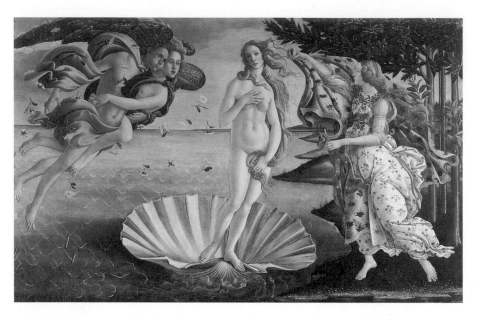

3.3 Feminine purity. Sandro Botticelli, *The Birth of Venus,* ca. 1482. Tempera on canvas. Galleria degli Uffizi, Florence. By permission of Ministero dei Beni e le Attivitá Culturali.

3.4 Feminine pluck. Édouard Manet, *Olympia,* 1863. Oil on canvas. Photo Hervé Lewandowski. Musée d'Orsay, Paris. Copyright Réunion des Musées Nationaux/Art Resource, NY.

Emery 1

Nicole Emery

Professor Molly LeClair

Humanities 122-150

April 12, 2002

 The Perfect Woman

 Depictions of the female nude date back to at
least 20,000 BCE, as evidenced by the Paleolithic
Venus of Willendorf, discovered in Austria. Often,
these creations would be representations of dif-
ferent archetypal feminine attributes, such as fer-
tility or heavenly love. Hellenistic art began to
show the pantheon of goddesses in sculpture, spe-
cifically the figure of Venus or Aphrodite. In mod-
ern times, the tradition continues, commonly as an
illustration of ideal female beauty. Venus is still
considered the epitome of heaven on earth. She is
the physical manifestation of the magic of sex,
passion, love, and beauty visited upon mortal men.
Sandro Botticelli's *The Birth of Venus* and Édouard
Manet's *Olympia* depict the goddess in two tradi-
tional poses. Though their message of an idyllic
female form is similar, each artist reflects the
different attitudes toward women typical of his
time. *The Birth of Venus* was rendered by an artist
who lived during an era in which the ideal woman
was thought of as modest, passive, and unearthly.

Thesis

*Point of
proof #1*

Emery 2

Olympia was rendered by an artist who lived during

*Point of
proof #2*

a time when women could be beautiful yet immodest,

confrontational, and earthly.

*Point of
proof #1
developed*

Botticelli was commissioned to paint the myth

of the birth of Venus during the Renaissance for a

member of the Medici family. The painting illus-

trates the moment when Venus emerges from the foamy

sea on her shell, wearing nothing but her hair. She

is blown to shore by a pair of sensuously entwined

figures and greeted at the shore by an elegantly

clad nymph, poised to robe the exposed goddess.

Pale pink flowers float in her wake. The water rip-

ples around the shell in the same direction that

the gust of breath from the mouths of the gods

blows. Her hair has escaped its binding, and de-

spite her attempts to control it, she remains

naked, even as strands of gold hair coil about her

curves.

In this painting, Venus is the picture of femi-

nine modesty and innocence, a nervous bride who an-

ticipates her wedding night, completely lacking

guile or lewdness. Venus pulls her hair around her,

hiding herself as best she can from the prying eyes

of the viewer. This Venus is passive. She awaits

her robes and gazes aside, demurely, as she is

Emery 3

pushed to the coast of the island. Botticelli's fe-
male figure receives her clothing; even the air
that she sails on is given to her. Though modest,
she allows herself to be viewed.

All of the figures in this painting suggest un-
earthliness. Not one of them is grounded. Her ser-
vant floats to her rescue. Even the palette of the
painting suggests unearthliness: pale blues and
greens and translucent flesh tones all portray the
scene as an ethereal snapshot.

Manet's *Olympia* was greatly influenced by Hel-
lenistic sculpture as well as by Titian's *Venus of
Urbino,* especially with regard to the reclining
pose of the model. The redheaded woman rests on her
elbow, casually holding a corner of her blanket.
Behind her, a servant leans in, presenting a bou-
quet of flowers.

Unlike Botticelli's Venus, this woman is immod-
est. Her shoes remain on, heightening the eroticism
of her nudity, though they dangle ever so carelessly
off her feet, as she nonchalantly crosses her ankles.
Her hair is done up, a flower arranged girlishly be-
hind her ear. Her jewelry, though minimal, emphasizes
her nakedness with its contrast. She could be any
high-class prostitute greeting her next customer.

*Point of
proof #2
developed*

Emery 4

Unlike Botticelli's passive goddess, this woman brazenly confronts the gaze of the viewer. She looks bored, yet actively aware of the presence of the viewer. She ignores the offerings of her servant, clearly a gift from some admirer. She luxuriates nonchalantly, as a woman who has earned her own way.

Manet's goddess is in an earthly guise, that of a woman who practices the art of love. Her bed is mussed, the white sheets and pillows wrinkled, suggesting bed-play. She is surrounded by sensuality. Her sheets have a subtle shimmer, suggesting silk or another high-quality fiber. Her fingers apparently stroke the soft blanket on which she lies. A heavy gold bracelet adorns her arm.

Conclusion The two women depicted in these paintings, created over four hundred years apart, share one fundamental commonality: both represent a feminine ideal. Both women are in the foreground of looming darkness. Whereas Venus seems to be drifting towards the darkness at the right of the painting, Olympia keeps her back to the dark background. Each woman glows like a beacon set against darkness. Both paintings present feminine beauty as a form of light in dreary times. From comparing the two paintings, we can learn something about different

Emery 5

attitudes toward women, but we also learn that
there is no one style that can capture female
beauty, in its multitude of facets, completely.

Speculating about causes and effects works well in analysis; it obligates us to make an inference based on facts. The following analytical essay, by Amanda Michalski, speculates on the effect of Iago on other male characters in Shakespeare's *Othello*.

Although we usually recommend that students state their points of proof in separate, complete sentences, we recognize that it is not always necessary to do so. Michalski has opted to collect all of her points of proof into one sentence, which, in this case, works well.

3.5 Is "honest Iago" honest? Iago watching Othello and Desdemona. Photographed 1930. © Bettmann/Corbis

Michalski 1

Amanda Michalski

Professor Joan Lord Hall

Tragic Drama

May 2, 2001

Iago: Deception as Catalyst for Truth

The audience will achieve a more complete un-
derstanding of Iago in *The Tragedy of Othello* if
Iago is viewed as a complex character and not sim-
ply as a conventional "villain." Iago's devious
schemes destroy lives both literally and figura-
tively, but they may also serve to reveal the char-
acter of others in intricate ways. A critical in-
terpretation of Iago reveals that although he is
principally a deceiver, he is also a dramatic agent
of truth. Even though his acts are malicious and
deceitful, the title "honest Iago" is fitting in

Thesis the sense that he reveals the true nature of his
victims, as well as the propensity for human beings
to act in accordance with their inherently dark na-

Points of tures. Though based in deception, Iago's machina-
proof tions expose the truth of Brabantio's hidden
racism, Cassio's inner vanity, and Othello's re-
pressed sexual possessiveness.

Point of Iago cleverly emphasizes the issue of race and
proof #1 its association with devilry when he and Roderigo
announce to Brabantio that Desdemona, a "white

Michalski 2

ewe" has eloped with Othello, an "old black ram"
(1.1.85-86). Iago then associates Othello with the
image of "the devil" (88) because he is black, warn-
ing Brabantio that he has "lost half [his] soul"
(84) now that Desdemona is married to Othello.

Granted, it is unlikely that Iago's few brief
statements give birth to Brabantio's racism; yet by
plaguing Brabantio's thoughts with a dialogue that
fuels his natural tendency towards racism, Iago
helps to expose Brabantio's true character. Braban-
tio seemingly laments the fact that his daughter
has married a black man, falling in love "with what
she feared to look on!" (1.3.98), more than the
fact that she has betrayed him.

In his defense speech to the council of Venice,
Othello discloses his belief that he and Brabantio
were previously friends: "Her father loved me; oft
invited me; / Still questioned me the story of my
life [. . .]" (1.3.127-28). Yet rather than attack
Othello's character, Brabantio launches a vicious,
race-based verbal assault against him. In much the
same manner as Iago, Brabantio begins his attack by
citing Othello's color in the image of a "sooty
bosom" (1.2.69). Brabantio alludes to the idea that
Othello, on the basis of his color, is the devil
when he accuses him of witchcraft, saying he is

Michalski 3

"damned" (62) as an "abuser of the world" (77) who uses "practices of cunning hell" (1.3.103). Brabantio's appeal that Desdemona must have been tricked into marriage with a "dram" (105) shows that he thinks that Desdemona, unbewitched, never would have been able to overcome the hurdle of Othello's color. In actuality, Iago's ability to provoke Brabantio's true nature suggests that it is Brabantio who has never been able to overcome the issue of Othello's race.

Point of proof #2

Even though Iago's devious intrigues are not the origin of Cassio's vanity, his remarks and obscure songs are precisely calculated to appeal to and to demonstrate Cassio's egotistical tendencies.

Cassio first reveals his vanity when he is convinced by Iago to drink, presumably in order to prove that he is "a man." Iago appeals to Cassio's desire to be liked by all, saying that Othello's wedding guests "are our friends" (2.3.35) and that "the gallants desire" (40–41) Cassio to drink in celebration. Even though he admits he has "very poor and unhappy brains for drinking" (31–32), Cassio drinks. He is quickly swayed by Iago's lyrics suggesting that drinking makes one a proper man in the eyes of his peers; the song implies that a proper soldier should drink: "Why then, let a sol-

Michalski 4

dier drink" (70). Iago even suggests that drinking makes a fellow a better Englishman, because a true Englishman "drinks you with facility" (79). Iago does the tempting, but Cassio eagerly takes the bait, announcing that Iago's songs and statements are "excellent" (72) and "exquisite" (95) because they appeal to his vanity.

Cassio's desire for popularity may be questionable as evidence of an egotistical nature, but once he becomes drunk, his boasts clearly demonstrate his vanity. Cassio confirms that he has a high opinion of himself not only by insisting "I hope to be saved" (104), but also by reminding Iago that Iago will be saved "not before me [Cassio]" (106). In his drunken state, Cassio cannot refrain from speaking his belief that he is of greater spiritual value than Iago and that he will be "saved" first by God simply because he is a lieutenant, whereas Iago, as an ancient, is below him in the social hierarchy. The significance Cassio places on social rank above the state of his immortal soul clearly argues for his predisposition towards vanity.

It is strange that after he is stripped of his office as lieutenant, Cassio hardly mentions feeling regret because he has lost his position and his friendship with Othello. His greatest concern seems

Michalski 5

to be the loss of his "reputation," a word that he mentions six times in quick succession (261–64). As Iago so clearly states, "Reputation is an idle and most false imposition, oft got without merit and lost without deserving" (267–69). Again, though, Cassio is superficial in that he considers his reputation to be the "immortal" (262) portion of himself. Through the employment of Iago's clever devices, Cassio's high opinion of himself and the need for others to affirm this opinion quickly reveals itself.

Point of proof #3

 Othello is also vulnerable to Iago's ability to intensify inherent negative traits. Othello's words of love to Desdemona in early portions of the play, calling her his "fair warrior" (2.1.179) and "soul's joy" (182), appear to be genuine. However, Othello's original speech about her as he defends their courtship, and his reasons for wanting her to join him in Cyprus, reveal that he is sexually motivated from the play's beginning. By overstating his denial of his lust—"I therefore beg it not / To please the palate of my appetite, / Nor to comply with heat—the young affects / In me defunct—and proper satisfaction" (1.3.256–59)—Othello exposes his tendency to be sexually possessive. Seemingly out of respect, he does refer to wanting to be "free and bounteous" (260) to Desdemona's mind

Michalski 6

(showing his appreciation for her mental attrib-
utes); yet in comparison to the length and inten-
sity of his sexual statements, it seems a mere
afterthought.

Iago's sexual imagery capitalizes on Othello's
original sexual preoccupation first by administer-
ing the lie that Desdemona has been false. Othello
then promptly shows that what he desires is not his
wife's faithfulness as much as the ability to con-
trol and possess her sexually, when he laments
"That we can call these delicate creatures ours /
and not their appetites!" (3.3.268-69). Act 3,
Scene 3, is crucial in understanding Iago's ability
to goad Othello into a more heightened state of
sexual possessiveness. Othello is finally pushed to
the point that he would rather kill his wife—"Down,
strumpet!" (5.2.79)—than lose control of her sexu-
ally. Iago's bestial sexual reference to Desdemona
and Cassio as being "prime as goats, as hot as mon-
keys, / As salt wolves in pride" (3.3.400-01) and
the alleged dream where Iago graphically describes
Cassio as having "laid his leg o'er my thigh" (421)
play upon Othello's sexual suspicions. Othello's
description of Desdemona's hand as being sexually
liberal—"Hot, hot, and moist" (3.4.39)—is a direct
result of Iago's provocations in the previous act.
Othello's fears that he does not have sole posses-

Michalski 7

sion of Desdemona's body becomes clear when he later declares, "I had rather be a toad / And live upon the vapor of a dungeon / Than keep a corner in the thing I love / For others' uses" (3.3.269–272). His fever to possess Desdemona is reinforced by Iago's devious "med'cine" (4.1.47); nevertheless, his sexual perception of her infidelity, seen in his statements, "Cuckold me!" (202) and "I took you for that cunning whore of Venice" (4.2.88), reveals that Iago indeed has great persuasive powers, but only insofar as he is able to tap into the dark vices that already exist within his victims.

Conclusion The *dramatis personae* simply lists Iago as "a villain," and his description seems fitting as the audience witnesses his ability to deceive nearly every other character about his true motivations. Yet from the beginning, Iago warns the audience that he is not what he appears to be, stating outright in the first scene, "I am not what I am" (1.1.62). Is there a possibility that, as the audience, we too have been deceived? Just as the other characters in the play are deceived into viewing Iago as too honest, perhaps we have judged him to be too false. Indeed, Iago has the "last laugh" in being "honest Iago" as an agent of truth—for he manipulates not only the characters, but the audience as well.

Michalski 8

Works Cited

Shakespeare, William. *The Tragedy of Othello.* New
 York: Penguin, 1998.

The following student paper, "Bach's Enduring Influence" by Matt Hoffman, examines the effect of Bach's techniques on contemporary music. Notice that Hoffman's essay does not cite any sources, and so there is no works cited page. There is, however, one content note, a footnote offering clarifying information.

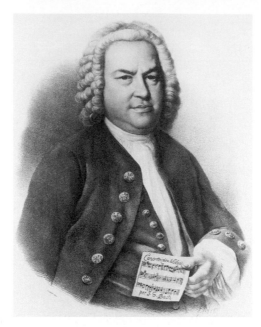

3.6 Harmonious euphony for the Glory of God. Johann Sebastian Bach. © Bettmann/Corbis

3.7 Harmonic hierarchy for the huddled masses. U2's Bono. Photographer Peter Anderson. Photographed ca. 1995. © S.I.N./Corbis

Hoffman 1

Matt Hoffman

Professor Linda Jenks Colby

Writing about Music and Society

April 26, 2001

Bach's Enduring Influence

Classical music has lost its luster in America today.[1] People listen to pop rock, country ballads, folk tunes, hip-hop, blues, and nearly every imaginable mix except for Bach, Brahms, or Stravinsky. Generally speaking, Americans consider the music they like to hear as vastly different from classical music. However, composers during Bach's time really began setting the standard for the music we *Thesis* listen to today. Beginning with Bach, the so-called classical composers appealed to instinctive human needs by using a hierarchy of chords and harmony, *Points of* major and minor triads, and specific seventh chords *proof* within their pieces.

Johann Sebastian Bach and his contemporaries *Point of* established a system of harmonic motion and voice- *proof #1* leading that has endured approximately three hun-

[1]The term "classical music" will be used somewhat loosely in this paper. Bach is technically considered a Baroque composer, but he—as well as other Baroque, classical, and Romantic composers—is often referred to generally as a "classical" composer.

Hoffman 2

dred years. Bach's system is different from his predecessors' methods in one way that is crucial to today's composers. Bach's system first establishes the hierarchy of interdependent chords, which generates what we consider to be harmony. The scale serves as the musical alphabet; chords derive from specific notes within the scale. The chords of a scale establish a hierarchy; that is, some chords are more important than others. Voice-leading entails the specific motion of specific pitches while moving from chord to chord.

What does all of this really mean? In essence, Bach and his contemporaries formulated a system of voice-leading and harmonic motion that pertains to a human need. No matter how inexperienced a person may be in music, he can tell where the "leading tone" needs to resolve; this tone has such strong implications—dictated by our innate need to hear its specific motion—that it virtually cannot move to any place other than the tonic note (the first degree of the scale, which serves as home base) without sounding extremely strange to our ears. Our inherent need for note-specific movement from chord to chord also reinforces a sense of tonic, or home. With the exception of atonal music, practically all music has a tonal center. At the same time, essen-

Hoffman 3

tially all music with tonality operates on the
premise of Bach's method. For example, virtually
every blues song uses three chords from the scale;
the one chord or tonic, the four chord, and the
five or "dominant" chord. These chords come from
Bach's hierarchy as the three most important chords
in the scale. Another example involves the music of
rock legends U2. Their newest album, *All That You
Can't Leave Behind,* uses Bach's hierarchy of chords
within the scale, and many times U2's songs follow
the specifics of voice-leading: the song "Stuck in
a Moment You Can't Get Out Of" provides a perfect
example of voice-leading—particularly in the bass.
An integral point to make here involves the fact
that throughout all of U2's existence, the band has
operated within the harmonic hierarchy formulated
during Bach's time. The same is true for blues leg-
end Stevie Ray Vaughan, jazz singer-songwriter
Harry Connick, Jr., popular boy band the Backstreet
Boys, eighties rock sensation Bon Jovi, and the
list goes on.

Another aspect of Bach's music that is essen-
tial to today's music involves major and minor tri-
ads. Generally speaking, composers before Bach's
time relied heavily on the open fifth, an interval
that divides the octave in a very "pure" or "open"

*Point of
proof #2*

Hoffman 4

sound. A third note can be added to the open fifth,
creating a triad (three-note chord). The key inter-
vallic element in major and minor triads is the in-
terval of the third. Once used, thirds—as well as
major and minor triads—prevailed throughout music
as we know it. Thirds as pitch-intervals sound
beautiful to us; they create a sense of resolution
and harmony that is absent from the open fifth. It
would be difficult to find an example of music—out-
side the atonal genre—subsequent to Bach's time
that did not contain triads instead of the open
fifth (unless, of course, the desired effect were
to mimic ancient compositions). The Dave Matthews
Band serves as a perfect example of thirds' predom-
inance today. In their song "Tripping Billies," the
bass guitar and the violin move in parallel thirds;
literally every note of the opening in the melody
(violin) has the bass in either a major or minor
third below it. This serves as one good example of
thirds today; however, essentially all music heard
on the radio contains thirds and major or minor
triads.

Point of proof #3

Furthermore, Bach used specific chords that re-
main integral elements in music on the radio today.
When people think of jazz, oftentimes "seventh
chords" come to mind. Seventh chords include four
notes, most commonly a major triad with an extra

Hoffman 5

third added on the top. The most well-known types
of seventh chords are the dominant seventh chord,
the minor seventh chord, and the major seventh
chord. These chords sound jazzy to us; their sonori-
ties imply something beyond straight major or minor
triads. The major seventh chord has an element of
dissonance in it due to its intervallic makeup. For
the most part, people would tend to think that
these chords are inherent to jazz—that they came
out of jazz's need to be innovative and new. How-
ever, Bach used these three types of seventh chords
regularly. For example, *The Well-Tempered Clavier,*
Book I, Prelude 1, contains all three of these
chords. The minor seventh chord appears four times,
the dominant seventh eight times, and astonishingly
enough, the major seventh chord appears three
times. Seventh chords play an essential role in
blues and jazz; nearly every blues or jazz triad is
converted into a seventh chord. A great example
from the pop genre is found in 'N Sync's "It's
Gonna Be Me." The climax of this 'N Sync smash hit
involves four of the singers arpeggiating up a dom-
inant seventh chord, which ultimately resolves to
the tonic. Who would think that Bach used the same
arpeggiated approach in his great "D Minor Toccata"
over three hundred years ago?

```
                                                  Hoffman 6
```

Conclusion
```
       The majority of people today are largely un-

   aware of what Bach has done for music and for hu-

   mankind. Die-hard U2, the Dave Matthews Band, and

   millions of rock, pop, and blues fans fail to real-

   ize that it was Bach who laid the foundation for

   contemporary music.
```

REVISING AND EDITING YOUR ESSAY

The analytical essay that lands on the page exactly right the first time—that is in need of no revision whatsoever—is a rarity. Indeed, we doubt that such a thing exists at all. We encourage you, therefore, to regard revision as a standard part of the process of writing analytically, and not as a sign of having failed in your first attempt to produce an analytical essay. The following exercise is predicated on such an attitude. The first paragraph in the following exercise, written by student Molly Dyson, represents Molly's attempt to construct an introductory paragraph analyzing Shakespeare's *Richard III*. The second paragraph represents Molly's revision, based on the feedback she received from her peers and her instructor.

EXERCISE 3-4

Read the following introductory paragraph, containing a thesis and points of proof. Use the Guidelines for Peer Review in Chapter One to analyze the paragraph. What suggestions would you give the author for revision?

```
                    Pure Evil

                by Molly Dyson

     In Richard III, the character of Richard is

   portrayed as the very essence of evil, for he is

   dishonest, perverse, and replete with hatred, envy,

   and nastiness. However, despite this, the play's
```

other characters repeatedly fail to recognize the evil with which they are confronted, in the form of Richard, and, even when they are able to sense Richard's guilt, they choose, for whatever reason, not to take a stand against it. Shakespeare, therefore, is forcing readers to recognize that the success attained by Richard, Duke of Gloucester, depends upon the refusal of others to stand up to him and that which he represents—pure evil. We are to see that evil succeeds in this world because people are flawed, and much too weak, unintelligent, or afraid to take a stand against it. Instances wherein evil, in the form of Richard, succeeds because of the assumed ignorance or lack of awareness of the other characters can be found throughout the play. When Richard attempts to woo Lady Anne, she chooses to disregard his past offenses. Additionally, when the archbishop has the opportunity to prevent Richard from gaining access to the young princes, he allows Richard to overrule his initial decision to help protect them. Third, when Lord Hastings learns of Lord Stanley's dream, wherein it is implied that Richard possesses a villainous plan, he chooses to disregard it. Lastly, when the Scrivener appears with the indictment of Lord Hastings, he questions whether anyone is brave enough to confront a bold manifestation of evil, and implies that those whose ignorance and cooperation benefit evil acts are responsible for the deaths of innocent people.

EXERCISE 3-5

Read the following paragraph, a revised version of Molly Dyson's introductory paragraph in exercise 3-4. Compare the two paragraphs, mark the changes, and discuss what you believe to be the reasoning behind them. Use the "Guidelines for Peer Review" in Chapter One, pages 23–25, to assist you.

Shakespeare's Messenger

by Molly Dyson

In Shakespeare's *Richard III*, the character of Richard is the essence of evil, for he manipulates and betrays those around him, heartlessly murdering members of his own family and shaming his own mother. Regardless, the play's other characters repeatedly fail to confront Richard. When the Scrivener appears with the indictment of Lord Hastings, he asks if anyone is brave enough to confront evil. Though his appearance is brief and his words are few, the Scrivener serves as a medium through which Shakespeare conveys his message that individuals who ignore and cooperate with evil are fully responsible for the havoc it wreaks upon their lives. Those within the play who fall victim to Richard, according to the Scrivener, are responsible for Richard's reign of terror, because they ingratiate themselves with Richard, disregard his past offenses, or fail to seize opportunities to bring his malevolent conduct to an end.

Use the following checklist to be certain that your essay is ready for submission. Consult the Handbook at the end of this book for guidance in sentence structure, grammar, punctuation, mechanics, and style.

REVISION AND EDITING CHECKLIST

- ☐ Thesis statement is clear and present. It makes an inference about the work. It is narrow and specific enough to be adequately supported in the space of the paper but general enough to need support.
- ☐ Points of proof are clear and present. Each answers the proof question. Each is narrow and specific enough to be supported adequately in one to three paragraphs and general enough to need support.
- ☐ Introduction contains specific details. It leads the reader to the thesis; it does not mislead the reader about the subject of the paper.
- ☐ Essay adheres to the essay plan set out in the list of points of proof.
- ☐ Body paragraphs are unified, adequately developed, organized, and coherent.
- ☐ Conclusion solidifies the essay's main point without resorting to mere repetition of thesis and points of proof. It is unified and developed. It does not bring up any new issues.
- ☐ Sentences are well constructed. There are no run-ons or fragments. Sentences are correctly punctuated.
- ☐ Words are correct and well chosen.
- ☐ All quotations use acknowledgment phrases.
- ☐ Sources are correctly cited in text.
- ☐ Title is appropriate.

4

WRITING THE ARGUMENT ESSAY

The Nature of Argument	*Appeals of Argument*
	Types of Reasoning
	Logical Fallacies
Planning and Drafting Your Argument Essay	*Choosing a Topic*
	Topic Suggestions
	Introduction
	Counterarguments
	Thesis
	Points of Proof
	Templates for Organizing Your Essay
	Body Paragraphs
Student Essays	
Revising and Editing Your Essay	*Revision and Editing Checklist*

CHAPTER PREVIEW

Often, we use the word *argument* to mean *quarrel*—that is, to engage in a discourse fueled by anger. We think in terms of winning and losing arguments, which reduces the purpose of argument to a competition of wills or personalities. In academic settings, we must adjust our thinking about argument. Here, to argue is to persuade a rational, educated audience to move to a position that is closer to our own. To argue, in this context, is not to squabble and bicker but to engage in a noble occupation. To argue is to verify that we have values and consciences, that we concern ourselves with the task of raising our awareness, of leading the examined life. It is a testament to civilization that we are free to argue, and so we want to use our freedom wisely. This chapter will introduce you to concepts related to argument and guide you through the process of developing an argument essay, emphasizing the skills of stating the counterarguments and engaging in refutation.

THE NATURE OF ARGUMENT

The word *argument* has been used in so many contexts and toward so many purposes that there is no entirely accurate and comprehensive definition of it. Some rhetoricians make a distinction between *argument* and *persuasion*, claiming that argument intends to lead audiences to a certain belief or conviction, and that persuasion intends to move audiences to action. This distinction can become exceedingly fine, as the aims of arguments tend to blend and overlap.

The essential difference between the argument essay and the analytical essay in the humanities is that the argument essay engages directly in *refutation*. The writer disagrees with a particular view or interpretation of a work. The argument writer's job, therefore, is not only to defend his or her opinion but also to refute someone else's opinion. In so doing, we believe, it is essential to articulate the opposing viewpoint in fair and generous terms and to treat the opponent with respect.

APPEALS OF ARGUMENT

Arguments succeed or fail as a result of having made the proper appeal to the proper audience. The terms *ethos, pathos,* and *logos* (Greek for *ethics, emotion,* and *logic*) are useful in analyzing arguments. **Ethos** is the appeal to the audience's sense of ethics. One could point to the essays of Thomas Paine or to Dr. Martin Luther King, Jr.'s "Letter from the Birmingham Jail" as examples of ethical arguments. **Pathos** is the appeal to the audience's emotions. Dr. King's "I Have a Dream" speech appeals to the audience's emotions by means of an altogether different set of rhetorical devices—rhythm and repetition, for example. Goethe's play *Faust* appeals to emotion; it warns against the lust for experience and power by means of the mysterious and fantastic. **Logos** is the appeal to the audience's logic, or sense of order. The ancient Greek philosopher Pythagoras, who claimed that the mysteries of the universe could be unlocked by mathematical means, and the eighteenth-century English poet Alexander Pope, who believed that truth is attainable through sets of universal rules, employed *logos*. Here again, there are gray areas of overlap among the styles. Henry David Thoreau's *Walden*, for example, is written in an orderly and logical style, but its subject matter, nonetheless, appeals to its audience's emotion—its need to escape the confines of civilization and to commune with nature.

TYPES OF REASONING

The process of reasoning is sometimes said to be either inductive or deductive. **Inductive** reasoning moves from specific facts to a general conclusion. This movement requires an **inductive leap,** a leap from certainty to uncertainty. Your conclusion is considered valid when there are enough facts in support of it to convince an educated, sympathetic, yet skeptical audience. If

you base your inference on scant evidence, your audience may accuse you of "jumping to conclusions," as the expression goes.

Deductive reasoning moves from the general to the specific, for instance by means of a syllogism. A **syllogism** begins with a general rule, moves to a more specific fact, and arrives at a conclusion. Thomas Jefferson's argument in the Declaration of Independence can be analyzed as a syllogism:

Major premise: All tyrants should be overthrown.

Minor premise: George III is a tyrant.

Conclusion: Therefore, George III should be overthrown.

Such an argument is considered valid if the **major premise,** or underlying assumption, would not be disputed by an intelligent, rational audience, and the **minor premise** is adequately supported. Jefferson assumed his audience would agree with his major premise. His task, then, became to support his minor premise, and so he did by listing twenty-seven human rights violations enacted by King George III.

LOGICAL FALLACIES

Fallacies are lapses in logic. They are the result of mistaking faulty premises for valid ones, misusing evidence, or distorting the counterarguments. Following are some of the more common logical fallacies:

Ad hominem attacks the person rather than the argument. It would be an *ad hominem* argument to claim that Woody Allen's film *Husbands and Wives* is not good because Allen was, at the time of filming, dating his wife's adopted daughter. One may decide not to see the film on these grounds, but to claim that the film is not artistic on these grounds is unfounded.

Appeal to tradition claims that something should be done in a certain way simply because it has always been done that way. This is the argument of Old Man Warner in Shirley Jackson's short story "The Lottery." "There's *always* been a lottery," he says, in defense of the barbaric practice of human sacrifice.

Bandwagon claims that everyone believes something to be true, and therefore, it is true; or it claims the obverse: that no one believes something, and therefore, it is not true. The vast majority of critics disliked the film *Ishtar;* therefore, it was a bad film, according to this fallacy.

Begging the question sidesteps the issue, assuming what needs to be proved. A question often asked is "How did life begin?" It would be begging the question to reply, as some science fiction writers do, that aliens seeded the earth. The question remains, "How did alien life begin?"

Circular reasoning mistakes a cause for an effect, and vice versa. "Writers continue to write about Odysseus because he is a fascinating character." In essence, this sentence says that Odysseus is fascinating because he is fascinating. The real question is, "What is so fascinating about Odysseus that writers continue to write about him?"

Either/or reasoning assumes that there are only two options, whereas there may be many more. Shakespeare's Richard III claims that he cannot be a lover, deformed as he is; therefore, he must be a villain.

False analogy assumes that because two things are alike in some ways, they must be alike in other ways. In 1633, Scipio Chiaramonti, professor of philosophy at the University of Pisa, argued against Galileo's claim that the earth orbits the sun by means of the following analogy: "Animals, which move, have limbs and muscles. The earth has no limbs and muscles; hence it does not move."

Hasty generalization is based on too little evidence, as in the claim that Jessica Lange is a poor actress because her performance in *King Kong* is laughable. Similarly, the claims that artists have volatile temperaments, or that female artists appeal to the emotions, rely more on stereotyping than on evidence.

Oversimplification leaves out relevant considerations about an issue, as in, "More funding for the arts would result in better art."

Post hoc ergo propter hoc is Latin, meaning "After this, therefore because of this." This fallacy assumes that because one event *followed* another, it was *caused* by the other. For example, night follows day; therefore, day causes night. If an actor forgets to wear his lucky charm and gives a bad performance, it would be a logical fallacy to conclude that the bad performance was the direct result of forgetting the charm.

Non sequitur is Latin, meaning "It does not follow." This fallacy derives a conclusion that doesn't follow from the previous premise. In Charlotte Brontë's *Jane Eyre*, Rochester is rich. Therefore, Jane shouldn't fall in love with him. An intermediate bit of information, or the minor premise, is missing, which, if supplied, may result in a valid statement.

Straw man is an opponent who is easily knocked down. To say "Anyone who says that violence on television does no harm to children should have her head examined" is to misrepresent the opposition's viewpoint, or in other words, to set up a straw man for an opponent. The real opponent, assuming she is rational and educated, may have said something like "Cartoon violence does not significantly harm most children."

PLANNING AND DRAFTING YOUR ARGUMENT ESSAY

CHOOSING A TOPIC

For your argument essay, choose a topic that is controversial. Your professor, textbook, and class discussions will alert you to some existing debates in the humanities, but new issues are constantly arising. Be on the lookout for such topics as you read newspapers, magazines, and journals.

You must also find a rational, educated opinion against which to argue. Arguing against a weak opinion compromises the strength of your own. Your professor may suggest an opinion to refute, or you may need to find credible opponents on your own through library research. You might consult Chapter

Seven of this book, "Writing the Research Paper," for advice on finding essays and articles in the humanities, particularly opinionated ones. The following topic suggestions could provide you with a topic for your own argument essay in the humanities, or they may spark ideas for other topics. Or you may use them simply as models of the type of question you should devise for your own project.

TOPIC SUGGESTIONS

In debate, arguments are based on **propositions,** statements that may be either defended or refuted. You might defend or refute any of the following propositions:

- I. M. Pei's glass entrance pyramid to the Louvre is discordant with the Louvre and, thus, should be removed.
- Classical-style painting requires more talent than the abstract-expressionist style and, therefore, is superior.
- Sexually explicit art exhibitions, such as the Brooklyn Museum of Art's "Sensation," should be censored.
- Video art is as valid a medium as sculpture.
- Ancient Roman sculpture is inferior to Hellenic sculpture.
- Picasso's work conveys an attitude of misogyny.
- William Blake's art is good enough to stand on its own, not merely as accompaniment to his poetry.
- In Sophocles's *Antigone,* Creon, not Antigone, is the true tragic hero.
- In Ibsen's *A Doll's House,* Nora is wrong to leave her family.
- Sappho's poetry indicates a lesbian relationship with her students.
- The *Law Code of Hammurabi* treated women unfairly.
- Plato used Socrates as a spokesperson for his own ideas.
- In Herman Melville's *Bartleby the Scrivener,* the narrator was wrong to have Bartleby arrested.
- In Albert Camus's *The Stranger,* Meursault was wrongfully executed.
- In Susan Glaspell's "Trifles," the women were wrong to conceal the evidence that would have implicated Minnie Wright.
- The ending of Charlotte Perkins Gilman's "The Yellow Wallpaper" is a positive one.
- Mark Twain's *The Adventures of Huckleberry Finn* promotes racism.

INTRODUCTION

Much of the following discussion uses Rebecca Penkoff's essay, "Torvald Isn't Such a Bad Guy," for demonstration purposes. The essay is an argument about Henrik Ibsen's drama *A Doll's House,* a play that has been stirring up argu-

ments since its premiere in 1879. The discussion may be clearer if you know the plot of the play, which follows:

Nora, a seemingly happy Norwegian wife and mother, has forged a signature on a loan in order to afford her deathly ill husband, Torvald, time to recuperate in warm, sunny southern Italy. Torvald does not know, nor would he approve, of either the loan or the forgery. Back home in Norway, now that Torvald has been restored to health, Nora must resort to deception in order to obtain the funds with which to repay the loan. Her web of deceit unravels, she and Torvald argue, and she understands for the first time the state of ignorance and poverty in which she has been living, and in which she has been complicit. Rather than live one more day in such a state, she leaves her husband and children. The play ends with the resounding slam of the door shutting behind her.

Your introductory remarks will identify the work(s) about which you are writing, the artist(s), and the issue in contention. If you are writing about a literary work, you might offer a short synopsis of the plot, like the preceding one, if you believe your reader would benefit by it. If you are writing about a work of art, perhaps you should describe the work before you proceed with your argument.

COUNTERARGUMENTS

Next, write what your *opponent* thinks and why. These are the **counterthesis** and **counterpoints.** Be specific about who said or wrote what, and when and where they said or wrote it. Present your opponent's strongest arguments, and present them in terms that your opponent would consider fair. If you present only his weakest arguments, or if you make them seem weak or ridiculous, you only undermine your own argument. A balanced introduction gets the essay off to a strong start; the reader understands immediately the issue under debate, the opinion against which you are arguing, what your opinion is, and how you will support your opinion. Constructing your introduction in this manner also has the effect of keeping you focused and organized.

In a short essay, your introductory remarks, counterthesis, and counterpoints should fit into one paragraph. When writing longer essays, however, you may need more space, perhaps one paragraph each, to establish each element.

THESIS

If the statement of the issue in contention, the counterthesis, and the counterpoints constitute a full-bodied paragraph in their own right (six or seven sentences), begin a new paragraph for your thesis and points of proof. Use a transition to ease the shift from counterthesis to thesis and to cue the reader that a change in attitude is coming. Something as simple as the word *however* at the beginning of the thesis will often suffice.

The thesis must be in your own words; this is not the time to quote or paraphrase a source. This is *your* argument. You must make all the major assertions. Your sources will corroborate what you say, but you must not let them speak for you. Like the thesis of the analytical essay, the thesis of the argumentative essay fulfills the following criteria:

- is one complete, unified statement about the issue in contention
- is precise enough to limit the material
- is general enough to need support
- is defensible
- is not too obvious

To the above list, add two more criteria specific to the argumentative thesis:

- answers the charge made in the counterthesis
- makes a statement with which a rational, educated person could disagree

Use the preceding guidelines to complete the following exercise:

EXERCISE 4-1: FAULTY ARGUMENTATIVE THESES

Following are ten faulty argumentative theses. The issue in contention concerns the manner in which Torvald Helmer, the antagonist of Henrik Ibsen's drama, *A Doll's House*, should be played. Theater critic Harold Clurman sees Torvald as a "nice bourgeois man," whereas another theater critic, Marvin Rosenberg, calls Torvald a "true villain." In this exercise, assume that the counterthesis is Rosenberg's. The thesis, then, should contradict the assertion that Torvald is a "true villain." Use the preceding guidelines to determine the problems with the following argumentative theses. After you have determined the problems with these theses, compare your answers to those on the next page.

1. Torvald's character is complicated.

2. Torvald's character is complicated for three reasons.

3. This paper will argue the merits of Torvald's character.

4. Torvald is a conscientious businessman.

5. But *is* Torvald a "true villain"?

6. *A Doll's House* is purely feminist propaganda.

7. If readers and theatergoers understood Torvald's character, they might change their minds about him.

8. Torvald's detractors are simply being narrow-minded.

9. Radical feminism drives this criticism of Torvald.

10. Torvald reflects the social influences of the time in which he lived.

ANSWERS TO EXERCISE 4-1:
FAULTY ARGUMENTATIVE THESES

1. The thesis doesn't contradict the charge made in the counterthesis. Torvald could be both complicated and a villain.

2. The thesis has the same problem as thesis #1. Adding "for three reasons" does not solve the problem. The thesis is also indefensible, for there are an indeterminate number of reasons why Torvald's character is complicated. It is highly unlikely that there are exactly three reasons.

3. This thesis is really a statement of purpose. It tells what the paper will do, but not what it will argue.

4. The thesis is a fact, not an arguable statement.

5. The thesis is a question, whereas it should be a statement. The essay must argue the truth of the thesis. One cannot argue the truth of a question.

6. This thesis has many problems. For one, it does not contradict the counterthesis. For another, it overstates its case: the play may be partly feminist propaganda, but any thoughtful person would know that the play has other aspects as well. Another problem with this thesis is that in tone, it is more emotional than rational, especially because of the loaded word *propaganda*.

7. The thesis assumes that opponents are uneducated and that simply presenting them with the facts will persuade them. You

> must assume that your opponent possesses the same facts that you possess but interprets them differently. An additional problem with this thesis is that it will lead to a descriptive paper—one that merely describes Torvald's character.
>
> 8. This thesis resorts to name-calling and assumes that opponents are not rational. A strong argument takes on a rational, educated opponent.
>
> 9. The thesis is not about the issue in contention. This thesis will lead to an argument about feminism, not about Torvald's supposed villainy.
>
> 10. This thesis is more analytical than argumentative. No rational, educated person would be predisposed to disagree with it. Besides, like thesis #9, this thesis is not about the issue in contention.

POINTS OF PROOF

Your points of proof should answer the proof question—the question that the thesis provokes. In argument, there are often two proof questions: (1) Why don't you believe what your opponent believes? and (2) Why do you believe what you believe? For example, the thesis of the essay "Torvald Isn't Such a Bad Guy" is, "Torvald's words and actions do not fit the profile of a victimizer, but rather of a man who works hard and loves his wife and, like Nora, is a victim of society's rigid and outdated traditions." In response to that thesis, the following two questions arise:

- Why don't you believe (with your opponents) that Torvald fits the profile of a victimizer?
- Why do you believe Torvald's words and actions fit the profile of a man who works hard and loves his wife and is a victim to society's traditions?

The answers to the first question are the author's **refutations** of the counterpoints; the answers to the second question are the author's **constructive arguments.**

Following are some of the qualities of workable points of proof:

- You must state your own points of proof. Do not quote or paraphrase a source for this task. This is *your* argument, not your sources' argument.

- Each point of proof will serve as the central claim of one section of the essay. In turn, each must make a claim that needs support.
- Points of proof are reasons why you think what you think, not facts.
- The point of proof cannot dodge the responsibility of making a point, as in the sentences, "First we shall look at Torvald's words. Then we shall look at his actions." Once you have looked at Torvald's words and actions, what conclusions will you come to? The answers to that question will be your points of proof.

TEMPLATES FOR ORGANIZING YOUR ESSAY

Following is an outline for Rebecca Penkoff's argument essay that follows this discussion, "Torvald Isn't Such a Bad Guy." Notice that the organization of the body of the paper matches the organization projected in the points of proof.

ARGUMENTATIVE ESSAY OUTLINE
"TORVALD ISN'T SUCH A BAD GUY"

I. **Introduction**

 A. **Identification of issue in contention:** Torvald's villainy

 B. **Counterthesis:** Torvald victimizes his wife and, therefore, earns himself the title of villain.

 C. **Counterpoints**

 1. Torvald refuses to support his wife's actions when he discovers her forgery.

 2. His treatment of Nora reflects his opinion that women are weak and lacking the capabilities to make logical, informed decisions.

 D. **Thesis:** Torvald's words do not fit the profile of a victimizer, but rather of a man who works hard and loves his wife and, like Nora, is a victim of society's rigid and outdated traditions.

 E. **List of points of proof**

 1. **Refutation of counterpoint #1:** Torvald would have to turn his back on everything he believes to be true and good in order to condone Nora's dishonest actions.

 2. **Refutation of counterpoint #2:** Torvald is justified in his treatment of Nora, because oftentimes she proves she needs and depends on her husband's better judgment.

 3. **Constructive argument #1:** Torvald protects and provides for his wife admirably.

 4. **Constructive argument #2:** Torvald's decision to abide by the rules of society does not make him a villain.

II. **Body (development of points of proof)**

 A. Torvald would have to turn his back on everything he believes to be true and good in order to condone Nora's dishonest actions.

 1. Fires Krogstad for same crime.

 2. Reaction justified because of ugly, clumsy way he discovers it.

 B. Torvald is justified in his treatment of Nora, because oftentimes she proves she needs and depends on her husband's better judgment.

 1. Nora sneaks macaroons.

 2. She is irresponsible with money.

 3. Can't dress herself.

 C. Torvald protects and provides for his wife admirably.

 1. Works himself nearly to death.

 2. Believes money makes Nora happy.

 D. Torvald's decision to abide by the rules of society does not make him a villain.

 1. Kohlberg's stages of moral development.

 2. Torvald is in Stage 4.

III. **Conclusion**

Use the following template to organize your own argument essay, as Rebecca Penkoff has done in the preceding example. Tailor the template to reflect the number of counterpoints, refutations, and constructive arguments suitable for your essay, keeping in mind the following guidelines:

- Your thesis must oppose the counterthesis. The thesis and counterthesis can't both be true at the same time.

- It is not always necessary to articulate the counterpoints, especially when the counterthesis is narrow enough not to merit breaking down into subpoints.

- If you have listed counterpoints, organize your refutations in the same order as the counterpoints. In other words, your first refutation should refute the first counterpoint, and so forth.
- Your essay may be more persuasive if you place your constructive arguments *before* your refutations. If so, arrange your points of proof accordingly.
- Constructive arguments are optional. Sometimes an argument is "won" with refutations alone.
- Your strongest point of proof should be your last one.

MY ARGUMENT ESSAY OUTLINE

Title of Essay _____

I. Introduction

 A. Identification of issue in contention _____

 B. Counterthesis _____

 C. Counterpoints (Listing counterpoints is optional, but if opting to list them, you should list at least two.)

 1. _____

 2. _____

 D. Thesis _____

 E. List of points of proof (An option is to list constructive arguments first. The number of refutations must match the number of counterpoints listed in C.)

 1. Refutation of counterpoint #1 _____

 2. Refutation of counterpoint #2 _____

 3. Constructive argument #1 _____

 4. Constructive argument #2: _____

II. Body (Develop each point of proof, in same order as E. The number of supporting details and examples will vary according to the needs of your own argument.)

 A. Refutation #1 _____
 1. Detail _____
 2. Detail _____
 B. Refutation #2 _____
 1. Detail _____
 2. Detail _____
 C. Constructive argument #1 _____
 1. Detail _____
 2. Detail _____
 D. Constructive argument #2 _____
 1. Detail _____
 2. Detail _____
III. Conclusion (briefly) _____

BODY PARAGRAPHS

Well-written body paragraphs for the argument essay contain the same qualities as those for the analytical essay: unity, adequate development, organization, and coherence. *Refutation paragraphs* are often organized by first stating the counterpoint and the reasons that support it. The paragraph then goes on to make a *refutation statement* and offer support for it.

Use the following template to organize each body paragraph of your refutations:

BODY PARAGRAPH: REFUTATION

Restate the counterpoint

_____.

Evidence for counterpoint (optional)

1. _____.
2. _____.
3. _____.

Your refutation statement

_____.

Evidence for your refutation (Fill in at least two blanks.)

1. _____.

2. _____.

3. _____.

4. _____.

Note the following when organizing your refutation paragraph:

- The counterpoint may be easily understood and stated in one sentence. If that is the case, begin your paragraph with the counterpoint and proceed immediately to refute it without beginning a new paragraph.
- If the counterpoint needs to be more fully explained, you might allot a whole paragraph to it and then begin your refutation in a new paragraph. For example, in her essay, Rebecca Penkoff devotes a whole paragraph to explaining counterpoint #1 and begins her refutation in a new paragraph.
- You may have more than one paragraph's worth of support for your refutation statement. If that is the case, break up your evidence into separate paragraphs, and begin each paragraph with a topic sentence that states the point of the paragraph.

Paragraphs that offer *constructive arguments* usually begin with a topic sentence that states the argument. They then go on to supply the evidence for that statement. These paragraphs present reasons why you, the author, believe your thesis to be true, in the absence of counterarguments. Use the following template to organize each body paragraph of your constructive arguments:

BODY PARAGRAPH: CONSTRUCTIVE ARGUMENT

Constructive argument (Fill in the blank with one point of proof.)

_____.

Evidence (Fill in at least two blanks.)

1. _____.

2. _____.

3. _____.

4. _____.

You may have more than one paragraph's worth of support for one constructive argument. If that is the case, you may divide your support into as many paragraphs as you need. Begin each paragraph with a topic sentence—a sentence that summarizes the paragraph.

STUDENT ESSAYS

The following essay, written by Rebecca Penkoff, argues with critics who believe that Torvald Helmer, Nora's husband in Henrik Ibsen's *A Doll's House*, is a villain. Penkoff adopts a kinder attitude toward Nora's antagonist. Notice that Penkoff recognizes and addresses the most damning evidence against Torvald, rather than ignoring it or pretending that it is not important. Ignoring or trivializing your opponent's strongest arguments will only cast suspicion on your own argument.

4.1 Torvald's "skylark" is not the only victim of society's stringent codes. Actress Lydia Yavorska as Nora in Ibsen's *A Doll's House*. Photographed early 20th century. © Hulton-Deutsch Collection/Corbis

Penkoff 1

Rebecca Penkoff

Professor Suzanne Hudson

Writing about Theater and Drama

13 December 2000

Torvald Isn't Such a Bad Guy

Introductory remarks In *A Doll's House,* Ibsen examines the restrictive traditions that impact all members of society. It is the story of Nora Helmer and her husband, Torvald, on the surface a happily married couple, who fall apart under the threat of public scandal.

Counterthesis Theater critic Marvin Rosenberg agrees with George Bernard Shaw and many other critics in calling Torvald a "true villain" (192). The main reason for

Counterpoint #1 adopting this attitude is that Torvald refuses to defend his wife's actions when he discovers her

Counterpoint #2 forgery. Another reason critics label Torvald a villain is that his treatment of Nora reflects his opinion that women are weak and lacking the capabilities to make logical and informed decisions.

However, upon closer examination, Torvald's

Thesis words and actions do not fit the profile of a victimizer, but rather of a man who works hard and loves his wife and, like Nora, is a victim of soci-

Refutation #1 ety's rigid and outdated traditions. First, Torvald would have to turn his back on everything he believes to be true and good in order to condone

Penkoff 2

Nora's dishonest actions. Second, although Torvald
does treat Nora as though she is not capable of
making a decision, he is justified because often-
times she proves she needs and depends on her hus-
band's better judgment. Furthermore, Torvald pro-
tects and provides for his wife admirably. Society
has relegated Torvald to a role that he is expected
to play without question, but his decision to abide
by those rules does not make him a villain.

On the surface, Torvald's angry reaction to
Krogstad's letter containing the evidence of Nora's
criminal act of forgery serves immediately to make
him look cold and selfish, which is why labeling
Torvald a villain appears logical. Nora has suf-
fered with her secret for a long time, and rather
than berate her as he does, Torvald should be un-
derstanding and supporting of his wife. After all,
just minutes before Torvald reads the letter, he
declared his wish for the opportunity to risk
everything to save Nora from a grave danger. Of
course, he said that believing that his wife was
completely safe. But once Torvald reads the letter,
his attitude toward Nora drastically changes. Nora
is planning to kill herself to prevent him from as-
suming the blame for her crime. She says, "When I'm
out of the way, you'll be free." He calls her a

Constructive argument #1

Constructive argument #2

Counter-point #1 fully explained

Penkoff 3

"miserable creature," and in the heat of the moment
cruelly says, "What good would it be to me if you
were out of the way, as you say?" (62). He knows
his reputation will be ruined whether Nora kills
herself or not. This is Torvald's most ignoble,
self-incriminating moment.

Refutation #1 Looking past the words Torvald speaks in anger
and instead focusing on the situation facing him,
we see that he is justified in his shocked out-
burst. His response is the product of a strong
moral code, and any other response would make Tor-
vald a hypocrite. Torvald was firing Krogstad for
the same crime Nora committed, and he clearly
states to Nora that he considers Krogstad's actions
completely deplorable: "I literally feel physically
ill when I am in the company of such people" (20).
For Torvald to hear of his wife's deed from the
very man he considers so horrid would be disastrous
for Torvald, and Nora knows how Torvald will react.
Nora says, "To think of his learning my secret
[. . .] in such an ugly, clumsy way" (23). After he
reads the letter, Torvald's cruel dismissal of
Nora's offer to commit suicide as pointless is in-
excusable, except that she doesn't kill herself,
and it is true that even if Nora were "out of the
way," that would do nothing to help Torvald escape

Penkoff 4

the shame and repercussions that would come. Also,
Torvald would be left grieving for a dead wife, and
his children would have no mother. Unsuspecting
Torvald really does not deserve such a downfall.
Also, Nora thinks only of herself when she expects
Torvald to turn his back on society and his own
moral code to dismiss her crime. Torvald says to
Nora, before he reads Krogstad's letter, that he
could forgive a person for a wrong deed, but he
qualifies that by saying, "if he openly confessed
his fault and takes his punishment" (28). Nora
could demonstrate some courage and confess her de-
ceit, in which case Torvald's reaction might be
very different. Instead, Nora allows Torvald to
find out in the ugliest, clumsiest possible manner.

The issue concerning Torvald's treatment of
Nora on a daily basis provides a second point for
some critics to name Torvald a villain. The many *Counter-point #2*
instances wherein Torvald refers to Nora as a "sky-
lark" or some other silly animal gives the impres-
sion that Torvald does not take Nora seriously, but
it would be challenging to take seriously a woman
who sneaks macaroons behind her husband's back. *Refutation #2*
Torvald constantly guides Nora and makes all of the
decisions, while rarely consulting her, which ulti-
mately leads to Torvald's being tagged a villain.

Penkoff 5

However, Nora reinforces Torvald's treatment of her at every instance. Nora wants to spend the money Torvald will earn from his promotion before they have it and says they can borrow until then. Torvald exhibits responsibility and consideration for the moneylenders in the event he did borrow money and was not able to repay it. Nora shows her lack of consideration for anyone but herself when she replies, "Who would bother about them?" (3). Another instance of Nora's apparent dependence on Torvald is illustrated when Nora cannot decide on a dress for the ball they are attending. To her husband Nora says, "Torvald, I can't get along a bit without your help" (28). Nora's behavior leads Torvald to believe he is acting exactly as she needs him to act. Therefore, it never occurs to Torvald that he is treating his wife in a derogatory manner. Furthermore, to his credit, once he sees the errors of his ways, he offers to change: "I have it in me to become a different man" (64).

The society in which Torvald and Nora conduct their married lives together places restrictions not just upon the women, but upon the men as well. As a husband, Torvald's duties include providing a home for his family and doing so in an honorable and respectable manner. In both respects, Torvald

Penkoff 6

demonstrates he is a worthy husband, a man that
Nora can be proud of. Regarding the one episode
during their marriage that threatened their happy
home, Nora says Torvald "overworked himself dread-
fully [. . .], and he worked early and late" (14),
which led to Torvald's becoming sick. A man working
himself to death for his family bespeaks a noble
hero, not a selfish villain.

*Constructive
Argument #1*

 Along with the duty of providing for his fam-
ily, Torvald is expected to be the social and moral
leader of his family. It is a husband's responsi-
bility to understand the rules that govern the mem-
bers of society, and Torvald takes that duty seri-
ously. During the 1980s, psychologist Lawrence
Kohlberg did extensive research concerning moral
understanding. He organized moral development into
three general levels, with each level having two
stages. Torvald belongs in Stage 4 because at this
stage, the individual moral standards are based on
societal laws, which must be enforced in the same
evenhanded fashion for everyone. Moral choices do
not depend on close ties to others, but rather each
member of society has a personal duty to uphold
them. Studies provide evidence that few people move
past the Stage 4 level of moral development (Berk
613). Those studies were done in the last few

Penkoff 7

decades in a liberal, freethinking society. It
seems reasonable to assume that it would be much
harder to move past Stage 4 in Torvald and Nora's
society than it would be today. Torvald's level of
morality limits his understanding of marriage to
the guidelines society sets.

Conclusion When taking all the different aspects of Tor-
vald together, it is impossible to consider him a
villain. The problem with Torvald is that he does
not realize, until Nora confronts him, that there
is another way to think. He honestly believes that
he is doing everything that society and Nora want
him to do. Henrik Ibsen delivers a message with
this play, but it is not just that women are the
oppressed victims of men. Ibsen seems to want
people to realize how repressive society is for
both men and women. The rules society places on
women are obvious, but men often do not realize
that even though they are living in a man's world,
many of the rules limit them as well. Nora's walk-
ing out the door serves not only as a stand for
women's rights, but serves also to enlighten men
about how blindly they organize their lives accord-
ing to society's standards without realizing how it
forces them into living shallow existences.

Penkoff 8

Works Cited

Berk, Laura. *Infants, Children and Adolescents.*
Boston: Allyn, 1999.

Ibsen, Henrik. *A Doll's House.* London: Everyman,
1993.

Rosenberg, Marvin. "Ibsen vs. Ibsen or: Two Ver-
sions of *A Doll's House." Modern Drama* Sept.
1969: 187–196.

The following essay, written by Todd Shelton, argues with readers who believe that Claggart, the ship's master-at-arms responsible for the death of Billy Budd, the angelic sailor in Herman Melville's short story titled "Billy Budd," symbolizes evil. First, Shelton lists the reasons why readers generally believe that Claggart symbolizes evil. These reasons are his counterpoints. Then he proceeds to tell why these reasons are not convincing. Notice that the essay contains only one constructive argument and that Shelton has placed it before his refutations, a logical organizational strategy, given the content of the essay.

One of the charms of this essay is its straightforward language. Shelton explains his complex ideas clearly, without resorting to inflated language, and the result is an interesting, convincing, and easily understood argument.

4.2 Master-at-arms Claggart maintains order on board the *Indomitable*. Forbes Robinson in *Billy Budd*. Photographer Ira Nowinski. Photographed 1978. © Ira Nowinski/Corbis

Shelton 1

Todd Shelton

Literature 202

Professor Molly LeClair

May 3, 2001

Claggart Was Just Doing His Job

Most readers of Herman Melville's short story "Billy Budd" are likely to view the title character as representing "good" while viewing Claggart, the master-at-arms, as representing "evil." The narrator leads the reader to see Claggart as evil be- *Counterthesis* cause of his actions and attitudes toward Billy and other members of the crew. First, Claggart is a se- *Counter-point #1* vere disciplinarian, as evidenced by his flogging of the after guardsman. Furthermore, Claggart ha- *Counter-point #2* rasses Billy through his corporals, tries to entrap him in a contrived plot to mutiny, and then lies. These are strong indictments of Claggart's character. Claggart, however, isn't evil; he was simply *Thesis* doing his job. Claggart has to determine Billy's *Constructive argument* intentions based only on his own previous experience and Billy's actions. The flogging of the *Refutation #1* after-guardsman and the harassment of Billy were not unusual punishments, and though the attempted *Refutation #2* entrapment and subsequent lies compromise Claggart's honor, they are not sufficient to earn for him the label "evil."

Shelton 2

*Constructive
Argument
Developed*
The first condition that must be considered
when judging Claggart is that, prior to the narra-
tion, there were mutinous events both at Spithead
and at the Nore. It is difficult to determine how
many of the *Indomitable*'s crewmen were aware of
these events, but the ship's officers and Claggart
knew of them. This knowledge must have made Clag-
gart, the individual responsible for the ship's
security, vigilant toward determining any signs
of rebelliousness among the crew, especially
since there were a number of impressed sailors
on the ship.

Another consideration is Claggart's history.
Claggart started off his navy career rather late
and at the most menial position. His abilities were
soon recognized, and he was promoted to master-at-
arms. There is no indication that his superior of-
ficers had any regrets about his promotion to this
position or any displeasure with his performance
in it. However, Claggart was not liked among the
crew, as evidenced by the many rumors from the men
concerning his background. However, even the narra-
tor admits "that no man holding his office in a
man-of-war can ever hope to be popular with the
crew" (27).

Thus, Claggart is a petty officer who has
worked his way up from the most junior naval posi-

tion. He is in charge of the ship's security in a
time of war, when there have been two known major
mutinies led by impressed sailors. He is respected
by his superiors, hated by the ship's crew, and
has numerous impressed sailors aboard his ship.
Into this scene enters impressed merchant seaman
Billy Budd.

Before Billy is even aboard the *Indomitable,*
he has probably alerted the suspicion of Claggart.
For as he is leaving the merchant ship, he stands
up and, waving his hat to his former shipmates,
calls out, "And good-bye to you too, old *Rights-
of-Man*" (10). Billy's words could easily be taken
to have a double meaning in reference to his im-
pressment and resulting loss of freedom. In addi-
tion, Claggart would probably view such undisci-
plined actions as representing individuality,
something that is not accepted in military environ-
ments. Claggart could have felt that it was his
duty to break down Billy and rebuild him as a mili-
tary sailor.

There are other events that add to Claggart's
suspicion toward Billy. Upon his being mustered
into naval service, Billy is asked about his ori-
gins. Billy replies to the officer that he knows
neither of his birthplace nor who his parents were
(13). Billy's ability to endear himself to the

Shelton 4

ship's crew so quickly is certainly no crime, but
it is unusual. This ability to gain such influence
over the crew would have to be of concern to Clag-
gart. Could Billy sway the crew to violence if he
desired? Claggart may have thought so.

Refutation #1 Some of Claggart's actions do need to be ad-
dressed. The day after Billy was impressed, he wit-
nessed the flogging of an after-guardsman. Claggart
issued this punishment because the after-guardsman
had left his assigned post and created a situation
in which the ship had to make difficult and danger-
ous maneuvers suddenly. Claggart did not have to
use such a heavy-handed punishment. Yet this dere-
liction of duty could have resulted in serious con-
sequences. Furthermore, the punishment had the nec-
essary effect on the crew, as evidenced by Billy's
reaction. Upon witnessing the punishment, Billy
vowed never to allow himself to be in a position to
receive such a punishment.

Obviously, Claggart was harassing Billy by
having him cited for minor offenses that Claggart
himself had manufactured. However, this is common
in the military. Citing someone for minor offenses
is a way of testing one's mettle. Being tested is
part of becoming a soldier. This is not to say that
all of the corporals were just in their actions.

Shelton 5

Squeak, in particular, fuels Claggart's suspicions
of Billy by inventing falsehoods made about Clag-
gart by Billy.

Eventually, Claggart's suspicions get the best
of him, and he tests Billy's loyalty. He arranges *Refutation #2*
for Billy to be invited to join a fictitious mutiny
planned by other impressed sailors. However, the
planned entrapment neither succeeds nor fails com-
pletely. Billy, when he is approached, reacts with
loyalty and threatens the supposed mutineer. How-
ever, Billy does not report the incident to anyone.
Claggart has to assume that this reaction is that
of a sympathizer. If Billy's loyalties were to
duty, he would have reported the mutiny plan. Clag-
gart now must report his suspicions of Billy to
Captain Vere.

It is at this point that Claggart does both
himself and Billy wrong. He does not report the in-
cident to Vere as it happened. He does not want to
implicate himself in trying to entrap Billy. So he
outright accuses Billy of dereliction of duty while
the *Indomitable* pursues a French warship, in addi-
tion to his conspiring in a possible mutiny. Vere
is skeptical of the accusations and rightly allows
Billy to confront his accuser. Billy, however,
finds himself unable to verbally defend himself and

Shelton 6

strikes Claggart, causing his death. Whether Clag-
gart's death was intended or not, the fact that
Billy, an underclassman, has struck Claggart, a
petty officer, during a time of war would require
Captain Vere to execute Billy in order to maintain
discipline on the ship.

Conclusion The narrator's attempt at portraying Claggart
as evil incarnate works well until the reader tries
to see the situation from Claggart's point of view.
Claggart is a military man. He is on a military
ship during a war. Is he harsh and suspicious, per-
haps even paranoid? Yes, he probably is. Does he
act less than honorably? Yes, he crosses the line
when he tries to entrap Billy and later falsely ac-
cuses him. Is he evil? No. He was just doing his
job as well as he knew how.

Shelton 7

Works Cited

Melville, Herman. *Billy Budd and Other Tales*. New
 York: Signet, 1998.

In the following argumentative essay, student Trey N. Magee argues with literary critic Louis Simpson about the causes and cures of the neglect of poetry in the contemporary world. Notice that, whereas most essays in the humanities are written in third person, this one is written in first person because Magee considers himself to be a representative of the public whom, Simpson says, poets should not concern themselves with pleasing.

EXERCISE 4-2

Find the stated counterthesis, counterpoints (if there are any), thesis, and points of proof in the following essay. Tell whether each point of proof is a refutation or a constructive argument. Show where each point of proof begins development.

4.3 "Now voyager sail thou forth to seek and find." Walt Whitman. Photographed 1879. © Bettmann/Corbis

Magee 1

Trey N. Magee

Professor Don Eron

Contemporary Poetry

October 18, 1999

On Walt Whitman, Bette Davis,

and the Neglect of Poetry

In the contemporary world of poetry, there is a debate regarding the relationship between the poet and the public, a relationship where the poet is torn between the need to find an audience and a desire to write, uncompromisingly, the best he or she can with a total disregard for the consequences of critical opinion. In his essay "On the Neglect of Poetry in the United States," Louis Simpson contends that the poet should be neither constrained nor corrupted by trying to please the public. Only by disregarding the public can the poet remain true. He goes on to insist that poetry itself should stand alone, that to incorporate it with other art forms, especially performance art, in a quest to broaden poetry's appeal is useless. Great poetry, he says, needs no assistance (85-93). While certain aspects of Simpson's argument certainly have merit, it is in his negative assessment of the role other art forms play in expanding poetry's appeal that he falters. Today, great poetry does indeed need assistance.

Magee 2

To begin with, the intellectual audience of to-
day grew up with poetry as a fringe element of its
education and, as a consequence, poetry became in-
creasingly esoteric and lost its relevance as an
art form of much importance to the educated public.
Second, the great poets of the past to whom Simpson
refers—Chaucer, Milton, Whitman—unlike the poets of
today, never had to compete with the new artistic
media or modern culture—a competition Simpson ad-
mits the poet would lose. Finally, no matter how
great a work of poetry may be, it cannot regain its
cultural importance if it remains locked within the
confines of academia.

Today's audience of general intellectual inter-
est, of which I am a part, grew up with the notion
that poetry was a noble and beautiful art form but
never seemed to get past that point. We were not
schooled in poetry's history, rhyme, or meter and
could not venture to tell you why a poem was good,
fair, or poor, much less great. We simply were not
exposed to poetry enough to acquire the skills
needed to appreciate what was deemed "great." Basi-
cally, it was something that had to be slogged
through and endured. Robert Frost was an exception
whose "Stopping by Woods on a Snowy Evening" gave a
glimmer of hope to the poetically challenged fifth
grader. That same fifth grader was soon thrown

Magee 3

hopelessly back into apathy with Wallace Stevens's
puzzling, yet whimsical, "Bantams in Pine-Woods,"
a great poem in our young minds for no other reason
than that our teacher said so. No other explanation
needed. And yet an explanation was needed; without
one we stopped caring, and poetry ceased to matter.
This indifference was implanted then and remains
now. How can we overcome it? How can we reignite an
interest in something that has the capacity to
touch us deeply and speak so eloquently about our
lives? In short, how can we begin the process of
rediscovering poetry?

In his essay, Simpson maintains that great po-
etry alone will set us on the road to rediscovery:
write it, and we will come. It is both simplistic
and quixotic to believe, as Simpson does, that "the
way to overcome the present neglect of poetry is to
write great poems" (91). He does not take into con-
sideration that the majority of the educated public
no longer knows what great poetry is. Ignorance
plays a bigger role in poetry's fall than Simpson
may realize. A great poem, written by a poet with
no concerns other than beauty, meaning, and truth,
is not going to miraculously appear at our bedside.
Something has to get it there; something has to
pique our atrophied interest. This is where other
art forms can have a positive effect. Dana Gioia

Magee 4

expressed this issue in his work *Can Poetry Matter?*
Gioia writes that integrating poetry with the media
of other art forms, such as music, has the poten-
tial to reach that critical, culturally influential
audience that would otherwise remain distant from
poetry. This audience, representing "our cultural
intelligentsia," is composed of the people who sup-
port the arts and concern themselves with their in-
fluence on our society (18). It is also the audi-
ence poetry has lost but that remains faithful to
other art forms.

Simpson and I do agree upon the role of poetry
as performance art. I, too, believe that a great
poem does not have to rely on gimmicks to find or
keep an audience. My purpose here is to suggest
possibilities of creating a broader appeal for po-
etry by using other, more popular art forms, and
not to advocate the fusion of poetry with those art
forms. Integrating poetry with these other art
forms can expose individuals to its beauty in ways
that poetry alone has failed to do. I am lucky
enough to have benefited from such a situation. One
sleepless night many years ago, I was watching an
old Bette Davis film, *Now Voyager*. At a turning
point in the film, a Whitman poem was read. It was
a very short, seemingly ephemeral poem, and yet I
was struck by its message and beauty. The classic

Magee 5

film itself paled in comparison to Whitman's haunt-
ing poem. Unable to forget it, I soon found myself
scouring the shelves of the public library in
search of a poem whose title I didn't know. Before
long I stumbled upon an old edition of Whitman's
Leaves of Grass. There, buried in the middle, was
"The Untold Want." I had found it. With that single
poem, I discovered the possibilities of poetry. But
it was film that got me there. I discovered Whitman
through Bette Davis. Go figure. Simpson would say
that my sentimental little story, touching as it
may be, is irrelevant. So what if one or two con-
verts to poetry are found? It's nice that someone
is listening, but that is secondary to the true
purpose of poetry: greatness. I ask, what good is
greatness if it has no impact?

Another interesting aspect of Simpson's essay
is his reverence for the great poets of the past
and their consideration of the public as secondary
to their writing. He says that to Dante, Chaucer,
Milton, Wordsworth, Whitman, Yeats, and Eliot,
among many others, the act of writing reigned su-
preme over important matters such as politics, phi-
losophy, and religion. Public opinion was of sec-
ondary importance. But poets and their great works
were read and discussed at a time when poetry made
an impact—a time when poetry was a staple of the

Magee 6

intellectual diet. They had the luxury of not being
completely overshadowed by television, movies, rock
'n' roll, and the computer revolution. Great poets,
such as Lord Byron and Walt Whitman, could be sub-
jects of great and heated debate within the higher
circles of society as well as being relatively well
known to the general population. Those days are far
behind us. Today, would they be great poets? Most
assuredly so. Would they be famous? I doubt it.
Would the "audience of general intellectual inter-
est" be thrilled or shocked by their poems? Highly
doubtful. Today, we do not care. The phrases "cre-
ated a literary sensation" and "turned the poetry
world upside down" are almost comical in their in-
nocuous implications for our culture.

Today poetry lies in the shadow of other art
forms in its cultural importance, unable to reach a
society incapable of listening. It must break free
and show its splendor to more than its creators,
more than its critics. It must find a way to be
heard again, for if it does not, it is doomed to
remain locked away in the institutionalized con-
finement Louis Simpson abhors, tragically resplen-
dent in its unheard beauty.

Magee 7

Works Cited

Gioia, Dana. *Can Poetry Matter?* St. Paul: Graywolf,
1992.

Simpson, Louis. "On the Neglect of Poetry in the
United States." *New Criterion* Sept. 1991: 85–93.

REVISING AND EDITING YOUR ESSAY

Use the following checklist to be certain that your essay is ready for submission. Consult the Handbook at the end of this book for guidance in issues of sentence structure, grammar, punctuation, mechanics, and style.

REVISION AND EDITING CHECKLIST

☐ Thesis is clear and present. It makes an argumentative statement—a statement with which a rational, educated person might disagree. The thesis is narrow and specific enough to be adequately supported in the space of the paper but general enough to need support.

☐ Introduction contains specific details. It leads the reader to the thesis; it does not lead the reader to believe the essay will be about something it is not about.

☐ Introduction contains a counterthesis and counterpoints, and it clearly identifies opponents.

☐ Points of proof are clear and present. Each point answers the proof question. Each point is narrow and specific enough to be supported adequately in one to three paragraphs and general enough to need support.

☐ Points of proof include refutations of all the counterpoints.

☐ Essay adheres to the essay plan set out in the points of proof.

☐ Body paragraphs are unified (containing one and only one topic sentence), adequately developed (containing evidence in support of topic sentences), organized, and coherent (containing appropriate transitional expressions).

☐ Conclusion finds a way to solidify the essay's main point without resorting to mere repetition of the thesis and points of proof. It is unified and developed and does not bring up any new issues.

☐ Sentences are well constructed. There are no run-ons or fragments. Sentences are correctly punctuated.

☐ Words are correct and well chosen.

☐ All quotations use acknowledgment phrases.

☐ Sources are correctly cited in text.

☐ Title is appropriate.

☐ Paper is properly formatted.

WRITING THE EXAMINATION ESSAY

CHAPTER PREVIEW

The in-class essay examination can be an anxious experience for any student; the best remedy is to be ready. How do you prepare for an essay exam? How do you order your thoughts and write a unified, adequately developed, and coherent essay during a single class period? The following strategies will help you prepare for and succeed in taking such an exam.

PREPARING FOR THE EXAMINATION

The best way to ready yourself for a humanities essay exam is to review the material regularly. There is simply no substitute for rereading passages in the text and making notes on what you have read.

STUDY CHECKLISTS

Study checklists, like the one that follows, are useful for defining the scope of the essay exam. What must you read to be adequately prepared? With what specific subjects must you be familiar before going into the exam? As you complete your reading and mastery of subjects, mark a check on your list.

STUDY CHECKLIST: HUMANITIES EXAM

Readings
- ■ Cunningham/Reich: Chapter 21 ____
- ■ Calvin Tomkins handout ____
- ■ Hudson/LeClair: Chapter 5 ____
- ■ Lecture notes 3/5–3/21 ____

Subjects
- ■ Cubism: Picasso, Braque ____
- ■ Fauvism: Matisse ____
- ■ Futurism: Boccioni ____
- ■ Expressionism: Munch, Kirchner ____
- ■ Nonobjective: Kandinsky, Mondrian ____
- ■ Metaphysical: de Chirico ____
- ■ Dada: Duchamp, Ernst, Grosz ____
- ■ Surrealism: Miró, Klee, Magritte, Dali ____

TWO-COLUMN NOTES

Two-column notes are particularly effective for exam preparation and review. Draw a line down the center of a piece of paper. In one column, you might write a question; in the other, the answer; or in one column, a vocabulary word; in the other, its definition; and so on. These notes allow you to see answers and relationships at a glance.

NOTES FOR HUMANITIES EXAM

Question	Answer
Vocabulary word	Definition
Main idea	Subordinate idea
Character	Description
Opinion	Proof
Quotation	Response

FLASHCARDS

Flashcards can help you remember key figures and concepts. You might use colored cards for different periods or styles. For example, you could use yellow cards for Greek sculptures and blue cards for Roman sculptures.

5.1 Myron, *Discobolus*, Roman marble copy
of Greek bronze, ca. 450 B.C.E. Copyright
Alinari/Art Resource, NY.

BACK OF FLASHCARD

> *Discobolus (Discus Thrower)*
>
> *Myron*
>
> *Roman marble copy of Myron's Greek bronze of*
> *ca. 450 B.C.E.*
>
> *Like bronze Zeus of ca. 460 B.C.E., discus thrower captures ideal mo-*
> *ment when mind guides body's action. Aristotle's notion of excellence:*
> *will ruled by reason. Symmetry; outer poise and inner dynamism; noble*
> *grandeur*

STRATEGIES

- Ask your instructor what to expect.
- Make up your own exam and take it.
- Study with a classmate or a small group of serious-minded classmates.
- Do not be nervous; be ready.

TAKING THE EXAMINATION

BEFORE YOU BEGIN WRITING

- Listen to verbal instructions as the test is distributed; you do not want to miss any special directions or helpful hints.
- Read the written instructions carefully.
- Take time to scan the entire exam.
- Consider the importance of each section and gauge your time appropriately.
- Make notes in the margins as ideas occur to you; you do not want to lose a thought or a connection that may come in handy.

PREPARING TO ANSWER THE ESSAY QUESTION

- Underline key terms, as shown in the following sample essay questions:

 Select two sculptures, one from the Greek period, and one from the Roman period. Compare the two sculptures, and include the narrative behind each work. Discuss how they reflect their particular styles.

 What is the appeal of Castiglione's "l'uomo universale" in his Book of the Courtier? How are the qualities he finds important the same or different from qualities you find important?

 Identify the three artworks shown and name the artists. The early twentieth century was a time in which traditions in art were rejected, even violated. Briefly describe the circumstances that brought about this break with the past. Discuss how each artist created a new vision for a new time.

- Create an outline for your answer. The following outline would work for the preceding essay question on early twentieth-century art.

> I. Identify artworks and name artists
> II. Describe circumstances
> III. Discuss new visions
> A. Artist 1
> B. Artist 2
> C. Artist 3

- Consider your audience. Even though your instructor will read and grade your essay, it is advisable to write as though you were communicating with a less knowledgeable audience. If you think of your reader as someone who does not know the material intimately, you are likely to explain your answer more thoroughly.

WRITING THE ESSAY

- Get to the point. Skip vague and general introductions, such as "There are a number of interesting ways to look at this question," or "Throughout Western history, art has gone through numerous changes."
- Stick to the question. Reread it as often as you must to avoid straying from the point.
- Answer all parts of the question.
- Be specific. Every time you write a general statement, take time to include specific details that illustrate or support that generalization. For example:

> Miró summoned the unconscious mind to create hieroglyphic, hallucinatory images. His *Person Throwing a Stone at a Bird* is truly a journey into the interior, in which a fantasy figure with one very large foot faces what looks like an elemental rooster. A straight line and a curved, dotted line seem to direct the action of the painting as a stone, thrown by the white, partially formed body, is on a trajectory toward the startled prey.

- As you write, leave space to add further information.

STUDENT EXAMINATION ESSAY

QUESTION:

Identify the three artworks shown and name the artists. The early twentieth century was a time in which traditions in art were rejected, even violated. Briefly describe the circumstances that brought about this break with the past. Discuss how each artist created a new vision for a new time.

5.2 Pablo Picasso, *Les Demoiselles d'Avignon,* 1907. Oil on canvas. Museum of Modern Art, New York. Acquired through the Lille P. Bliss Bequest. (333.1939) Digital Image © The Museum of Modern Art / Licensed by Scala/Art Resource, NY. © 2004 Estate of Pablo Picasso/Artists Rights Society (ARS), New York.

5.3 Marcel Duchamp, *The Bride Stripped Bare by Her Bachelors, Even (The Large Glass)*. Oil and lead wire on glass. © Philadelphia Museum of Art/Corbis: Bequest of Katherine S. Dreier. Photo by Graydon Wood, 1992. © 2003 Artists Rights Society (ARS), New York/ADAGP, Paris/Succession Marcel Duchamp.

5.4 Joan Miró, *Person Throwing a Stone at a Bird*, 1926. Oil on canvas. Museum of Modern Art, New York. Purchase. (271.1937) Digital Image © The Museum of Modern Art / Licensed by Scala/Art Resource, NY. © 2004 Successió Miró/Artists Rights Society (ARS), New York.

ANSWER:

Student Name: Liam L. Collyer

Tradition Busters

When avant-garde artists burst on the scene in
the early twentieth century, rejecting time-honored
traditions in art, such as the academic standards
of line, perspective, and imitation, the new age
was exploding in diverse ways of looking at the
world. Cross cultural influences, scientific dis-
coveries, technological innovations, psychological
theories, and the traumatic effects of the Great
War all contributed to a world breaking free from
the past. Pablo Picasso's *Les Demoiselles d'Avi-
gnon*, Marcel Duchamp's *The Bride Stripped Bare by
Her Bachelors, Even*, and Joan Miró's *Person Throw-
ing a Stone at a Bird* are three supreme examples of
how early twentieth-century artists invented rather
than represented the new world they faced.

If any one painting forecast a new style and a
radical break from the past, it was Picasso's *Les
Demoiselles*, depicting five female nudes. Of
course, the female nude group in itself was nothing
new; Titian's *Pastoral Concert*, Rubens's *Rape of
the Daughters of Leucippus*, and Delacroix's *Death
of Sardanapalus* were long-accepted masterpieces,
describing an event and telling a story. Picasso's
fractured, fetish-like females are not so accessi-

ble. Instead, the viewer fixates on the hard-edged, contorted forms and expressionless faces, wondering how art that once served meaning could become art burdened with uncertainty. The influence of tribal art from Africa and Oceania, exhibited in Europe during the World's Fair in Paris, is clear in the striated, mask-like faces of the figures on the far right. In addition, the figures seem to have been disassembled, then hastily reconnected, as if Einstein's fluctuating universe of atomic particles were configuring into forms, then dispersing. Picasso thus evokes images that can no longer live in a literal or certain world, but in the subjective universe of an artist living in precarious times.

Marcel Duchamp did not pretend to live in a sane world where answers were readily available. New technology now included weapons of war capable of killing millions of soldiers and civilians, ostensibly out of nowhere. "Things fall apart," Yeats had written in "The Second Coming," and "the center cannot hold." Truly the world had gone mad, the dadaists proclaimed, and Duchamp assaulted all forms of convention and rationality in response. Between 1915 and 1923, he worked on his *Bride Stripped Bare*, an erotic and enigmatic piece that defies conclusive meaning. It is part painting on glass and part diagram of an elaborate machine, in-

cluding a water mill, a chocolate grinder, pulleys,
tubes, clamps, and prisms. The combustion-engine
"bride" occupies the upper half of the glass. The
nine "bachelors," differently shaped molds con-
nected by thin wires, occupy the lower half. One
can look at it for a very long time and not make
sense of it. In 1923, Duchamp declared it to be
"finally unfinished." Why should art strive to con-
vey meaning, it seems to say, in a cracked and
senseless world?

Whereas Picasso forged new ways of looking at
figures in time and space and Duchamp created a
technological conundrum that, for all its complex
bells and whistles, didn't function (and made no
apologies for it), Miró summoned the unconscious
mind to create hieroglyphic, hallucinatory images.
His *Person Throwing a Stone at a Bird* is truly a
journey into the interior, in which a fantasy fig-
ure with one very large foot faces what looks like
an elemental rooster. A straight line and a curved,
dotted line seem to direct the action of the paint-
ing as a stone, thrown by the white, partially
formed body, is on a trajectory toward its startled
prey. As if in a dream, the viewer engages in free
association, trying to decipher symbols and elicit
meaning, and although the picture is playful and
colorful, it cannot be passively enjoyed. Again,

representation has given way to a highly personal and emotional vision.

Early twentieth-century artists—cubists, dadaists, surrealists, and other visionaries—cast off conventions and challenged time-honored notions of what art is. Taking their cue from new discoveries and world events, artists such as Picasso, Duchamp, and Miró broke free from the past. They expanded the boundaries of appropriate subject matter, experimented with media, and invented new techniques, determined to shape rather than be shaped by the new century.

BEFORE TURNING IN THE EXAMINATION

- Save enough time at the end of the exam period to reread your answer.
- Add any applicable and appropriate information.
- Review and improve connections among your ideas.
- Correct any spelling or grammatical errors that you see.

WRITING THE REVIEW

CHAPTER PREVIEW

What is a *critical review?* How is it different from a *critical essay?* A **critical review** offers an *evaluation* or estimate of a work, an exhibition, or a performance. For example, during the semester, your instructor may ask you to review an art or photography exhibition, a musical performance, a theatrical production, or a film. Your class may visit a building designed by I. M. Pei, a permanent collection of pre-Columbian artifacts at a museum, a traveling show of works by Miró and Klee, or a gallery display of photographs by Annie Leibovitz. You may attend a Brahms symphony, a Verdi opera, a Joffrey ballet, a *lied* recital, or a jazz performance. You might take in a new play by David Mamet, or meet at the local movie house for a John Huston double feature. A review is your critical impression of that event. This chapter will guide you through the steps from attending the event and taking notes to polishing your review.

PURPOSE AND AUDIENCE

As a critic, your purpose is to articulate your impression of an exhibition, performance, or whatever artistic event you are reviewing for a general reading audience. Some readers are considering whether or not to attend an event and will look to the reviewer to discuss what the event had to offer and what it was lacking. Other readers may not be planning to attend, but are nonetheless relying on a solid review to present salient details and thoughtful commentary. What should show through, whatever your opinion of the event, is the love of the art.

TONE

Assume the *voice of authority.* Do not volunteer the information in your review that you are a novice at writing reviews. You are not being asked to misrepresent yourself here; you are being asked to become an authority, and as such, you are entitled to write as one. Ideally, you should study not only the particular work or works you are to review, but the artist's body of work, his or her biography, and reviews of his or her work. Realistically, few critics, even professional ones, can know everything there is to know about a work before they evaluate it. Still, they learn as much as they can, and then, when writing, they assume the voice of authority. This is what you must do.

Support your assertions. Your reader will not accept unsupported judgments. You must prove that your assessment is valid by supplying evidence. For example, critic Richard Hornby, in a review of a 1987 production of *King Lear,* claims the production was "hamstrung by David Hare's inept direction." In support of this claim, Hornby offers the example of "wretched blocking" that occurred when Lear brought in Cordelia's body: "Hare had [Anthony] Hopkins [who played Lear] place her on a table and then sit down behind it for his final speech, effectively disappearing from half the audience."[1] If you supply support for your opinions, as Hornby does, you too will command respect as a critic.

If you are dazzled by what you have seen or heard, do not rave. Be explicit. Consider the elements that have made the event superior. When mezzo-soprano Marilyn Horne made her debut in *Norma* at the Met in 1970, singing the role of Adalgisa with soprano Joan Sutherland playing Norma, opera critics responded with praise. In the following paragraphs, the *Time* reviewer first defines *bel canto* for the reader, then finds a way, through analogy, to describe the sound and thrill of these two women's voices:

> The essence of *bel canto* is making the vocally difficult sound delectable. Long, lung-stretching phrases, rococo trills, breathtaking leaps of voice slide into the air and ear with soft, summery ease and grace. The quintessential *bel canto* role is Norma, the most taxing female part in all opera. Giuditta Pasta, the first singer to try the part after Bellini created it in 1831, found it so difficult that the violins had to play out of tune to disguise her failures.

6.1 Sister druidesses. Joan Sutherland and Marilyn Horne in Bellini's *Norma*. Frank Dunand/Metropolitan Opera Guild.

Last week, New York's Metropolitan Opera offered a new *Norma* production with Joan Sutherland in the title role. Hardly had she finished her first duet with mezzo-soprano Marilyn Horne (as Adalgisa) than the audience began to cheer and occasionally stamp and yell. The enthusiasm was fully justified. Sutherland's voice warmed toward a soaring, languorous tenderness. Horne, making one of the greatest Met debuts, showed a vocal reach and richness that exceeded nearly everybody's grasp. In "Mira, O Norma," closing Act III, the two together floated along like two strings of a violin being stroked by the same bow. The way their voices blended and interwove produced moments of sheer delight— moments to justify opera and fleetingly suggest that the shaky conspiracy called civilization may actually be worth all the trouble.[2]

If you don't like what you have seen or heard, do not rant. Be fair. Consider whether you are attending a professional or an amateur event, and make sure your expectations are properly adjusted. Then decide what specifically failed to convince or move you. Charles Isherwood, writing for *Variety*, makes his position clear.

Oedipus Rex it isn't—"Oedipus wrecked" is more like it. The promising presence of Oscar winner Frances McDormand and talented up-and-comer Billy Crudup turn out to be mere bait for one of the more tortuous theatrical traps in memory. This new spin on the legendary Greek tale is a four-hour-long orgy of self-indulgence on the part of author and director Dare Clubb, bad theater of a kind that holds no ancillary rewards—no cheesy sets to invite titters, no histrionic

excesses to relish, just endless torrents of fake profundity and muddled mono-loguing, delivered with no small amount of dedication by a cast of sincere actors.[3]

STYLE

Several issues of style recur for the beginning critic. One of those issues is verb tense. Generally, write in *present tense* when reviewing plays, films, art exhi-bitions, buildings, or books, the idea being that the show is still running, the building still standing, the story or poem still able to be read. For events that happen only once, such as a concert, write in the *past tense*. Thus, in *American Beauty*, "Kevin Spacey *gives* a stellar performance," but last night at Lincoln Center, "Wynton Marsalis *gave* a stellar performance." Pay particular atten-tion to the tenses in which the sample paragraphs that appear later in this chapter are written.

Name the set designer, the costume designer, the composer, the author, the dancer, rather than refer to them generically. You would not write "the ac-tress who plays Cinderella . . ." but instead, "Emily Hagburg, who plays Cin-derella" Also, make careful distinctions between character and actor. Cinderella loses her glass slipper, but Emily Hagburg slides out of her slip-per gracefully as she runs across the stage. The first time you refer to an artist, use first and last names, such as Emily Hagburg. From then on, refer to that person as Ms. Hagburg or simply Hagburg, but never Emily.

ATTENDING THE EVENT

Before you attend an artistic event, you must inform yourself about the art, music, or play, so that you can write an authoritative review. You may think that all this preparatory work will take the fun out of the experience, but think again. Do you refrain from attending a Santana concert because you have al-ready heard the CD? Do you refuse to see Kubrick's *Lolita* because you have al-ready read Nabokov's novel? If anything, knowledge enhances the experience.

If you do not live in a city with a major museum or a center for the perform-ing arts, you can always attend shows at smaller galleries, local theaters, or a nearby university or college's fine arts department. Support the arts in your area, and you will find the opportunity to practice writing reviews.

AIDS TO APPRECIATING THE EVENT

WRITTEN MATERIAL

Almost any artistic event you visit will provide written material to enhance your appreciation of the art and artist. Although you want to record your own impressions of an exhibition or performance first, a brochure or cata-logue can provide you with valuable data for your review. A brochure from the Baltimore Museum of Art, for example, presents "Matisse in The Cone Collection," including biographical information on the artist, the milieu in

which he worked, his relationship with the Cone sisters, and details about his style, method, and aesthetic vision. A catalogue for a large exhibition (available for purchase) at the Walker Art Center in Minneapolis features "Noguchi's Imaginary Landscapes." The catalogue is essentially an art book, filled with scholarly writings and quality reproductions of works, that becomes part of your art library. In addition to picking up written material, spend some time reading the information displayed on the walls of the exhibition, and check out the museum's reading room, if it has one, for books that pertain to the exhibition.

Audio Aid

Large art exhibitions often offer audio programs to rent at a very reasonable price. The benefits of listening to some historical background and an informed description of selected works will outweigh the strain of toting around a cassette player and earphones. When you have had enough of the program, revisit the works with a new appreciation, and remember to view the works in the exhibition that were not discussed on the tape.

Taking Notes

Whether you are visiting an art exhibition or attending a concert, take time to read the accompanying text or program notes. In a notebook, or on index cards or a personal digital assistant, record your observations and responses to the works you want to review. Remember that you will need to jot down specific information, such as the title of the work, artist, date, medium, formal elements, and so on.

Capturing Your Impressions

Now that you have your notes from the event, it is time to settle someplace quiet and add other ideas that are whirling around in your head. Let your thoughts pour out without concern for spelling, punctuation, grammar, or organization. Try not to judge and censor your preliminary writing, no matter how wild or illogical it might be. You can edit later. If you censor your thoughts, you will not set them down on paper, and they will not be there for you to cultivate later. You might use a tape recorder to capture those initial impressions and reactions.

DRAFTING THE INTRODUCTION

If the introduction does not catch the reader's attention in the first couple of sentences, it has not done its job. First, the reader specifically wants to know what is being reviewed: title, artist(s), location, dates. Second, the reader wants to hear from you nothing routine or predictable, but what a serious and informed critic thinks about what he or she has witnessed.

Your introduction should meet the following criteria:

- Use specific names, times, and places.
- Have a sense of organization.
- Develop one controlling idea.
- Express an opinion in a full, declarative, defensible sentence.

CONTROLLING IDEA

One job of the introductory paragraph is to develop a single controlling idea. Without a controlling idea, the introduction lacks unity and organization, often lapsing into a series of choppy, unrelated sentences; in short, the review is already adrift in cold waters. You want to orient the reader, to provide appropriate background information that will prepare the reader for the ensuing thesis statement.

STATING YOUR THESIS

Another job of the introductory paragraph is to state the *thesis,* the claim that the reviewer intends to validate. Expressing an opinion is delicate work, but you have your notes. Look them over carefully and discover your overall impression of the event. Consider what assertion you can support with the details you have recorded. This is no time for weakness or waffling. "The concert was fabulous" or "The exhibition was interesting" just will not do. In one evaluative statement, tell what effect the work has created. All of the following sample introductory paragraphs end with a thesis statement that evaluates the work being reviewed.

FIRST IMPRESSION

David Dillon, writing for *Architecture,* capitalizes on his first impression in his review of the Lucile Halsell Conservatory in San Antonio. He describes his reaction to the façade, and then, entering the building, continues his analogy of a "prehistoric earthen tomb."

> First impressions can be as important in architecture as in real life, and at the Lucile Halsell Conservatory in San Antonio our first impression is of a prehistoric earthen tomb. Undulating stone walls converge at a narrow cleft in the earth, through which we pass cautiously and uncertainly, not knowing what lies beyond. Suddenly we are confronted by an open circular pavilion, made of raw concrete and containing only a single totemic palm tree. The experience is unsettling, more like an initiation rite than an entrance to a building.[4]

HISTORICAL CONTEXT

Another way to develop an introduction is to explain the historical context in which the work was conceived. For example, you might briefly discuss the theatrical history of a play, including earlier audiences' reception of it, the condi-

tions under which a choreographer created a dance, or the cross-cultural influences of wartime photographers. The following introductory paragraph by theater critic Robert Hofler focuses on the influence that earlier renditions of the play had on the director of *Princess Turandot:*

> Darko Tresnjak's *Princess Turandot* is not an opera, but it's nearly as funny as the over-the-top masterpiece that Puccini left unfinished at his death in 1924. Tresnjak has gone back to the original source material, Carlo Gozzi's 1762 tragicomedy *Turandot,* as well as *The Arabian Nights* and a few other classic chestnuts to fashion an adult fairy tale that recalls, at its best, the heyday of Charles Ludlam's Ridiculous Theatrical Co. There are no arias here, but *Princess Turandot* manages to sing up a storm of high and low comic notes.[5]

Other opportunities for the historical perspective include examining the lifetime work of an artist, a **retrospective,** paintings from youth to old age, for example. You might focus on a classification of art, such as sculptural hieratic heads through the ages, or on a theme, such as *film noir* cinematography in America.

SOCIAL CONTEXT

Some art is created to incite its audience, to deliver a message, or perhaps to change the viewer's mind. Peter Schjeldahl, writing for *The New Yorker,* reviews an exhibition whose subject is political art. In the opening paragraph, the reader immediately learns the artist's name, the title of the show, the location, and the date. Schjeldahl's position that most political art is bad art and that "every exception seems a singular miracle" is clear. He acknowledges such a miracle in the singular and subversive work of Gerhard Richter.

> "October 18, 1977," a suite of fifteen sombre paintings by Gerhard Richter, belongs to a tiny category: great political art. Both the rarity and the majesty of the work shine in "Open Ends," a multiplex array of mini-shows at the Museum of Modern Art. The last three grand decantings of the museum's collection, this exhibition addresses art since 1960; it will run until January 30th. Varieties of political art make up about a quarter of "Open Ends." The emphasis feels well timed. Today, politics is passé on the art scene, after three decades of countercultural rampancy. What was that about? What can it mean now? Because this is MOMA, which skims the cream of every tendency, the show's survey of political art—including sections entitled "Counter-Monuments and Memory" and "The Path of Resistance"—has more than a few high points. But it would be a scrappy affair without Richter's Saturnalian aura at its center.[6]

COMPARISON

The comparison is versatile. If you are reviewing an exhibition of cubists, your introductory paragraph might include a brief comparison of the different artists. Of course, you cannot cover every artist and mention every detail, so you will have decisions to make. Perhaps you will limit your discussion to two or three artists and focus on the formal elements of space, time, and motion. Then again, you might decide to focus on one artist, say, Picasso, and

compare one of his early cubist paintings, *Les Demoiselles d'Avignon,* with a later surrealist painting, *Seated Woman.* In music, you might compare the early compositions of Alban Berg with those of his teacher, Arnold Schönberg.

In an opening paragraph from *Dance Writings,* in a review titled "Toumanova in *Giselle,*" dance critic Edwin Denby compares the title-role performances of two ballerinas, Tamara Toumanova and Alicia Markova:

> Miss Toumanova with her large, handsome, and deadly face, her sword-like toe steps, her form positions, her vigorous and record-high leg gestures—and with her bold and large style of dancing—by nature makes a very different figure from delicate Miss Markova, whose star role in *Giselle* she undertook for the first time last night. Dancing at the Metropolitan as guest of Ballet Theatre in the familiar Ballet Theatre version (including Mr. Dolan as the star's partner), Miss Toumanova was very striking and was properly cheered. But Miss Markova's Giselle is still incomparable.[7]

Having stated his preference, Denby develops his thesis in subsequent paragraphs, showing his reader what Toumanova's Giselle lacked "last night," and what Markova's Giselle always seems to deliver.

6.2 Giselle dances in the Rhineland moonlight. Ballerina Alicia Markova in *Giselle.* Photographed ca. 1950
© Bettmann/Corbis

EXPECTATIONS DASHED

You may have expected to enjoy an event, but did not. Your reasons, or perhaps one major reason, for not liking what you came to see or hear may fuel an introduction. Following is an introductory paragraph of a 1928 review by Aaron Copland of a Stravinsky composition, in which his and the audience's expectations are clearly unmet:

> Oedipus Rex is Igor Stravinsky's most recent composition. Jean Cocteau made a new version of the Sophocles drama, which Stravinsky set as an opera-oratorio in two acts for a speaker, solo voices, male chorus, and orchestra. It was first performed last spring in Paris without stage action (as an oratorio) by the Russian Ballet. An audience that had come to be diverted by a spectacle and dancing was confronted with rows of singers in evening clothes who sang—none too well—an austere choral composition that proved far from amusing. Little wonder, then, that Oedipus Rex was coldly received. People on all sides could be heard regretting the old, familiar Stravinsky of Le Sacre and deploring what seemed to be an illogical volte-face on the part of the composer.[8]

Remember, the reverse also could be true. You may be expecting very little from an event and be utterly swept away. Be sure that your expectations are reasonable and informed. If you go to a production of Ibsen's Ghosts expecting a supernatural thriller, you'll be disappointed; more important, a review that complains about the disappointment will only reveal the critic's lack of preparation.

EXPECTATIONS SURPASSED

Marc Bridle concedes the difficulty of achieving Stravinsky's tempo markings in any given performance of the Rite of Spring. In this review, conductor Riccardo Chailly clearly rises to the occasion:

> For the wrong conductor (and often the right one), a performance of the Rite of Spring can be a nerve-shattering experience. It is one of the few works that leaves no margin for error, with many performances embracing catastrophe almost inevitably. Most collapse under the weight of Stravinsky's extraordinary tempo markings—even before the beginning of the sacrificial dance. This happened most noticeably at a Philharmonia concert some years ago when the conductor was Valery Gergiev. There, the tempi were so broad as to make rhythm irrelevant, with the work suddenly, and unexpectedly, plundered of its voltage. Not here, however. Riccardo Chailly's two Rites with the London Symphony Orchestra were both electrifying, with speeds (albeit short of Stravinsky's own metronome markings—but then everyone is) much faster than I have heard for a long time.[9]

QUESTION

You might ask your reader a provocative question. Christopher Bowen's review of Giselle, performed by the Northern Ballet Theatre, considers the challenges of reviving classical ballets. Bowen poses a question to the reader that

is relevant, answered in the thesis, and developed in the subsequent body paragraphs.

> Reinventing the classics is nothing new; in continental Europe, mainstream choreographers like John Neumeier, Roland Petit, and Mats Ek have been doing it for years. But the current trend for reinterpreting ballet's classical repertory which has lately gripped the smaller dance ensembles in Britain seems as much a product of market forces as of artistic innovation. This development makes a kind of sense, though. After all, if you don't have the resources to muster forty-eight swans or even a couple of dozen *wilis,* yet your audience is clamoring for the classics, isn't it better to completely re-form these ballets to suit the size and performing strength of your company rather than cut the old choreographic cloth to fit? Yes . . . and no.[10]

DRAFTING THE BODY PARAGRAPHS

Body paragraphs for the review, as in any essay, should be *unified, adequately developed, organized,* and *coherent.* These qualities of the successful body paragraph have been discussed in detail in Chapter One.

Now you must organize your notes into categories. If you have several notes regarding, say, the music in a film, you should probably plan to write at least a paragraph on that element of the film in your review.

Once you have decided what points your review will cover, you will write a body paragraph or two on each point. A review may touch on any or all artistic elements, but most reviews discuss in depth only a few of them. Following is a list of some of the more common elements discussed in reviews:

Art Exhibition	Music Concert	Play	Film	Dance
Theme	Theme	Theme	Theme	Theme
Artists	Musicians	Actors	Actors	Dancers
Curator	Conductor	Director	Director	Choreographer
Selections	Selections	Set design	Cinematography	Set design
Formal elements	Interpretation	Blocking	Editing	Interpretation
Medium	Instrumentation	Music/Sound	Music/Sound	Music/Sound
Design	Staging	Costumes	Costumes	Costumes
Lighting	Acoustics	Lighting	Special effects	Lighting
Style or "ism"	Style	Style	Style	Style

The following examples will be helpful for writing your own body paragraphs, providing models that demonstrate the development of a thesis.

THEME

The *theme* of a work is its central idea, the abstract concept or concepts made concrete through the elements of a work, whether they are features of a building, colors in a painting, imagery in a poem, or steps in a dance. Behind every artistic endeavor lies a specific intent whose elements have been selected and

arranged to convey that intent. In a short poem, a single theme may be developed, such as the *carpe diem* (seize the day) theme in Andrew Marvell's "To His Coy Mistress." A longer work may develop several themes, although there may be only one dominant theme. Because the artist's experience in conceiving the work likely differs from the viewer's experience in interpreting it, valid statements of the theme may vary.

In the following excerpt, art critic Lee Parsons discusses the theme of women in the sculptures, drawings, and paintings of Alberto Giacometti, exhibited at the Musée des Beaux-Arts in Montreal. Parsons explores Giacometti's obsession "to find the real through external appearances" from the artist's years with the surrealists to his association with Jean-Paul Sartre and the existentialists.

> From themes expressed through portrayal of the human figure, Giacometti began to use objects as representations of more abstract concepts. In works such as *Composition (Man and Woman)* (1926), included in the Montreal exhibit, he deals in abstraction with tormented relations, between men and women in particular. While it has been said that his attitude toward women was problematic, treating them as passive objects in his work, this obsessive interest manifested what was for him an inescapable pursuit of personal truth. Many of these works involve a figure or a dismembered appendage ensnared or precariously suspended. In this particular work, made of bronze, there are no such recognizable forms, but a dense sort of cage straining to hold the tumbling shapes constrained within. The evocation is of sensual danger and a desire for liberation.[11]

STRENGTH OF THE ARTIST

Your paragraph may focus on the outright mastery of an artist—painter, sculptor, architect, dancer, writer, musician, or actor—to affect the viewer. A paragraph in a review by film critic Pauline Kael focuses on the genius of actor Marlon Brando in *Last Tango in Paris,* who plays an expatriate American reacting to his wife's suicide and forming a torrid and tragic attachment to a French girl.

> Bertolucci has an extravagant gift for sequences that are like arias, and he has given Brando some scenes that really sing. In one, Paul visits his dead wife's lover (Massimo Girotti), who also lives in the run-down hotel, and the two men, in identical bathrobes (gifts from the dead woman), sit side by side and talk. The scene is miraculously basic—a primal scene that has just been discovered. In another, Brando rages at his dead wife, laid out in a bed of flowers, and then, in an excess of tenderness, tries to wipe away the cosmetic mask that defaces her. He has become the least fussy actor. There is nothing extra, no flourishes in these scenes. He purifies the characterization beyond all that: he brings the character a unity of soul. Paul feels so "real" and the character is brought so close that a new dimension in screen acting has been reached. I think that if the actor were anyone but Brando many of us would lower our eyes in confusion.[12]

A reviewer is the eyes and ears of a reader, and in a musical review, one must rely on the critic's capacity to describe what the artist does that is so remarkable. The following paragraph by Marty Rosen about Phil Woods's perfor-

mance at his University of Louisville Jazz Week 2001 concert gives the reader a sense, an earful, of jazz saxophone with a seamless ensemble:

> Next came the ballad "Body and Soul." Woods opened with an accompanied cadenza that roamed from register to register, sometimes high and achingly sweet, then suddenly plummeting downward to a barely husky baritone, fine-grained and seductive. When the ensemble joined in with a quiet surge of brushwork, bass tones, and hushed chords, Woods responded with a haunting exploration, full of warmth and wit, that peaked with a striking sequence of organ-like chords constructed from superbly controlled overtones.[13]

FORMAL ELEMENTS

Formal elements, such as line, color, shape, value, texture, space, time, and motion, even sound and smell, are the basic components with which artists create works. Writing about Sarah-Jane Selwood's luminous porcelain vessels, art critic Christopher Andreae discusses in the following paragraph from *Ceramics* the effect of line, shape, and texture on a wheel-thrown pot.

> From the observer's standpoint, the spiralling line, which is sometimes like a bone under skin, like water movement under the ice, or like a geological fault, asks for the pot to be turned and turned in the hands. You know that to take the whole form, the whole pot, must be explored, outside and inside. Sometimes Selwood makes her lines into what she calls a "deception." This opens up the question of what you know and do not know about a pot, thus intensifying its mystique and fascination. The rim of a vessel, for instance, may or may not indicate where the climbing spiral ends; sometimes it is resolved at the rim as a beak or lip, sometimes not. Or a pot viewed from one angle may seem to have no interruptive line at all. It is revealed only as the pot is turned; and where the line is least pronounced—subtly responsive as it is to the glassy, lucent quality of her celadon glazes—it may become visually merged into a play of shadows, lights, and reflections that the pot's responsive surface and form involve.[14]

MEDIUM

Medium refers to the physical materials used to create an artistic work, the means of expression, the substance through which art is communicated. David Bonetti, reviewing three shows at the Ansel Adams Center in San Francisco, describes the medium used by the featured photographers Alfred Stieglitz, Ruth Bernhard, and Michael Kenna.

> The works are all photogravures, a photochemical means of reproducing photographic imagery that results in refined prints that look as if they might have been made by a traditional print-making process like etching. The medium suits pictorialism, the style that aimed to win respect for machine-made photography, by making it look like fine art printmaking or even painting.[15]

STYLE OR "ISM"

The reader of a review should have a sense of the time and milieu in which the artist works. Discussing the style or "ism"—the principles or ideology

influencing the artist or group of artists—helps the reader to place the work or performance historically, culturally, and aesthetically. Christopher Knight, writing for the *Los Angeles Times*, describes a new "ism" born of an old Japanese aesthetic tradition:

> "Superflat" is the best name for an art movement since—well, since Pop, from which it descends. Name-wise Superflat has it all over mid-1980s Neo-Geo, its most recent conceptual cousin. The name is market savvy. It has retro-snap. It's wry. It takes the hoary critical arguments of the pre-Postminimal 1970s, which insisted on flatness as essential to the truth of painting, and gives them a shove: Oh, yeah? Superflat is more true. It's supertrue.[16]

COMPARABLE OR INFLUENTIAL ARTISTS

Drawing parallels with other or influential artists may help the review reader to make connections—that is, to draw on images, words, or sounds that are already familiar. David Bonetti, reviewing an exhibition at the San Francisco Museum of Modern Art titled "Ansel Adams at 100," discusses Adams's enormous popularity and the effort made to take at "fresh look" at the master's photographs. The "formalist" Adams produced images that may remind the viewer of other celebrated photographers.

> There are three images from around 1935 of grass growing out of the water in Tuolumne meadows, for instance, that look more like Harry Callahan's images of dune grass than work by Adams. And there are many images of objects focused on closely—stone formations, twisted tree trunks—that seem more like Edward Weston than they do like Adams, the photographer of panoramic mountain landscapes. Adams's awesome 1942 series of five images of Old Faithful—plumes of angry steam erupting against the sky—might remind you of Alfred Stieglitz's cloud studies, the experiments in abstraction Stieglitz called "equivalents."[17]

BEGGING TO DIFFER

You may not always see eye to eye with the majority of critics, and, of course, you are entitled to your opinion as long as you offer enough compelling reasons for your contention. Despite *West Side Story*'s ten Oscars and enthusiastic reviews in 1961, Pauline Kael did not jump on the bandwagon:

> The irony of this hyped-up, slam-bang production is that those involved apparently don't really believe that beauty and romance *can* be expressed in modern rhythms—for whenever their Romeo and Juliet enter the scene, the dialogue becomes painfully old-fashioned and mawkish, the dancing turns to simpering, sickly romantic ballet, and sugary stars hover in the sky. When true love enters the film, Bernstein abandons Gershwin and begins to echo Richard Rodgers, Rudolf Friml, and Victor Herbert. There's even a heavenly choir. When the fruity, toothsome Romeo-Tony meets his Juliet-Maria, everything becomes gauzy and dreamy and he murmurs, "Have we met before?" That's my favorite piece of synthetic mysticism since the great exchange in *Black Orpheus:* "My name is Orpheus." "My name is Eurydice." "Then we must be in love." When Tony, float-

ing on clouds of romance (Richard Beymer unfortunately doesn't look as if he *could* walk) is asked, "What have you been taking tonight?" He answers, "A trip to the moon." Match that for lyric eloquence![18]

DRAFTING THE CONCLUSION

Conclusions, like introductions, come in many shapes and sizes, but the controlling idea is still at their core. Without it, the conclusion may wander off into hazy speculation and general musing. Save some ammunition for the conclusion—comments that will give the reader a sense of your unique insight. Reiterate your overall evaluation of the event without merely repeating the thesis.

- Use a controlling idea.
- Use concrete imagery.
- Do not repeat points already covered.
- Give the reader a sense of closure.

The following examples will be helpful in developing your own concluding paragraphs.

BROADER IMPLICATIONS

One way to find common ground with your audience in a review is to set the event in a context that creates a bigger picture, a larger truth. Gene Santoro, writing for *Down Beat*, reviews Paul Simon's *Graceland*, praising its blending and interaction of styles as well as its provocative implications, all of which combine to make a broader, in this case political, statement about apartheid:

> Without ever making any direct political statements, without ever abandoning the infectious musicality that first drew him into this project, Simon demonstrates that apartheid—apartness—is not only racist and stupid but ultimately untenable in a shrinking world whose confluent cultures create cross-currents as rich as these. And by returning home for the last two cuts with Dopsie and Los Lobos, he brings us face to face with the implications of the music—and ourselves.[19]

QUOTATION

Quoting a well-known historical or literary figure in the concluding paragraph may dramatically enhance your own final remarks. Music critic Wes Blomster, reviewing a concert in which poet laureate Robert Pinsky joined the Takács String Quartet, begins his review with the sentence, "While smoke still rose from the ashes of World War II, Theodor Adorno asked whether, after Auschwitz, a lyric poem was still possible." The idea is taken up again in

his conclusion, which makes use of a quotation from Thomas Mann's *The Magic Mountain*.

> In 1924, at the end of *The Magic Mountain*, Thomas Mann, the German Nobel Prize winner and later also a refugee in this country, looked back upon the battle-fields of World War I and asked: "Out of this universal feast of death, out of this extremity of fever, kindling the rain-washed evening sky to a fiery glow, may it be that Love one day shall mount?" On Sunday, Robert Pinsky and the Takács left Boulder with some slight hope that, were we to stop in our tracks at this mo-ment, think what we are doing and readjust our priorities, a positive answer to Mann's question might be possible. It might be the arts—and not arms—that can save us.[20]

ACCOLADES

A conclusion is a good place to commend artists for a successful debut, a tri-umphant comeback, or, as in the example below, a deft treatment of difficult material. Andrew Druckenbrod, reviewing the Pittsburgh Chamber Music Project's presentation of Stravinsky's *L'Histoire d'un Soldat* [A Soldier's Tale], applauds the ensemble's handling of this intricate chamber work composed during World War I.

> The musicians . . . navigated this musically adventurous piece with aplomb. [Louis] Lev spun the tale rhapsodically and with edgy verve, while bassist Don-ald Evans held his ground as the important musical adhesive for the rhythmi-cally difficult piece. Particularly stunning were the chorales that had a splendid eeriness to them. It was the intended purpose of the concert to showcase Stravinsky's genius, and by all accounts the Chamber Project succeeded.[21]

POINT BACK TO THE INTRODUCTION

In the following concluding paragraph, film critic Roger Ebert returns to the idea that controls his introductory paragraph—that the simplistic mes-sage of glorious nature versus nasty urbanization in the film *Koyaanisqatsi* is a letdown. He then considers the problems that may really throw "life out of balance."

> *Koyaanisqatsi*, then, is an invitation to knee-jerk environmentalism of the most sentimental kind. It is all images and music. There is no overt message except the obvious one (the Grand Canyon is prettier than Manhattan). It has been hailed as a vast and sorrowful vision, but to what end? If the people in all those cars on all those expressways are indeed living crazy lives, the problem is not the expressway (which is all that makes life in L.A. manageable) but perhaps so-cial facts such as unemployment, crime, racism, drug abuse, and illiteracy—is-sues so complicated that a return to nature seems like an elitist joke at their ex-pense. Having said that, let me add that *Koyaanisqatsi* is an impressive visual and listening experience, that Reggio and Glass have made wonderful pictures and sounds, and that this film is a curious throwback to the 1960s, when it would have been a short subject to be viewed through a marijuana haze. Far out.[22]

FINAL IMPRESSION

If your mind is abuzz after reading the last page or exiting the exhibition hall or theater, your review might end with a description of your final impression. Frank Rich reviews Sam Shepard's *Fool for Love*, in which the myth of the American West is redefined by Shepard, if not detonated. Rich reflects that this play, like others in the playwright's prolific career, lingers in the mind long after the final curtain:

> It could be argued, perhaps, that both the glory and failing of Mr. Shepard's art is its extraordinary afterlife: His works often play more feverishly in the mind after they're over than they do while they're before us in the theater. But that's the way he is, and who would or could change him? Like the visionary pioneers who once ruled the open geography of the West, Mr. Shepard rules his vast imaginative frontier by making his own, ironclad laws.[23]

INVENTING A TITLE

An inventive title for your review not only attracts the reader's attention but captures the spirit and narrows the focus of the review. A review of an art exhibition called "Vermeer and the Delft School" will not be titled "Vermeer and the Delft School." Kenneth Baker's review title, "Why Vermeer Surpassed Peers," aside from its pleasant assonance, signals his intention to discuss what sets Vermeer apart from his contemporaries. Christopher Knight cleverly titles his review of the Superflat art movement "Flat-Out Profound." Anthony Lane titles his review of the film *Pollock*, "Floor Show," calling up an image of the artist's famous action paintings. Nicholas Howe, reviewing poet Seamus Heaney's translation of *Beowulf*, lifts a phrase from Heaney himself and titles his review "Scullionspeak."

PROFESSIONAL REVIEW

One way of learning to write scintillating reviews is reading the works of professional critics. In the following review from *Architecture*, Catherine Slessor critiques Frank Gehry's design and construction of three towers in Düsseldorf. Note that Slessor assumes her readership is interested in more than a simple travel-guide description of Gehry's work. She briefly offers information about Düsseldorf to lay the groundwork for her remarks. She then makes specific observations about Gehry's preliminary sketches, building materials, site plan, and computer-aided designs to support her claim that Gehry's structures are nothing less than curious, extraordinary, in a word, *funky*. When the reader comes to the end of the review, what Gehry's trio of buildings has to offer has been made entirely clear.

Digitizing Düsseldorf[24]

CATHERINE SLESSOR

Orderly, prosperous, and self-confident, Düsseldorf is one of Germany's richest cities. Its economy is dominated by financial wheeling and dealing, and its skyline by the towers of multinational corporations. But as if a tea dance had been gate-crashed by a can-can troupe, this sedate civic ambience has been ruffled by a trio of exuberant interlopers, deftly choreographed by Frank Gehry. The dance analogy is well rehearsed. Gehry's "dancing couple" headquarters for the Nationale-Nederlanden bank in Prague evoked comparisons with Ginger Rogers and Fred Astaire—one frothy swirling volume poised in a clinch with a suave partner—but this more recent project for a site on the edge of the Rhine is an altogether funkier affair.

While Ginger and Fred had to defer to Prague's 19th-century historic fabric by completing an existing city block, Düsseldorf's Zollhaven (Customs Dock) presented fewer contextual inhibitions. Formerly the site of warehouses, factories, and harbor installations, the area to the southwest of the city center is slowly being regenerated in a familiar pattern of urban recolonization. Gehry's brief was to provide speculative office space for the media, design, market research, and advertising firms that are expected to provide crucial impetus for economic and social regeneration of the neighborhood.

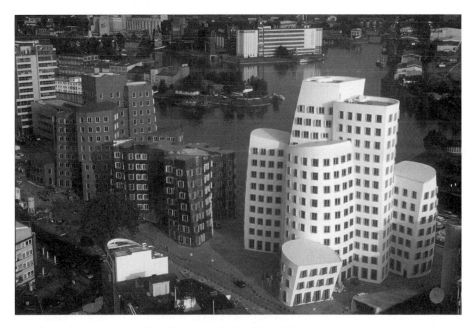

6.3 Gehry's tectonic tactile office complex in Düsseldorf. Frank O. Gehry, *Der Neue Zollhof*, completed 1999. Thomas Mayer/Das Fotoarchiv.

For all his inventive appropriation of computer technology, Gehry still re-
lies on the generative capacity of the sketch. His Düsseldorf project began life
as a blotchy black pen rendering of whirling, indeterminate forms quickly
captured on a paper napkin. This doodle has evolved into a trio of crumpled,
abstract blocks ("father, mother, and child," he calls them) each distinguished
and enlivened by different materials. The smooth white plaster of the largest,
a 13-story structure, alludes to the traditional material of Düsseldorf's urban
architecture, while the terracotta brick of the crystalline 11-story block is an
homage to the muscular dock warehouses that originally occupied the site.
Clad in smooth polished steel scales that irresistibly recall Gehry's titanium-
skinned Bilbao Guggenheim, the lowest structure, a seven-story block, is a
sensuously shimmering mirror that reflects its larger neighbors.

Although each is an individual object-building, the towers are carefully ar-
ranged so as to create public space around them and permit through-views
of the harbor basin and river Rhine. The site forms part of a long riverfront
walk that sweeps into the center of town, and is a highly popular local prom-
enade. On warm summer evenings it swarms with walkers, joggers, cyclists
and skaters. Gehry's contorted towers are an inevitable focus of attention, es-
pecially the polished steel skin of the lowest block, which prompts occasional
inquisitive fondling from passersby.

The translation of Gehry's ideas into built form is achieved through his now
familiar design and construction process: preliminary generative sketches—
which often defy conventional geometric organization—evolve into a long
series of handmade models. Then, using the CATIA program originally
developed for the French aerospace industry to represent complex three-
dimensional objects, the crude wood and cardboard models are scanned into
the computer and digitally translated back into working models and draw-
ings. The computer supplies all the data needed for the cut and structure of
the building's outer skin. Used as an instrument of translation rather than as
a generative device, the computer enables the representation and manipula-
tion of that which cannot otherwise be drawn. But it is still only a tool. As
Randy Jefferson, project principal on Düsseldorf notes, "Fifty years ago there
were only pens and pencils for architects. Just because you could buy a pen-
cil didn't mean you could create architecture. CATIA is not different."

Unlike the Guggenheim, which was built using a distorted steel frame cov-
ered with a lightweight curtain-wall façade of metal, glass, and stone—a
wrapped-up roller coaster—the Düsseldorf towers have solid, load-bearing
external walls made of reinforced concrete. (The Guggenheim's stone cladding
was also robotically milled.) Transcribed into reality through computer, the
precast panels have the exact shape of the design model and fit together pre-
cisely, despite their complexity. Computer-aided design has now become
computer-aided manufacture. Buildings can now be sculpted and customized
like car bodywork or aircraft wings.

Yet what makes Gehry's work so compelling is its capacity to raise the level
of the real to the realm of the ideal. As Düsseldorf shows, his buildings, for

all their calculated eccentricity, are essentially good-natured and capable of enlivening disregarded urban corners. Driven by a spirit of intuitive invention, his great gift is to challenge but not threaten, to generate order and disorder without tyranny. While other architects rush headlong into the sterile world of virtual space, Gehry's interest in computer technology is solely as a means of creating real, tactile architecture. He shapes rooms that can be used, figured spaces with centers that can be occupied, intimate alcoves and bay windows. (Though speculative office, the Düsseldorf towers retain an intrinsic domestic quality, like warped or melted apartment blocks.) He celebrates space and the surfaces that define it, and the primitive beauty of an architecture that is not about technology, but about building. Düsseldorf has a solid, crafted, tectonic quality; it is not simply flimsy scenography. As a narrative of process and culture that conveys a vigorous sense of both sculptural and surface beauty, Gehry's work constitutes an architecture at once timely and timeless, contextual and totally personal.

Source: Catherine Slessor, "Digitizing Düsseldorf," *Architecture,* v. 80, Sept. 2000: 118.

REVISING AND EDITING YOUR REVIEW

Most of your work is done—your visit to the event, your note taking, developing a central idea, writing an introduction, body paragraphs, and a conclusion, and inventing a title. Use the following checklist to be sure that your review is ready for submission. Consult the Handbook at the end of this book for help with grammar, punctuation, mechanics, sentence structure, and style.

REVISION AND EDITING CHECKLIST

- ☐ Review assumes the voice of authority.
- ☐ Thesis statement is clear, making an evaluative statement about the subject overall.
- ☐ Introduction contains specific details and develops a controlling idea.
- ☐ Body paragraphs are unified, adequately developed, organized, and coherent.
- ☐ Conclusion develops a controlling idea.
- ☐ Sentences are well constructed and correctly punctuated.
- ☐ Words are correct and well chosen.
- ☐ Verb tenses are correctly used.
- ☐ All quotations use acknowledgment phrases.
- ☐ Title is suitable.
- ☐ Review fulfills requirements particular to instructor's assignment, such as length and subject matter.

7

WRITING THE RESEARCH PAPER

CHAPTER PREVIEW

Writing research papers can be a daunting task but also one that affords students several opportunities and rewards. Most humanities students find their interests expanding exponentially as a result of their coursework, so there is no shortage of exciting possibilities for further research. You have the opportunity to assimilate and synthesize diverse bits of information into a commentary that is uniquely yours. Moreover, you have the opportunity to become an expert on some small piece of the universe of culture and civilization. This chapter will guide you through the planning, drafting, revising, and editing stages of your research paper, particularly through the tasks of researching your topic and documenting your sources.

Research paper is a general term for any of several types of papers that use sources. **Term paper** may be the more specific term for a paper that is required to fulfill the requirements of an undergraduate course. A **thesis** is a paper required in a graduate course. A **dissertation** is a paper written in pursuance of a doctoral degree.

The research paper is different from the critical essay in that it makes more conscious use of sources and relies more on them. Many papers published in journals such as *Studies in the Humanities* are research papers. Characteristically, the writers of these papers refer to each others' comments and observations as they pursue a particular idea about the humanities, thus expanding the discussion. You might use your sources in several ways: as corroboration of your own ideas, as a springboard for your own ideas, or as an opinion against which to argue. Ultimately, you will capitalize on ideas contained in previously published papers to advance your own.

PLANNING YOUR RESEARCH PAPER

CHOOSING AND NARROWING A TOPIC

Before you decide on a topic for your research paper, you need to understand your assignment clearly. A major consideration is the *mode of discourse* in which you are expected to be writing. Will your research paper be objective or subjective? If subjective, will it be analytical or argumentative? Your thesis statement must reflect your paper's main point as well as its mode of discourse. Consider the following examples:

Objective Thesis	Greece and the British Museum are in a dispute over the custody of the Elgin Marbles.
Analytical Thesis	Returning the Elgin Marbles to Greece would constitute a significant loss to the British Museum's collection.
Argumentative Thesis	The British Museum has no right to keep the Elgin Marbles.

The *objective* thesis promises an impartial paper, one that describes the dispute without taking sides. The *analytical* thesis promises a paper that will support the author's own idea about the effect on the British Museum if it were to lose the Marbles. This paper will not try to settle the dispute, however, according to this thesis. The *argumentative* thesis promises a paper that will take a side in the dispute and advocate a solution.

Your instructor may have a specific design in mind for your paper that combines the modes of discourse. For example, you may be assigned the task of writing about an artist's life and influences objectively and then analyzing

that artist's work, perhaps by interpreting the work or by speculating about the causes of the artist's choices or the public's reaction to the art.

Once you have settled generally on a topic, you will probably find that it needs narrowing. Some narrowing will come naturally as you begin the planning process, which entails formulating a thesis and points of proof. But you may be able to eliminate some material even sooner. For example, Emily O'Connor, the author of "The Elgin Marbles: Saved or Stolen?," realized that a paper that attempted to cover every argument for returning the Elgin Marbles to Greece would be book-size. A ten- to twelve-page research paper would have to be significantly narrowed. She finally settled on an argument regarding legal ownership, based on historical records.

RESEARCHING THE TOPIC

Once you have chosen and narrowed your topic, you will collect as many books and articles on your topic as time and practicality will allow. Your library, including its electronic databases that are accessible online, is likely to be your best resource; the World Wide Web will probably prove second best. For extensive instructions and advice on library research, consult *The Oxford Guide to Library Research* by Oxford professor Thomas Mann. <http://contentselect.pearsoned.com/research-writing.html> Remember: whether you are searching the library or the Web, allot yourself more time than you think you need. Research takes time.

SEARCHING THE LIBRARY

FINDING BOOKS

To find books, use the library's computer catalog. Search by **keyword;** that is, type in a word that will be contained in the title or the description of the book. For example, if you are writing a paper on Greek sculpture, you would type "Greek sculpture" as your keywords. The computer will then generate a list of books on that topic as well as each book's *call number* so that you can find it on the library's shelves. If there are too many choices, you will limit your search by using another keyword, such as "classical." A search at the library of the University of Colorado at Denver yielded a list of sixty-two books using the words "Greek sculpture." The list was reduced to twelve when the search was limited by the use of the additional word "classical."

FINDING PERIODICAL ARTICLES

Finding periodical articles can be a bit more involved than finding books. **Periodicals** are **magazines,** written for general audiences, and **journals,** which are written by and for authorities in a particular discipline. You might find an article on your topic in a magazine like *Newsweek* or in a journal like *Art*

History. To find periodical articles, you may use print indexes or electronic databases.

Print indexes: An **index,** in this context, is a list of articles that have been published in magazines and journals on any of thousands of topics. The best index in print for articles on the humanities is the *Humanities Index.* This is a series of bound volumes, dating from 1974 to the current year, which lists articles about art, architecture, theater, film, dance, literature, music, history, and philosophy. Use your library's computer catalogue to obtain the call number, and then locate the *Humanities Index* on the shelves of your library. When you have found the *Humanities Index,* you will see that the volumes are organized by year. Internally, each volume is organized alphabetically according to keywords. In the front of each volume is a key to the abbreviations.

If you see an article listed in the index that looks potentially useful, you must then locate that article. Your library's computer catalogue will tell you where to find the periodical; it may be collected on the shelves in a hard binding or stored in a condensed format on microfiche or microfilm. Once you have located the periodical, you will easily find the correct issue and the desired article. If your library does not collect the periodical you need, you can find out which libraries do and request a copy of the article via interlibrary loan.

Following are some of the more widely used print indexes for humanities research:

Annual Bibliography of English Language and Literature

Art Index

Avery Index to Architectural Periodicals

BHA: Bibliography of the History of Art

Film Literature Index

Historical Abstracts

The Humanities Index

MLA (Modern Language Association) International Bibliography

The Music Index

The Philosopher's Index

Reader's Guide to Periodical Literature

Religion Index

Electronic databases: Another way to search for articles on your topic is through your library's electronic databases. Each database contains lists of books, articles, and other resources such as audiotapes and videocassettes. Some contain the full text of the articles. You may have to be physically present in the library to conduct your search, although most college libraries give students and faculty an access code and password so that they can conduct the search from home. Some textbooks also include a subscription to an on-

line database. Wadsworth Publishing's textbook *Gardner's Art through the Ages*, for example, is packaged with an InfoTrac subscription card, an excellent research tool.

Although it is not practical to instruct you here on all the possible avenues for researching your topic through computer databases, the following information should be enough to get you started.

Start by selecting an electronic service, such as InfoTrac.

Searches are usually conducted using keywords, such as "Elgin Marbles." Some of the articles that you will discover are available in full text online. Make decisions about which ones you want copies of, and print those articles, or email them to yourself and look them over later. If the full text of the article you want is not online, you will need to go to the library to obtain the article.

FINDING NEWSPAPER ARTICLES

If your topic has been written about in newspapers, you might expand your search to include newspaper articles. Like periodical articles, newspapers are indexed in both print indexes and electronic databases.

Print indexes: Some of the more widely used indexes include the *New York Times Index,* the *Los Angeles Times Index,* the [London] *Times Index,* and the *Christian Science Monitor Index.* Using a call number, locate the index on the shelves of your library. Indexes for newspapers are organized in the same way as indexes for magazines and journals. Use a keyword, "Elgin Marbles" for example, to find articles that have been printed on that topic in any of several newspapers.

Electronic databases: In order to conduct a computer search for newspaper articles on your topic, seek the *National Newspaper Index* online. You might also use an electronic service that will search several databases for you. Two such services are *InfoTrac* and *Northern Light.* Once you have decided which articles you want, you may find that some of them are available in full text online. Others you will need to locate in the library, either in hard copy or on microfiche or microfilm.

EXERCISE 7-1

Using InfoTrac, locate the article "The Parthenon Marbles—Past and Future" by James Allan Evans. Copy and read the article, which provides intriguing insights into the controversy surrounding the sculptures from Athens's Acropolis.

1. When the Turks captured Athens in 1456, they built a mosque in the Parthenon, adding an architectural feature. Identify this distinctively Muslim feature.

2. The bronze horses atop the Arc de Triomphe in Paris are not French creations. Identify the source from which they came.

3. Identify the specific building belonging to the Erechtheion from which Elgin removed a caryatid.

4. James Stuart and Nicholas Revett are credited with having founded the Greek Revival style. In a brief response of twenty to forty words, summarize the impact that these men had on architecture, especially in the United States.

5. Britain is not alone in having pilfered artworks from around the world. In a brief response of twenty to forty words, comment on Napoleon's role in plundering artworks from the Italian peninsula.

For more exercises in art history research, see Thomson Learning's *InfoTrac® College Edition: Student Guide and Exercises for Art & Art History.*

SEARCHING THE WORLD WIDE WEB

The World Wide Web is another possible source of information on your topic, but you should realize from the start that the results of a World Wide Web search are often unsatisfactory. One reason is that articles retrieved from the Web are suspect. They may not have gone through the filtering processes of editing, peer review, and library selection. Also, there are far too many sources to manage. Fortunately, the best matches appear at the top of the list.

To begin a Web search, simply type in the name of the search engine you want to use and touch the *enter* key on your keyboard. Some popular search engines are *AltaVista, Excite, InfoSeek, Lycos, WebCrawler, Google,* and *Yahoo.* Some Web browsers will assume, if you enter the word "google," for example, that you mean <http://www.google.com>. Once you have the home page of your search engine on screen, you simply fill in the keyword in the search box and enter. The more words you enter, the narrower your search becomes, and the shorter the list of relevant Web sites becomes.

The ability to evaluate a Web site is useful. In the Web site address, also known as the **URL** (*uniform resource locator*), the suffix ".edu" denotes an educational organization, and these sources could be worthy of your attention. Web sites with URLs ending in ".com" are usually selling goods or services, but they can provide needed information. The suffix ".org" denotes a non-

commercial organization. Many of these Web sites offer useful, objective, and accurate information; however, many private organizations have an agenda: their purpose is to persuade their readers to adopt their position.

The Wadsworth Art and Humanities Web site <http://www.wadsworth .com/art_d/> provides links to useful arts and humanities Web sites. Another particularly worthy Web site is BUBL LINK Creative Arts, an excellent catalogue of reliable internet resources <http://bubl.ac.uk/link/art.html>. Following are just a few Web sites that provide useful and reliable information for academic research:

- About.com <http://www.about.com>
- The Academy of American Poets <http://www.poets.org/index.cfm>
- Art History Research Centre <http://art-history.concordia.ca/AHRC/index.html>
- Art Reviews: New York Art World Encyclopedia <http://www.newyorkartworld.com/mag/artreview.html>
- Artists' Pallets <http://www.fidnet.com/~rah/artists.htm>
- Artnet.com <http://www.artnet.com/>
- Cinema <http://www.theatrelibrary.org/links/Cinema.html#cinema>
- ClassicalLink.com <http://www.musicweb.uk.net/other.htm>
- Classical Music Page <http://www.classical-music-review.org/>
- Classical Music Web Guide <http://www.brothersjudd.com/webpage/classicalmusic.htm>
- EDSITEment—The Best of the Humanities on the Web <http://edsitement.neh.fed.us/>
- Fine Art—World Wide Arts Resources <http://wwar.com/>
- World Empires <http://www.pbs.org/empires/>
- Guide to Philosophy on the Internet <http://www.earlham.edu/~peters/philinks.htm>
- Humbul Humanities <http://www.humbul.ac.uk/>
- Internet Public Library: Literary Criticism <http://www.ipl.org/div/litcrit/>
- Literary Resources on the Net <http://www.andromeda.rutgers.edu/~jlynch/Lit/>
- Panic Encyclopedia: The Definitive Guide to the Postmodern Scene <http://www.freedonia.com/panic/>
- Voice of the Shuttle <http://vos.ucsb.edu/>

TEMPLATES FOR PLANNING YOUR RESEARCH PAPER

Use the templates on the following pages to plan your research paper. Refer to Chapter Three, "Writing the Analytical Essay," or Chapter Four, "Writing the Argument Essay," if you need guidance in filling in the blanks. Remember that the templates are a starting point for organizing your ideas and information, not a rigid mold.

OBJECTIVE OR ANALYTICAL RESEARCH PAPER OUTLINE

I. Introduction

 A. Introductory remarks (briefly)

 B. Thesis

 C. Points of proof (Fill in at least two blanks.)

 1. _____

 2. _____

 3. _____

 4. _____

 5. _____

II. Body (Develop each point of proof.)

 (Copy your points of proof from C above; there should be at least two.)

 A. Point #1 _____

 B. Point #2 _____

 C. Point #3 _____

 D. Point #4 _____

 E. Point #5 _____

III. Conclusion (briefly)

ARGUMENT RESEARCH PAPER OUTLINE

(Note: You may tailor this outline to your own needs, offering as many counterpoints, refutations, and constructive arguments as are necessary to prove your thesis. The number of refutations, however, should match the number of counterpoints.)

I. Introduction

 A. Introductory remarks ————————————

 B. Counterthesis ————————————————

 C. Counterpoints

 1. Counterpoint #1 ————————————

 2. Counterpoint #2 ————————————

 D. Thesis ——————————————————

 E. Points of Proof

 1. Refutation #1 ——————————————

 2. Refutation #2 ——————————————

 3. Constructive argument #1 ————————

 4. Constructive argument #2 ————————

II. Body (developed refutations and constructive arguments)

 A. Refutation #1 ——————————————

 B. Refutation #2 ——————————————

 C. Constructive argument #1 ————————

 D. Constructive argument #2 ————————

III. Conclusion ——————————————————

DRAFTING YOUR RESEARCH PAPER

Having researched your topic, taken notes, planned, and outlined your paper, you are ready to begin writing the paper. As you write, keep in mind the following advice:

- Incorporate the words of authorities who have written on the same or related topics.

- Synthesize sources of information to create a unique view of the topic.
- Give credit for borrowed words and ideas to their originators.
- Assume the voice of authority. You have read extensively and have assimilated much information on your topic. You are qualified to postulate a unique point of view.
- Do not let your sources speak for you.
- Use your sources to corroborate your own ideas, which you have written in your own words by means of your thesis and points of proof.

Paraphrasing versus Plagiarizing

Much of your research paper will consist of information gleaned from your sources and then paraphrased. To **paraphrase** is to relate your source's ideas, using your own words and style, and giving your source credit for those ideas *in text.*

To **plagiarize** is to commit one of the following mistakes:

- copying a passage word for word without using quotation marks
- merely substituting synonyms for the passage's original words
- merely rearranging the sentence structure
- presenting someone else's ideas or writing as your own

Consider the following examples. The original passage has been copied from an article written by David Rudenstine.[1]

Original Passage from Source

Indeed, as things turn out (and as somewhat surmised by Christopher Hitchens in his book *The Elgin Marbles*), the assumption shared by advocates on both sides of the debate—that the Ottomans gave Lord Elgin permission to remove the marbles—is no more than a grand illusion.

Plagiarism

The supposition made by people on both sides of the argument—that Lord Elgin had permission from the Ottomans to remove the Parthenon sculptures—is illusory.

The preceding paraphrase matches the original far too closely. The writer has made some word substitutions, but the paraphrase is illegitimate on at least three counts: the sentence structure and style are lifted from the original passage, and the writer has presented David Rudenstine's idea as his own.

LEGITIMATE PARAPHRASE

```
According to David Rudenstine, author of an article

titled "Did Elgin Cheat at Marbles?" there is

little basis for the belief that Lord Elgin was au-

thorized to take any sculptures from the walls of

the Parthenon (31).
```

INCORPORATING QUOTATIONS

Many writers make the mistake of overquoting their sources. You should quote only in certain circumstances:

- when the source's phrasing is so apt, so well written, that you could not possibly say it better yourself
- when it is important that the reader see the original words of the source.

If quoting is warranted, you must *weave* the quotations into your paper, not insert them awkwardly. Each quotation should be accompanied by an *acknowledgment phrase* that tells who is being quoted and offers an explanation of the relevance of the quotation. It is a mistake to present an unacknowledged quotation like the following:

UNACKNOWLEDGED QUOTATION

```
Elgin probably exceeded the permission granted by

the Turkish government. "There is a great differ-

ence, as many were later to say, between permission

to excavate and remove and permission to remove and

excavate" (St. Clair 90-91).
```

The reader does not know who is being quoted in this passage, only that the quotation was taken from page 91 of St. Clair's book. Besides, the quotation seems stuck in, not woven into the paper. Simply tacking a source citation onto the end of an unacknowledged quotation, as in the preceding example, is not sufficient.

ACKNOWLEDGED QUOTATION

> Elgin probably exceeded the permission granted by
> the Turkish government. William St. Clair, Elgin's
> biographer, explains the subtleness of Elgin's tres-
> passes: "There is a great difference, as many were
> later to say, between permission to excavate and re-
> move and permission to remove and excavate" (90–91).

This quotation is correct because it is introduced by an acknowledgment phrase that tells who is being quoted and indicates the pertinence of the quotation.

The first time you quote a source, offer that person's first name, last name, and credentials as well. In the preceding acknowledgment phrase, for example, William St. Clair is identified as Elgin's biographer. Afterward, you may refer to this person by last name only.

CITING SOURCES

There are several documentation systems for citing sources. The ones currently in favor for arts and humanities papers are the Modern Language Association (MLA) parenthetical notes system and the Chicago Manual of Style (CMS) numbered notes system. This textbook demonstrates both of these documentation systems.

MLA PARENTHETICAL NOTES DOCUMENTATION SYSTEM

The MLA system entails using in-text parenthetical notes, or source citations, plus a list of works cited. The following condensed instructions may be comprehensive enough for your paper on the humanities, but if they are not, please refer to the *MLA Handbook for Writers of Research Papers,* fourth edition, by Joseph Gibaldi. Although the MLA handbook is not available in its entirety online, many colleges and universities offer online summaries of the system, including OWL at Purdue <http://owl.english.purdue.edu/handouts/research/r_mla.html>.

MODELS FOR PARENTHETICAL SOURCE CITATIONS

The basic idea is that the source citation should point the reader to the first word on the left margin of the works cited list. You should cite

- all quotations
- any facts that are not widely available
- statistics
- any paraphrased or borrowed ideas

Standard source citation: List author and page number.

> When Egypt had been restored to the Turks, Elgin
>
> was honored in celebrations and given a jewel from
>
> the Sultan's own turban, diamonds, and horses (St.
>
> Clair 82).

Author of the quotation or borrowed idea has been named in the passage: Do not name the author again in parentheses.

> The retentionists' case is probably best articu-
>
> lated by Michael Daley, an artist and director of
>
> ArtWatch UK. Daley claims, "The marbles were not
>
> taken from the capital of today's Greece—the state
>
> was not formed until 1829—but from a small town
>
> that had for three and a half centuries been part
>
> of the Ottoman Empire" (51).

Source is an anonymous work or author is unidentified: Use the first word or two from the title of the source, plus the appropriate page numbers. If the source is an article, enclose the shortened title in quotation marks; if the source is a book, movie, or television show, underline or italicize (not both) the shortened title.

> Prime Minister Tony Blair has no plans to return
>
> the Elgin Marbles to Greece ("Britain" 16).

One source is cited in another

> "None," Hunt replied (qtd. in Hitchens 67).

Works cited page lists more than one work by the same author

> The 1937 British "cleaning" of the Elgin Marbles re-
>
> sulted in some surface damage (Daley, "Beware" 57).

Use a semicolon to separate multiple references for the same assertion

```
Lord Elgin explained to Parliament in hearings held
in 1816 that his motive in seeking permission to
carry away the sculptures was to save them from the
destruction of war and vandalism as well as to en-
hance the arts in England (Hitchens 47; 44).
```

Work with two or three authors: List the names in the same order that they are listed on the title page of the work.

```
(Bailey, Shea, and Estrada 252).
```

Work with more than three authors

```
(Hodges, et al. 67).
```

Two authors with the same last name: Include the authors' first names.

```
(Brad Eliot 313).
```

```
(T. S. Eliot 25).
```

Multivolume work: The volume number precedes the page number(s).

```
(Gray 2:98).
```

Reference to discontinuous pages: Use a comma (not a semicolon) to set off page numbers.

```
(Cook 1, 10).
```

Interview or other source without pages

```
(Dailey).
```

SPECIAL PUNCTUATION CONSIDERATIONS WHEN CITING SOURCES

In general, treat the source citation as part of the sentence.

Sentence ending in a period: The period follows the note.

```
The military governor, said St. Clair, "received
bribes equivalent to 35 times his official annual
salary in return for turning his eyes aside" (qtd.
in Cook 10).
```

Quotation ending in a question mark or exclamation mark: The end mark stays as set in the original, and a period follows the note.

> Benjamin Haydon reacted to Payne Knight's attempts
>
> to discredit the authenticity of the Marbles: "These
>
> are the productions which Mr. Payne Knight says may
>
> be original! May be!" (qtd. in St. Clair 257).

Indented quotation: The note should follow the final period.

> A letter from Lusieri to Elgin downplays the damage
>
> done to the Parthenon in removing a metope:
>
>> I have, my Lord, the pleasure of announcing to
>>
>> you the possession of the 8th metope, that one
>>
>> where there is the Centaur carrying off the
>>
>> woman. This piece has caused much trouble in
>>
>> all respects, and I have even been obliged to
>>
>> be a little barbarous. (Qtd. in Hitchens 30)

THE WORKS CITED PAGE

This is an alphabetical list of the sources you have cited in your paper. Consult the *MLA Handbook* for details not covered here.

The mechanics of citing electronic sources vary from source to source because the medium itself is relatively new and in a state of flux. One excellent online guide to citing electronic sources, however, is the Columbia Guide to Online Style <http://www.columbia.edu/cu/cup/cgos/idx_basic.html>.

A sample MLA-style works cited page is on page 189 of this textbook. As you study the page, please notice the following:

- The works cited page is double spaced throughout.
- The first line of each entry is at the left margin; subsequent lines of the entry are indented a half-inch.
- Titles of books, journals, and plays may be either underlined or italicized, but not both.
- Cities are not accompanied by states, unless the city is obscure or multiple states contain cities with that name.
- Names of the publishers are shortened to one word.
- "UP" means "University Press."

- Disregard the articles—*a, an,* and *the*—when alphabetizing works cited; use the second word for alphabetical placement, but do not re-arrange the words in the entry.
- Abbreviate all of the months, except for May, June, and July.
- Dates are organized as follows: day month year, with no commas.

Student Research Paper, MLA Style

The following research paper, "The Elgin Marbles: Saved or Stolen?" by Emily O'Connor, demonstrates the MLA system of documentation. The paper's mode of discourse is argumentative.

Notice that O'Connor fully explains the counterarguments before refuting them and that she presents them fairly. Notice also O'Connor's positioning of her constructive argument between her two refutations—an unusual choice, but one that works well in this paper.

7.1 Lord Elgin's men removed statues and reliefs from the Parthenon. The eastern facade, Parthenon, Acropolis of Athens, 447–432 B.C.E. Pentelic marble. Werner Forman/Art Resource, NY.

O'Connor 1

Emily O'Connor

Professor Charles Esquivel

Art History 4030

8 December 1998

The Elgin Marbles: Saved or Stolen?

If you are planning a visit to London's British
Museum in the near future, run, don't walk, to the
Duveen Gallery, which houses the Elgin Marbles, be-
cause these art treasures may not be there much
longer. The Elgin Marbles were collected, or
looted, depending on your point of view, during
the first decade of the nineteenth century. Greece
was occupied by the Turkish Ottoman Empire while
Great Britain, the Turks, Egypt, and France, among
others, were engaged in the Napoleonic wars. During
the confusion, the British ambassador to Turkey,
Thomas Bruce, also known as the seventh Earl of
Elgin, seized the opportunity to walk away with
several sculptures that had been attached to or
housed in the Parthenon and other buildings atop
the Acropolis in Athens. These Parthenon sculptures
constitute the nucleus of a wider collection of an-
tiquities called the Elgin Marbles. The Parthenon
sculptures now reside in the British Museum, but
Greece wants them back. Naturally, the British Mu-
seum doesn't want to give them up.

Introductory remarks

Counterthesis

O'Connor 2

Counter-point #1

The British Museum's case for retaining the sculptures is based on the belief that Elgin obtained permission from the Turkish government, which had been in control of the territory for 350 years. Moreover, the Marbles were given to the

Counter-point #2

museum by an act of Parliament only after an 1816 investigation by the House of Commons Select Committee into the circumstances under which the Marbles had been acquired.

Transition

Thesis

The case for a legal right to the Marbles, however, contains numerous flaws, nearly all of which can be ascertained from the historical records themselves. The British Museum should return the Elgin Marbles to Greece because the sculptures were never rightfully Elgin's, nor the British government's, nor the British Museum's. Elgin exceeded

Refutation #1

the authority he had been granted by the Turkish government—that is, if authority was ever granted at all. Elgin's actions also exceeded the authority granted him by the British government as an ambas-

Constructive argument

sador and violated British policies against plundering. Finally, Parliament's appropriation of the

Refutation #2

sculptures was an act of expediency, not justice.

The retentionists' case is probably best articulated by Michael Daley, an artist and director of ArtWatch UK. Daley claims, "The marbles were not

O'Connor 3

taken from the capital of today's Greece—the state

was not formed until 1829—but from a small town

that had for three and a half centuries been part

of the Ottoman Empire" (51). In 1801, the Porte

(the government of the Ottoman Empire) in Constan-

tinople allegedly granted Lord Elgin and his team

of artists permission by means of a document called

a *firman* to carry off the sculptures. The firman

granted sweeping rights to Elgin's men and required

that neither the Disdar (the military commandant of

the Acropolis) nor the Voivode (civil governor)

should "meddle with their scaffolding or imple-

ments, nor hinder them from taking away any pieces

of stone with inscriptions or figures" (qtd. in

Cook 56).

Elgin, however, probably exceeded the inten-

tions of the firman granted by the Porte. The fir

man permitted Elgin's men to excavate "the founda-

tions, in search of inscriptions among the rubbish"

(qtd. in Cook 56). That the firman allowed Elgin's

men to remove the sculptures from the buildings

themselves is doubtful. There is, as William St.

Clair says in his book *Lord Elgin and the Marbles*,

 a great difference [. . .] between permission

 to excavate and remove and permission to re-

 move and excavate. The first implies that one

*Counter-
point #1
fully
explained*

*Refutation of
counter-
point #1*

O'Connor 4

can take away anything of interest that is dug
up; the second lets one take away anything of
interest from whatever place one likes. (90)

The existence of the firman is also at issue.
Under a cloud of suspicion and scandal, accusations
of spoliation and political opportunism, Elgin was
requested to present the firman to the House of
Commons Select Committee in 1816, to which he ex-
plained that the original document had been given
to Ottoman officials in Athens in 1801. Yet accord-
ing to David Rudenstine, a fellow of Princeton Uni-
versity's law and public affairs program, no re-
searcher, including Rudenstine himself, has been
able to uncover the original document, despite the
wealth of other documents from the period contained
in the Ottoman archives (30).

Elgin said that he could not produce any docu-
ment that verified his authority to remove the
sculptures. And then, suspiciously, upon the real-
ization that some documentation was needed, the
Reverend Phillip Hunt, Elgin's embassy chaplain,
presented the Committee with what he said was an
English translation of an Italian translation of
the original Ottoman document (Rudenstine 32).
Parliament credulously accepted the document as
authentic.

O'Connor 5

Lord Elgin may have exceeded not only Turkish
authority to collect his art, he may have exceeded
British authority as well. Collecting art was not
part of the job of being an ambassador. Lord El-
gin's project, initially, was simply to hire a few
artists to make drawings and casts of the Acropolis
sculptures. But the British government never lent
its support to the project, refusing to pay the
salaries of artists, writing,

> I do not think that we could (at least from
> any funds at the disposal of the Foreign De-
> partment) defray *with any propriety* the ex-
> pense of that encouragement which a person,
> qualified as you mention, would be entitled to
> expect for such an undertaking (qtd. in St.
> Clair 8) [italics mine].

In other words, it simply was not proper for the
British government to fund art collecting on the
part of ambassadors. If Elgin wanted to collect
art, he would have to do so at his own expense.

Even though Elgin wasn't authorized by the
British government to collect art, he used his po-
sition as ambassador in the acquisitions. First, he
took advantage of a fortuitous turn of events in
the Napoleonic Wars. Napoleon had overcome Italy,
Austria, Spain, Russia, and Egypt. Only the British

*Constructive
argument*

O'Connor 6

and the Turks had successfully resisted his aggres-
sion. Napoleon attempted to reinforce his army in
Egypt, but the British and the Turks joined forces
and won back Egypt for the Ottoman Empire. Lord El-
gin was a very popular man in Constantinople, having
supplied food, horses, and various provisions to
the British forces collecting at Malta. When Egypt
had been restored to the Turks, Elgin was honored
in celebrations and given diamonds, horses, and a
jewel from the Sultan's own turban (St. Clair 82).

Elgin's embassy chaplain, Reverend Hunt, black-
mailed the Disdar into cooperating. Hunt complained
to the Voivode that the Disdar had treated Elgin's
party with disrespect and had demanded money from
them. The Disdar himself was ill, and so the
Voivode sent for his son, who had hopes of succeed-
ing his father to the office of Disdar. The Voivode
threatened to make the young man a slave as punish-
ment for his father's offenses. Hunt interceded,
obtained a pardon for the young man, and thus had
the new Disdar in his pocket. Hunt wrote to Elgin,
"He [the young Disdar] is now submissive to all our
views in hopes of your speaking favourably for him
to the Porte" (qtd. in St. Clair 94).

New evidence that Elgin resorted to bribery has
recently surfaced. There had been rumors of gifts

O'Connor 7

and bribery ever since Elgin delivered the first
shipment of marble sculptures from Greece. But ac-
cording to William St. Clair, Lord Elgin's most au-
thoritative biographer, a thorough study of Elgin's
financial accounts had been largely ignored because
they are "in all kinds of languages" and in the Ot-
toman currency, piastres. On November 27, 1999, St.
Clair revealed that a recent study of Elgin's ar-
chives proves that Elgin bribed Turkish officials.
The military governor, said St. Clair, "received
bribes equivalent to 35 times his official annual
salary in return for turning his eyes aside" (qtd.
in Alberge). St. Clair asserted that Elgin paid
roughly four thousand pounds in bribes altogether,
and this was at a time when the entire costs of the
British Museum were three thousand pounds per year
(Alberge).

Clearly, Elgin had violated British policy, if
not law, in using his position to collect Greek an-
tiquities. There were no actual international laws
regarding plundering until the Hague Convention of
1954 (Stamatoudi). But the Hague Convention merely
reflects the sentiments against spoliation that al-
ready existed. Such sentiments certainly existed
during Lord Elgin's time. If such sentiments had
not existed, Elgin would not have been compelled to

Refutation of counter- point #2

O'Connor 8

defend himself against charges of receiving gifts
improperly and of bribing Turkish officials during
the 1816 House of Commons investigation.

If British policy against plundering hadn't ex-
isted, the House Select Committee wouldn't have
asked the Reverend Hunt whether there was "any op-
position shown by any class of the natives" (qtd.
in Hitchens 67) as he carried away their treasures.
"None," Hunt replied (qtd. in Hitchens 67). Hunt's
reply is contradicted, however, by a letter from
Lusieri to Elgin dated January 11, 1802, which
says,

> The details of these various little monuments
> are masterpieces. Without a special firman
> it is impossible to take away the last (the
> Pandroseion). The Turks and the Greeks are
> extremely attached to it, and there were mur-
> murs when Mr. Hunt asked for it. (Qtd. in
> Hitchens 67)

Perhaps these "murmurs" were not perceived by
Hunt and Lusieri as true opposition to their sawing
away at the ancient temples, but then Lusieri was
not inclined to take any Greek opposition seri-
ously. In an undated letter to Elgin, Lusieri made
his attitude toward the natives clear: "I intend
from henceforth to have nothing to do with the

O'Connor 9

Greeks. I don't need them. I talk the language suf-
ficiently, and shall begin directly to learn Turk-
ish, to dispense with them" (qtd. in Hitchens 48).

If British policy against plundering hadn't ex-
isted, Mr. Hugh Hammersley of the House of Commons
would not have condemned the manner in which the
Parthenon sculptures had been obtained.

> Hammersley publicly lamented that Lord Elgin
> did not keep in remembrance that the high and
> dignified station of representing his sover-
> eign should have made him forbear from avail-
> ing himself of that character in order to
> obtain valuable possessions belonging to the
> government to which he was accredited (qtd.
> in Hitchens 63).

Hammersley recommended that Parliament appropriate
twenty-five thousand pounds to buy the collection
"in order to recover and keep it together for that
government from which it has been improperly taken"
(qtd. in Hitchens 63).

Parliament simply failed to investigate the
situation diligently, perhaps because it needed to
protect itself from the charge of piracy. The Mar-
bles were in England and were not likely to be re-
turned to war-torn Athens, where, by now, Parlia-
ment believed, the "barbarous" Turks would surely

O'Connor 10

destroy them or the French would abscond with them
to the Louvre. The court of public opinion, how-
ever, needed legal sanction for the retention of
the Marbles, and so Parliament found it.

Conclusion The acquisition of the Elgin Marbles has never
been right; there is too much evidence of wrong-
doing to be ignored. Lord Elgin's behavior was
underhanded and felonious—behavior that does not
merit keeping the booty. Retention of the sculp-
tures will only result in the diminishing of the
British Museum's reputation, whereas restitution of
the sculptures will win for the Museum worldwide
approval and patronage. The Greeks are building an
Acropolis Museum at the foot of the Athenian Acrop-
olis, a stone's throw away from the Parthenon it-
self. This large building, which could beautifully
accommodate and showcase the Elgin Marbles, should
be finished in time for the Olympic games in 2004.
What a gesture of international peace and coopera-
tion it would be to return the sculptures to their
rightful home.

O'Connor 11

Works Cited

Alberge, Dalya. "Elgin Paid Massive Bribes for Mar-
bles." *The Times of London* 28 Nov. 1999. Museum
Security Network. <http://www.museum-security
.org/99/102.html> (12 June 2000).

Cook, B. F. *The Elgin Marbles*. Cambridge: Harvard
UP, 1984.

Daley, Michael. "Romancing the Stone." *Art Review*
June 1999: 51-52.

Hitchens, Christopher. *Imperial Spoils: The Curious
Case of the Elgin Marbles.* New York: Hill, 1987.

Rudenstine, David. "Did Elgin Cheat at Marbles?"
The Nation 29 May 2000: 30-34.

Stamatoudi, Irini A. "The Law and Ethics Deriving
from the Parthenon Marbles Case." Museum Secu-
rity Network. <http://www.museum-security.org/
The%20Law%20and%20Ethics%20Deriving%20from%20the
%20Parthenon%20Marbles%20Case.htm> (12 June
2000).

St. Clair, William. *Lord Elgin and the Marbles.*
London: Oxford UP, 1967.

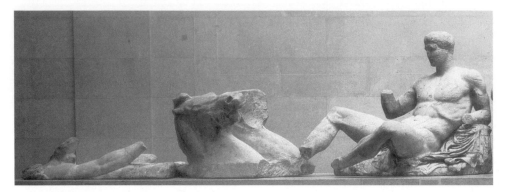

7.2 Helios was taken from the east pediment of the Parthenon. *Helios and his horses,* from the Parthenon, Acropolis of Athens, 448–432 B.C.E. Marble. Copyright the British Museum, London.

CHICAGO MANUAL OF STYLE NUMBERED NOTES DOCUMENTATION SYSTEM

The Chicago Manual of Style (CMS) system of numbered notes and a bibliography is commonly used in art history research papers. For a complete guide, consult *The Chicago Manual of Style,* which is available in libraries and bookstores everywhere. An excellent online summary of the CMS style is provided by Western Washington University <http://www.library.wwu.edu/ref/Refhome/Chicago.html>. CMS offers an FAQ (frequently asked questions) page at <http://www.press.uchicago.edu/Misc/Chicago/cmosfaq/cmosfaq.html>.

Passages that require the citation of a source end, typically, with a raised (superscripted) number. The sample research paper, "Displays of Female Power in the Film *Lara Croft: Tomb Raider*" by Mage Morningstar, uses this system.

The superscripted numbers occur consecutively throughout the text, marking the passages that use sources. The sources are then documented in either **footnotes** at the bottom of the page or **endnotes** collected together on a separate page at the end of the text. The paper on Lara Croft demonstrates the endnote option.

Notes give detailed information about the passage they designate. They may be **reference notes,** which give publication information about the source, or **content notes,** which comment on the text. You should note

- all quotations
- any facts that are not widely available
- statistics
- any paraphrased or borrowed ideas

Regard the following information on using notes:

- The endnotes page is titled "Notes."
- The standard reference note consists of the author's full name, the title of the work, the facts of publication, and the page number from which the information was taken.
- Titles of books, magazines, journals, newspapers, and works of art should be italicized.
- Titles of shorter works, such as articles within journals, should be enclosed in quotation marks.
- The first time you cite a source, use a full reference; afterward, use shortened references.
- Notes are single spaced, with a double space between notes.
- Abbreviate the months of the year.
- Dates are arranged as follows: day month year—with no commas between items.

Following are standard formats for the most widely used types of notes.

FIRST, FULL REFERENCE

Reference to a book with one author

> 1. Yvonne Tasker, *Spectacular Bodies: Gender, Genre and the Action Cinema* (New York: Routledge Publishing, 1993), 119.

Reference to an anthology or a compilation

> 2. Bernard Knox, ed., *The Norton Book of Classical Literature* (New York: W. W. Norton, 1993), 220.

A book by two or more authors

> 3. Lawrence Cunningham and John Reich, *Culture and Values: A Survey of the Humanities*, 5th ed. (Fort Worth: Harcourt College Publishers, 2002), 110-11.

A work in an anthology

> 4. Sophocles, *Antigone,* trans. David Grene, in *The Norton Anthology of Literature*, ed. Carl E. Bain, Jerome Beaty, and J. Paul Hunter, shorter 6th ed. (New York: W. W. Norton, 1995), 1452.

An article in a journal

> 5. Jean Charlot, "Ben Shahn," *Hound and Horn* 3 (1933): 633.

Reference to an article in a general interest magazine

> 6. Malcolm Jones, "An American Eye," *Newsweek* 31 Jan. 2000, 62.

Article in a newspaper

> 7. John Canaday, "This Way to the Big Erotic Art Show," *New York Times* 9 Oct. 1966, sec. 2, p. 27.

Work for which author is unknown

> 8. "Sacco-Vanzetti Series," *Art Digest* 6 (1932): 31.

Article that has been reproduced electronically (Note: the first date is the date on which the article appeared in the magazine. The second date is the date on which the researcher found the article online.

> 9. Ellen Hughes, "Byzantine Mosaics," *Art of the Ancient World* (16 May 1999), 23 May 2000 <http:// shakti.trincoll.edu/~helton/army.html>.

Review of art exhibition

> 10. Helen Dudar, "Time Stands Still in the Harmonious World of Vermeer," rev. of Vermeer exhibition. *Smithsonian* Oct. 1995, 110.

Sound recording

> 11. Charlie Parker Quintet, "Embraceable You," *The Definitive Charlie Parker,* The Verve Music Group.

Film or video recording

> 12. *Lara Croft: Tomb Raider,* Paramount Pictures, 2001.

SECOND, OR SUBSEQUENT, REFERENCES

- Shorten the reference to works previously referred to.

 6. Jones, 62.

- If you are using more than one work by the same author, indicate by the first word or two of the title of the work being referenced.

 14. Rosenblum, *Transformations,* 65.

- Use *Ibid.* (short for *ibidem,* Latin for "in the same place") plus a page number, if necessary, to refer to the immediately preceding work cited.

 22. *Ibid.,* 23.

BIBLIOGRAPHY

This is an alphabetical listing of the sources you consulted in writing your re search paper. Refer to page 211 of this textbook for a sample CMS-style bibliography. Notice the following characteristics of the bibliography:

- The bibliography is single spaced, with a double space between entries.
- The first line of each entry begins at the left margin. Subsequent lines of an entry are indented a half-inch.
- The bibliographical entries are arranged alphabetically, according to the last name of the author. If no author is given, alphabetize according to the first word of the title of the work. If the first word of the title is an article—*a, an,* or *the*—use the second word of the title to determine the work's place in the alphabetical order.
- The bibliography may contain entries for works cited in the paper as well as for works consulted but not cited.
- Titles of books, journals, magazines, and works of art should be italicized.
- Titles of newspaper, journal, and magazine articles should appear inside quotation marks.
- Cities are not accompanied by states, unless the city is obscure or multiple states contain cities with that name.
- The months, except for May, June, and July, are abbreviated.
- A 3-em dash takes the place of an author's name after the first appearance. For example:

 Asimov, Isaac. *Adding a Dimension.* New York: Discus
 Publishing, 1975.

 ———. "Fifty Years of Astronomy." *Natural History*
 Oct. 1985: 4.

Your instructor may request, before you submit your final paper, that you submit a **working bibliography.** This is a list of the sources you intend to use in your paper, although it is understood that changes often occur during the course of writing the paper.

You might also submit an **annotated bibliography.** The format is the same as that of any bibliography, except for the addition of a brief description of the work's usefulness. For example:

> Wolff, Theodore F., and George Geahigan. *Art Criti-cism and Education.* Urbana: University of Illi-nois Press, 1997.
>
> One of the most clearly written overviews of the various types of art criticism.

STUDENT RESEARCH PAPER, CMS STYLE

The following research paper, by Mage Morningstar, demonstrates the Chicago Manual of Style numbered notes system. The paper's mode of discourse is analytical. Notice the following characteristics of this research paper:

- The author has opted to list her points of proof before she states her thesis.

- Morningstar uses sources to corroborate her own analysis rather than to speak for her. Indeed, her bibliography reveals that she did not use any sources written about *Lara Croft: Tomb Raider* specifically. She has instead applied her sources' theories and observations to her own subject.

- Morningstar concedes certain points without allowing such concessions to undermine her own points. See, for example, her third point of proof, beginning on page 200. She begins by conceding that Lara Croft's use of language demonstrates her power in one arena, but proceeds to show how her use of language conveys a lack of power in other arenas.

Morningstar 1

Mage Morningstar

Sociology 4461

Prof. Eleanor A. Hubbard

13 Dec. 2001

Femininity and Other Textually Transmitted Diseases:

Displays of Female Power in the Film

Lara Croft: Tomb Raider

Wake up, America! Militant moms are stockpiling *Introductory remarks*
automatic weapons and whipping up homemade bombs!
Girls in high heels are winning in hand-to-hand
combat with would-be rapists and murderers! Angry
women are using automatic weapons to rid the Earth
of corrupt capitalist leaders! All these things are
happening as female stars infiltrate the genre of
action adventure film, previously dominated by male
protagonists such as Indiana Jones, Dirty Harry,
and James Bond. In fact, women have infiltrated the
genre to such an extent that it seems appropriate
to classify their contribution as the creation of
an entirely new genre, which, for the purposes of
this paper, will be referred to as women's action
film.

The most recently released film of the genre to *Research question*
date, *Lara Croft: Tomb Raider*, provides an opportu-
nity to decode the messages that such films send to
audiences about available and appropriate roles for

Morningstar 2

women. The producers of popular films maintain an uneasy relationship between femininity and power—one that often frames femininity as a disease, the main symptom of which is powerlessness. Does the character of Lara Croft, through its representation of female power, challenge this understanding of femininity or enforce it?

List of points of proof

The film's treatment of action and sex presents a challenge by portraying Lara as unquestionably powerful. In contrast, the film's failure to present Lara as free of male influence and direction results in a support of sexism. Finally, the film's use of language and portrayal of relationships, with its implication that Lara's strength depends on her dismissal of feminine traits and female company, resembles a divide-and-conquer tactic, a tactic often used against an enemy. Looking at the film in this way, one could read it as framing women as the enemy. It is hard to imagine a message more harmful to feminist progress than this one.

Thesis

Therefore, considering the messages inherent in the text, the film ultimately reinforces sexist ideals.

Point of proof #1

That Lara is a physically powerful character is obvious from the film's first action sequence, which features her using impressive muscular strength and coordination to support herself upside

Morningstar 3

down on a rope and propel herself into what appears
to be an ancient tomb filled with challenging phys-
ical dangers. Later, she climbs a giant cosmologi-
cal model of rotating planets and moons without be-
ing crushed or dislodged by the swinging metal
arms. She dogsleds at high speed down a collapsing
ice tunnel, without the sled. She dives off a high
waterfall and swims through turbulent whitewater to
safety. She is fiercer, faster, stronger and more
agile than her competitors in physical combat,
whether fighting bionic spider monsters, enchanted
stone warriors, or human enemies. These representa-
tions of a female body as physically superior di-
rectly contradict the standard sexism, which takes
for granted the physical inferiority of women.

The effect of her use of weapons and cars is
less obvious. According to Yvonne Tasker, author of
a 1993 study titled *Spectacular Bodies: Gender,
Genre and the Action Cinema,* "Within many Hollywood
action narratives, access to technologies such as
cars and guns (traditional symbols of power) repre-
sent a means of empowerment."[1] However, others view
these technologies as phallic symbols, which serve
to align female characters with heterosexuality by
portraying their desire to hold and possess signi-
fiers of male sexuality.[2] The ways in which Lara

Morningstar 4

uses these props support her autonomous strength,
rather than reinforcing heterosexual ideals of
female inferiority.

Lara is really into guns. She carries them in
every version of the promotional posters for the
movie and uses them frequently in the movie itself.
She uses them ambidextrously, reloads instanta-
neously, shoots while running and jumping, and even
uses them as blunt weapons. Furthermore, guns are
not her only access to physical power. Lara is
adept at hand-to-hand combat and occasionally
wields a sword, screwdriver, or bungee cord. Her
relationship to weapons is too complex to represent
a simple acquisition of power through a phallic,
and therefore masculine, object. Rather, her tal-
ented and varied use of guns and other weapons dem-
onstrates her ability to communicate her inherent
power through a variety of mediums.

Another way in which the action sequences in
the film support the reading of Lara as a powerful
person relates to the believability of her actions.
When she is racing her archenemy to the top of a
mystic pyramid, she wins without any apparent spe-
cial effects. When she is racing her motorcycle
down a heavily trafficked speedway, the visual im-
pression is that she is riding a real motorcycle

Morningstar 5

down a real speedway busy with real cars. Other
women's action films present physically powerful
women, but their power is mitigated through the use
of fantasy or parody. For instance, *Crouching
Tiger, Hidden Dragon* presents scenes of impressive
swordplay between women, followed by scenes of the
same warriors flying through the trees. Likewise,
in *Charlie's Angels*, the action heroines frequently
triumph over physical challenges through the use of
absurd stunts and tricks. They cheat death by mov-
ing faster than speeding bullets; they leap seven
feet in the air in high heels without a running
start; they take out teams of bad guys with fancily
named kung fu moves and never muss their hair.
Rather than challenge stereotypical ideas regarding
women's lack of physical power, *Charlie's Angels*
treats physically powerful women as a joke.

Most viewers would readily identify Lara as the
protagonist of the film. However, a look into the
definition of the word sheds doubt on this identi-
fication. In addition to being the "leading charac-
ter or hero,"[3] a protagonist is the character who
"moves the action forward."[4] Does Lara do this? No.
She wakes to find the mysterious clock ticking and
responds to its invitation. She receives the riddle
in the mail and solves it. She accepts the quest

*Point of
proof #2*

Morningstar 6

from her father and succeeds at it. She is invited to Venice by her archenemy and meets him there. She is taunted into fighting with him and beats him. She is rarely presented as an initiator; rather, she responds to situations. This treatment of her character serves to rob her of considerable authority and, thus, of power.

Point of proof #3

As any textual analyst must readily acknowledge, there is power to be had in the use of language. Lara is the only character in the film to communicate freely with residents of Cambodia and Iceland in their native language. Thus, she is more powerful than her male counterparts. However, a more specific examination of the use of language in the film reveals that Lara is powerful mainly through a disassociation with femininity. For example, Alex West, Lara's colleague and competitor, refers to his hired soldiers in feminine terms, though they are all men. He says, "Come on, ladies, we don't have all day," trying to berate them into moving faster. One might assume that the insult implicit in Alex's comment is negated by the strength, speed, and capability demonstrated by Lara's actions, which immediately follow the "ladies" comment. Such a reading, though tempting to make, is illogical because at this point in the

film, Lara has already established the term as not
applying to her.

In an earlier scene, Lara emerges from the
shower, wrapped in a white towel. Her butler Henri
presents her with a white dress, to which she re-
sponds, "Very funny." As she walks past him she
drops her towel, revealing her naked back. Henri
then informs her, "A lady should be modest." Lara
turns slightly, revealing the curve of her naked
breast, and smiles mischievously, saying, "Yes, a
lady should be." The implication is that she is not
a lady, nor does she desire to be one considering
the requisite behavior modifications.

Sherrie Inness, author of *Tough Girls: Women
Warriors and Wonder Women in Popular Culture,* ar-
gues that portraying female characters as sexual in
any way mitigates their power because of the tradi-
tional association between women's sexuality and
women's vulnerability.[5] However, a media culture
that presents only asexual women as powerful does
not represent or support women who wish to be both
powerful and sexual in their personal lives. Fur-
thermore, it does not reflect the reality of a cul-
ture in which real women are gaining power both in
and out of their sexual relationships. I would ar-
gue that the producers of anti-sexist imagery must

Morningstar 8

meet the challenge presented by our traditional as-
sociations and succeed in presenting female sexual-
ity in ways that empower women. I believe that the
producers of *Lara Croft: Tomb Raider* meet this
challenge in several ways.

Let's begin the analysis of Lara's sexuality by
considering the opening action sequence of the
film, in which Lara spreads her long legs wide
open. A spread-legged position typically connotes
sexual availability or submissiveness.[6] However,
this scene is far from typical. Lara is engaged in
a deadly battle with a huge spider-like robot in-
tent on her destruction. Having just charged the
robot and slid under its legs in order to shoot at
it from behind, she sits on the ground with her
legs pointing toward her attacker. As a huge me-
chanical arm is poised to smash her legs, she opens
them wide, forcing the robot to smash the stone
floor rather than damage her body. Had this been a
male action hero, the spread-legged evasive maneu-
ver would have been a poor choice, exposing as it
would his extremely sensitive and vulnerable sexual
organs. However, Lara doesn't have this problem.
This segment, though admittedly containing sexual
implications, also accentuates the fact that Lara
is less vulnerable than a man.

Morningstar 9

The next scene with sexual implications occurs when Lara, fresh from the shower, drops her towel in front of her butler, Henri. By openly displaying her nakedness in front of an adult male who is not her sexual partner, she is making a strong statement about the female body. She is asserting the right to be naked without being sexual.

The only scene during which Lara's sexual desirability is directly referred to involves Alex West, with whom she maintains an antagonistic yet familiar relationship. Lara breaks into his hotel room in order to confront him. Hearing a noise, he steps out of the shower and begins prowling naked about his hotel room, holding a loaded gun and looking for intruders. He is startled to turn around and find her sitting calmly with her feet propped up on his table. She moves to stand directly in front of him and looks down toward what the audience assumes to be his exposed genitals. Meeting his eyes again, she says with a smile, "Always a pleasure," and walks away. Alex watches her leave and then turns back toward the bathroom, muttering, "Now for a cold shower."

This is a very sexually charged scene, its implication being that Lara has given Alex an erection. This scene is revolutionary in that Lara is

Morningstar 10

not punished for arousing male desire without sat-
isfying it. Alex does not even suggest that she
should make herself available to him; her bound-
aries are clear, and he respects them. Furthermore,
she does not feel endangered being alone in a room
with a naked, sexually aroused man whose morals and
loyalties are questionable at best. The imagery of
this scene can be read as fiercely feminist, in
that it acknowledges the power of female sexual
attractiveness without demeaning it or making it
subject to male desire. This scene is a positive
revelation of what Naomi Wolf, in *Promiscuities:
The Secret Struggle for Womanhood,* refers to as
"women's longing to be absolutely sexual but ab-
solutely inviolable."[7]

No discussion of sexuality in *Lara Croft: Tomb
Raider* could be complete without mention of Lara's
breasts. They are her most notable physical charac-
teristic. Because breasts, especially large ones
like Lara's, are typically identified as objects of
male sexual desire, it would be easy for analysts
such as Inness to dismiss them as simply mitigating
her powerful image by making her into a sexual ob-
ject. However, the extent to which they establish
her as a sexual object is dubious. First, exposed
cleavage, which serves as a visible point of entry

Morningstar 11

for the heterosexual male gaze, is nonexistent in this film, implying that Lara's breasts are unavailable. Second, her foundation garments provide impressive support. There is little evidence of the "jiggle factor" so frequently referred to in reviews of *Charlie's Angels.* Third, in addition to their firmness, Lara's breasts are unusually shaped. They defy gravity, jutting outward from her body. Perhaps this sculpting of her body is done to increase the spectacle of these overly developed secondary sexual characteristics. However, I believe that the breasts' rigid and propulsory positioning effects the creation of dual phallic symbols. They project from her chest with force and authority, never wavering in their direction or threatening to spill over and breach the boundaries of the brassiere. Being breasts, and thus intimately associated with womanhood, they cannot be read solely as phallic symbols; rather, they are equivalent female power symbols, for which our culture has yet to develop a name.

As Inness repeatedly points out, Hollywood habitually mitigates the power granted to action heroines, so as not to overly threaten those invested in the current power imbalance. This mitigation is frequently achieved through the establish-

Point of proof #4

ment of a traditionally feminine relationship cate-
gory such as girlfriend, wife, or mother.[8] Lara's
failure to identify with these roles establishes
her as a potentially radical figure.

Motherhood is frequently employed to mitigate
female power by offering an explanation for it. For
example, in *Aliens,* Ellen Ripley's sole motivation
for surviving the alien-infested planet is to res-
cue the young girl, Newt. Sarah Connor of *Termina-
tor* and *Terminator II* transforms herself from a hy-
perfeminine waitress into a well-muscled militant
in order to protect and train her son for his
rightful leadership role. Lara Croft is an excep-
tion to this pattern; her obvious use and posses-
sion of power remains unexplained and, thus, seems
inherent.

Unfortunately, these promising elements of au-
thority and sexual/parental independence fall short
of establishing true autonomy for Lara, as she is
repeatedly shown as identifying with her father.
Throughout the film, dream sequences, emotional
breakdowns, mysterious letters, flashbacks, and
shots of Lara grieving at an ornate monument to her
father, place her firmly in the patriarchally con-
structed role of daughter. This identification with
her father—combined with her physical toughness and

Morningstar 13

lack of sexual feelings or relationships—creates
the image of a tomboy character rather than that of
a powerful, full-grown woman.

In film, as in other American media of popular
culture, a certain degree of power is acceptable in
girls like Lara who have not yet accepted the re-
sponsibilities of womanhood. Of course, the glori-
fication of the boyish girl is in itself a relief
and support to real-life tomboys and all women
whose wholeness as humans is invalidated by the
mainstream media's hyperfocus on femininity. Unfor-
tunately, images of tomboys ultimately serve to
contain masculinity (i.e., inappropriately gendered
power appropriation) in girls by portraying tomboy-
ishness as a natural, even admirable, phase. This
phase is, in a "healthy" woman, supplanted by the
full embrace of her secondary status, symbolized in
media imagery by the adoption of feminine props,
such as Lara's white dress, sun hat, and ladies'
shoes. The end of the phase is further indicated
when the tomboy ceases to identify with the mascu-
line through her father and begins to desire the
masculine through a sexual partner.

True to the tomboy formula, Lara undergoes a
coming of age in which she accepts her femininity.
In her final scene at her father's memorial, she

has given up the brooding, pained expression of
previous scenes at this location and seems to be
saying a fond farewell. Her attitude signifies to
the audience that she has given up her wish to be
with him and accepted his death. Likewise, her sud-
den and unexplained adoption of feminine attire
signifies that she has given up her unnatural,
impossible wish to be like him, and accepted her
womanhood.

Lara's identity, strongly associated with that
of her father throughout the film, is now free to
make the adult transition to a male partner. As she
ascends the stairs from the backyard memorial to
the house, audiences well versed in the traditional
tomboy-to-true-babe transition are probably expect-
ing to see Alex West at her door, ready to take her
out on a date. This would explain the dress and fit
the established formula perfectly.

However, here the film takes an unexpected
turn. When Lara reaches the top of the stairs, she
finds Henri waiting for her with a covered dish. In
the far doorway is the robot she destroyed in the
film's opening action sequence, repaired and ready
for a fight. Henri then whips the cover off the
platter to reveal two loaded handguns. Lara grabs
the handguns with a look of serious concentration

Morningstar 15

and aims the guns at the robot. The frozen image
of Lara, poised and ready to shoot, is the last
image of the film. This choice on the part of the
filmmaker would seem to present a challenge to
dominant images of women by asserting her indepen-
dence and presenting her as still physically power-
ful. Perhaps it does, but backing out of a sexist
formula at the last minute only minimally redeems
the film's mitigation of Lara's power through
relationships.

Even more problematic is the lack of other
women in the film. Although Lara does talk to a
young girl, their brief discussion concerns whether
or not Lara should risk everything to see her fa-
ther again. This complete lack of relationship or
communication with other women, except to talk
briefly about a man, doesn't directly compromise
the power presented by Lara's image. It does, how-
ever, suggest that relationships with women are
nonessential, whereas relationships with men are
vital. It furthermore positions Lara as an aberra-
tion of womanhood, able to take a place in the
men's world by removing herself from association
and identification with other women. Indeed, the
lack of female figures ultimately communicates to
audiences that it is a man's world after all.

Morningstar 16

Conclusion Thus, textual analysis of the strong female

protagonist of *Lara Croft: Tomb Raider* reveals that

physically powerful women are becoming more accept-

able to our culture. The film's treatment of femi-

nine sexuality also supports the idea that the

dominant culture is being challenged to broaden

its assumptions concerning female sexuality. How-

ever, the representation of Lara Croft as a male-

identified individual whose language and relation-

ships express disdain for association with women

ultimately endorses the hegemonic ideals of an un-

deniably sexist society.

Notes

1. Yvonne Tasker, *Spectacular Bodies: Gender,
Genre and the Action Cinema* (New York: Routledge
Publishing, 1993), 119.

2. Mary Rogers, "The Future of an Illusion:
Film, Feminism, and Psychoanalysis," *Gender and So-
ciety* 7.2 (1993): 308–311.

3. Stephen Watt, *Postmodern Drama: Reading the
Contemporary Stage* (Ann Arbor: University of Michi-
gan Press, 1998), 67.

4. Ibid., 68.

5. Sherrie A. Inness, *Tough Girls: Women Warriors
and Wonder Women in Popular Culture* (Philadelphia:
University of Pennsylvania Press, 1999), 66.

6. Jacinda Read, *The New Avengers: Feminism,
Femininity and the Rape-Revenge Cycle* (New York:
Manchester University Press, 2000), 232.

Morningstar 17

7. Naomi Wolf, *Promiscuities: The Secret Struggle for Womanhood* (New York: Random House, 1997), 195.

8. Inness, 66, 68, 72.

Bibliography

Inness, Sherrie A. *Tough Girls: Women Warriors and Wonder Women in Popular Culture.* Philadelphia: University of Pennsylvania Press, 1999.

Lara Croft: Tomb Raider. Paramount Pictures, 2001.

Read, Jacinda. *The New Avengers: Feminism, Femininity and the Rape-Revenge Cycle.* New York: Manchester University Press, 2000.

Rogers, Mary. "The Future of an Illusion: Film, Feminism, and Psychoanalysis." *Gender and Society* 7.2 (1993): 308-11.

Tasker, Yvonne. *Spectacular Bodies: Gender, Genre and the Action Cinema.* New York: Routledge Publishing, 1993.

Watt, Stephen. *Postmodern Drama: Reading the Contemporary Stage.* Ann Arbor: University of Michigan Press, 1998.

Wolf, Naomi. *Promiscuities: The Secret Struggle for Womanhood.* New York: Random House, 1997.

REVISING AND EDITING YOUR RESEARCH PAPER

Use the following checklist to be certain that your paper is ready for submission. Consult the Handbook at the end of this book for guidance in issues of sentence structure, grammar, punctuation, mechanics, and style.

REVISION AND EDITING CHECKLIST

- ☐ Thesis is clear and present. It is written in the appropriate mode of discourse. The thesis establishes the parameters of the paper.
- ☐ Points of proof are clear and present. Each point is narrow and specific enough to be supported adequately and general enough to need support. If the paper is argumentative, points of proof include refutations of counterpoints.
- ☐ Introduction contains specific details. It leads the reader to the thesis; it does not lead the reader to believe the essay will be about something it is not about.
- ☐ If the paper is argumentative, the introduction contains a counterthesis and counterpoints, and it clearly identifies opponents.
- ☐ Paper adheres to the plan set out in the points of proof.
- ☐ Body paragraphs are unified, adequately developed, organized, and coherent.
- ☐ Conclusion solidifies the paper's main point without resorting to mere repetition of the thesis and points of proof. It is unified and developed. It does not bring up any new issues.
- ☐ Sentences are well constructed and correctly punctuated.
- ☐ Words are correct and well chosen.
- ☐ All quotations use acknowledgment phrases.
- ☐ Sources are correctly cited, documented, and formatted.
- ☐ Title is appropriate.
- ☐ Paper is properly formatted.

8

LANGUAGE OF HUMANITIES

Approaches to Criticism	*Archetypal Criticism*
	Deconstructive Criticism
	Diarist Art Criticism
	Feminist Criticism
	Formalist Art Criticism
	Gay and Lesbian Criticism
	Historical Criticism
	Marxist Criticism
	Multicultural Criticism
	New Criticism
	New Historicism
	Postmodernist Criticism
	Poststructuralist Criticism
	Psychoanalytical Criticism
	Reader-Response Criticism
	Structuralist Criticism

CHAPTER PREVIEW

Students often humbly wonder what they can contribute to discussions in the humanities because so much of what they read has been written by experts in the field. You may think that everything has been said already about every work of art, literature, and music. But rest assured that your considered opinion about a painting, play, film, or concert, guided by research, classroom instruction, and personal experience, will produce a unique inquiry. Your role as critic is to help the rest of us recognize, understand, even possess a work of art, whatever it is, and make it part of our own vision. The following alphabetical overview of critical approaches, although in no way comprehensive, offers ideas and positions from which to consider your essay topic.

APPROACHES TO CRITICISM

The critic must assume that art does not speak for itself and that his or her investigations and insights will assist the viewer or listener, and perhaps even the artist, in reaching another level of understanding. Consider what Argentine author Jorge Luis Borges said in 1964 about a critic of his short stories: "Ana María Barrenechea's book has unearthed many secret links and affinities in my own literary output of which I had been quite unaware. I thank her for those revelations of an unconscious process."[1] Northrop Frye further validates the process of critical writing: "Criticism is to art what history is to action and philosophy to wisdom . . . and just as there is nothing which the philosopher cannot consider philosophically, and nothing which the historian cannot consider historically, so the critic should be able to construct and dwell in a conceptual universe of his own."[2]

In Chapters Three and Four, you learned about writing analytical and argument essays, and here you might apply a critical approach to writing. For example, a student involved in psychology may investigate the psychological motivations or implications of a novel, play, painting, or musical composition. A student drawn to politics may look for a political message in the work. Keep in mind that, whereas a particular critical approach may illuminate the text or art for the purpose of your essay, you are necessarily neglecting other ways of interpreting the subject. You should not suppose that, because you have "proven" that Melville's Bartleby is Marx's alienated worker, other ways of looking at his character, motivation, and actions are invalid.

ARCHETYPAL CRITICISM

The archetype, a recurring symbol, is the myth critic's basis for interpretation. In the psychological theories of Carl Jung, the **archetype** is an image from the collective unconscious, an inherited memory, a universal symbol represented in the mind and in dreams. Myth critics are also indebted to James Frazer's collection of legends, rites, and archetypal images in *The Golden Bough*.

In *Anatomy of Criticism*, Northrop Frye discusses the archetypal image of the hero in the labyrinth in the quest-romance:

> The image of the dark winding labyrinth for the monster's belly is a natural one, and one that frequently appears in heroic quests, notably that of Theseus. A less displaced version of the story of Theseus would have shown him emerging from the labyrinth at the head of a procession of Athenian youths and maidens previously sacrificed to the Minotaur. In many solar myths, too, the hero travels perilously through a dark labyrinthine underworld full of monsters between sunset and sunrise. This theme may become a structural principle of fiction on any level of sophistication. We would expect to find it in fairy tales or children's stories, and in fact if we stand back from *Tom Sawyer*, we can see a youth with no father or mother emerging with a maiden from a labyrinthine cave, leaving a bat-eating demon imprisoned behind him. But in the most com-

plex and elusive of the later stories of Henry James, *The Sense of the Past*, the same theme is used, the labyrinthine underworld being in this case a period of past time from which the hero is released by the sacrifice of a heroine, an Ariadne figure.[3]

Joseph Campbell, in his four-volume series titled *The Masks of God*, is another gold mine of information, examining the roots of mythology and comparing fundamental themes in art, religion, and literature.

DECONSTRUCTIVE CRITICISM

In the 1960s, French philosopher Jacques Derrida developed a strategic approach to literary (and other) criticism in which language is inherently ambiguous and contradictory; therefore, the text might have endless meanings with neither fixed points of origin nor of closure. The deconstructive critic might scrutinize the use of the word *soul* in a text, an expression loaded with implication, nuance, and undertones. Does *soul* have one true meaning, or is it tainted by a long history of use and various influences? Rather than looking to *unify* the text by examining its disparate elements, the deconstructive critic more likely scrutinizes the paradoxical or inconsistent elements in a text—or even what the text does not overtly say—until ultimate meaning is shown to be indeterminate. For the deconstructive critic, there is no finite meaning. One sign refers to something else and refers to something else again, until the associations are infinite. You are not dependent on previous contexts, universal values, or even the author, artist, or composer's authority to interpret a work; in this sense, you, like the creator, are free to invent your own reality.

A deconstructive reading of William Blake's poem "Infant Joy" from *Songs of Innocence* might focus on the word *befall*.

Infant Joy

"I have no name,
I am but two days old."
What shall I call thee?
"I happy am,
Joy is my name."
Sweet joy befall thee!

Pretty joy!
Sweet joy but two days old,
Sweet joy I call thee;
Thou dost smile,
I sing the while
Sweet joy befall thee![4]

Does the word "befall" mean *come to pass*, or *fall to as a share or right*, or *happen through the unexpected workings of chance or fate*? How does the word resonate with the phrase "sweet joy"? Why would the person addressing the child suddenly throw the word "befall" into the mix with "pretty," "sweet,"

8.1 "Sweet joy befall thee!" William Blake,
Infant Joy from *Songs of Innocence,* 1789/
c. 1800. Relief etching finished in watercolor.
© Christie's Images/Corbis.

"smile," and "sing"? Perhaps opposition (innocence versus experience, happiness versus melancholy, now versus later) is suggested by juxtaposing the child's words, whose identity is synonymous with feeling, "I happy am," and the other's words, whose singing will cease when the child stops smiling. Because "Infant Joy" is from Blake's *Songs of Innocence,* a dark, or at least ambiguous, reading may be unconvincing. On the other hand, Blake evidently chose the word *befall* carefully, because, according to the *Concordance of the Writings of William Blake,* the word does not appear anywhere else in his writings. In 1709, some eighty years before Blake wrote the poem, the word appears in the phrase, "the most deplorable misfortune that possibly can *befall* a woman."[5] Now *that* does not sound very happy. You can begin to see how deconstruction leads to many possible interpretations of a work, but nothing conclusive.

Deconstruction has its detractors, of course, but the process is useful for examining the way in which language creates or diminishes meaning and for rejecting the idea that meaning is inextricably tied to one central truth. To the deconstructive critic, meaning is multifarious, contradictory, and elusive.

DIARIST ART CRITICISM

In diarist art criticism, the reviewer records observations and expresses feelings, usually in the first person, about works of art. The critic's experience and opinions may be an integral part of the essay, although the skilled diarist will feature the artwork as the main attraction. For example, in the following excerpt, art critic Bernard Berenson gives the reader his personal musings about Michelangelo's *Moses* without focusing too much attention on himself:

> As a child I was fascinated by the story that Moses had horns on his forehead and that they shone with their own light. Indeed in most representations we see no horns but beams of light from his head. Michelangelo in the mighty icon of San Pietro in Vincoli gives him, as a sculptor should, real horns. I wonder whether the tradition does not go back to the fact that he had mighty protuberances on his forehead such as gorillas and Neanderthal humans have. If that could be assumed it would point to the historicity of Moses. A peculiarity of that kind could scarcely have formed part of the ideal law giver, and surely

8.2 The "mighty protuberances" of Moses
Michelangelo, *Moses*, 1513–1515. Marble. Detail of
head. Copyright Scala/Art Resource, NY.

would not form part of the Moses legend, if the peculiarity had not been there visible to all, rousing remarks, and thus was handed down through the ages and gradually became transfigured into rays of light.[6]

FEMINIST CRITICISM

Feminist criticism approaches art and literature from the sociopolitical position that women are equal to men and so deserve the same rights and opportunities. Virginia Woolf's *A Room of One's Own*, Simone de Beauvoir's *The Second Sex*, and Kate Millett's *Sexual Politics* have been influential in drawing attention to women's place in the literary tradition and to the patriarchal foundations that have prohibited women from exercising their creative voices. Mary Shelley's *Frankenstein* might be read in a feminist light. The monster, fueled with curiosity and feelings, is denied access to the rights and privileges of human society.

Patricia Hart, in her essay, "Magic Feminism in Isabel Allende's *The Stories of Eva Luna*," defends Allende against critics who have charged her with imitating male Latin American writers. Allende's sardonic treatment of prostitution in "Toad's Mouth," is, Hart writes, "a point of view notoriously unexpressed in the frivolous treatment of this subject by male authors."[7]

> "Toad's Mouth" is the first story in the collection that deals with prostitution. In it, a lone woman, Hermelinda, sells herself to sheepherders on the cold southern plains, inventing erotic games to alleviate their boredom. In the one alluded to in the title, a man who succeeds in tossing a coin that lodges in her vagina from a distance of four paces earns two hours alone with her. With this crude parody of the Cinderella myth, Allende is not out to prove that she can be as raunchy and insensitive as her male counterparts, but to expose the fairy-tale brainwashing. The "perfect fit" that in Cinderella is coyly expressed as shoe size here is rendered literally. In the fairy tale, the prince offers a palace, riches, and station; Cinderella, her virtue and her beauty. Here the equation is noted in vigorous shorthand—the woman offers sex and the man money.[8]

FORMALIST ART CRITICISM

Formalist art critics place emphasis on objective elements in art—line, color, shape, value, texture, space, time, and motion—disregarding other elements, such as historical setting, social milieu, political climate, and biographical data.

In an essay titled "Impressionist Technique: Pissarro's Optical Mixture," Richard F. Brown focuses on the element of color in Pissarro's *Factory near Pontoise*. Brown uses the Wilhelm Ostwald color measurement system, which maps the values of hue, saturation, and brightness, to analyze the painting:

> In examining Pissarro's painting of 1873 in this manner, we are impressed by two facts. First, Pissarro uses as complete a range of values as possible. His actual pigments go all the way up to pure white and as far down towards black as

they can while still retaining any appreciable amount of hue content. He uses a number of devices, such as abrupt contrasts of value or hue to make the whites seem whiter and the darks as deep as possible. Secondly, in nearly all the colors he limits his range of intensities to a surprising degree. In this painting, amazingly few of the smaller colored areas extend farther away from complete neutral than Ostwald's second step. This means that the intensity range is restricted, for the most part, to less than thirty percent of the total range that can be attained by ordinary oil pigments.[9]

GAY AND LESBIAN CRITICISM

Gay and lesbian criticism makes available to the reader or viewer perspectives on literature and art that the heterosexual community may have failed to notice or appreciate. David Halperin's *One Hundred Years of Homosexuality and Other Essays on Greek Love; Lesbian and Gay Writing: An Anthology of Critical Essays*, edited by Mark Lilly; and *The Gay and Lesbian Literary Heritage: A Reader's Companion to the Writers and Their Works, From Antiquity to the Present*, edited by Claude J. Summers, are three of many essential reference works. The critical approach may consider the treatment of a disenfranchised group, or attempt to modify society's notions of sexuality, or reexamine works judged in an earlier, more cautious, time.

Earlier critics of Walt Whitman's "Song of Myself" concede Whitman's glorification of the male body, but see the following passage in terms of brotherly love and equality for all humanity. Robert K. Martin, in his book *The Homosexual Tradition in American Poetry*, expands that understanding to include a specific sexual meaning:

> The young men float on their backs, their white bellies swell
> to the sun . . . they do not ask who seizes fast to them,
> They do not know who puffs and declines with pendant and
> bending arch,
> They do not think whom they souse with spray . . .

The exuberance of this final image comes partly from sexual desire but also from Whitman's buoyant belief in the possibility of distributing sexual energy. The "spray," the life force of the twenty-eight young men, is released into the world and becomes a token of the value in multiplicity of the world. Against nineteenth-century medical theories of the conservation of energy through the withholding of sperm, Whitman proposes a radical redistribution of that energy through the release of sperm.[10]

HISTORICAL CRITICISM

Historical critics view works of literature and art in a historical context, as products of and influences on the time and culture in which they were created, assuming that understanding the social, political, economic, and philosophical conditions in which a work was produced will shed light on the

work itself. The historical critic might ask what struggles and aspirations are reflected in a work; for example, Charles Dickens's *David Copperfield* might be examined against the backdrop of the Industrial Revolution and the conditions that existed in Victorian England. William Blake's text and illustrations from the *Book of Urizen* might be analyzed in the context of scientific theories and philosophical discourses of the European Enlightenment.

In his essay, "Romantic High Baroque in the Art of Delacroix," from *David to Delacroix,* Walter Friedlaender attributes Delacroix's less appealing, if not technically masterful, paintings to his immersion in the "general current of his time."[11]

> Even Delacroix did not entirely escape the romantic epidemic of medieval and patriotic historicism which, beginning among the *muscadins* of David's atelier, then engendered those awful historical pictures that flooded France and the rest of Europe as a sort of semi-official art. Even Delacroix fell a partial victim to the historicizing taste of his period, a taste whose original romantic expression had a certain justification and produced certain significant results, but which in the wake of Walter Scott and others engendered little that was worthwhile either in literature or in painting.[12]

MARXIST CRITICISM

Marxist criticism applies the theories of Karl Marx and Friedrich Engels to the work of an author or artist examining the work's relationship to society, particularly economics, class structure, and power struggle. Thomas Hardy's *Tess of the d'Urbervilles* might be critiqued as a social document whose central theme is the disintegration of the peasantry at the hands of capitalist farmers. Working-class Tess is sacrificed by her family to the ruling class, and her social degradation continues from there.

You might see Herman Melville's quirky character Bartleby, forever saying, "I would prefer not to," as rebelling against a system in which he neither cares about nor benefits from the fruits of his labor. Louise K. Barnett, in an essay titled "Bartleby Is Marx's Alienated Worker," analyzes the behavior of workers in the dismal but utilitarian law office, each worker suffering from a modern malaise:

> Physically as well as mentally, the scriveners illustrate Marx's diagnosis of malaise. Turkey's inflamed face witnesses his overindulgence; Nippers is given to teeth grinding and nervous attacks; Bartleby is pale and thin. Nursing their vain expectations, Turkey and Nippers take what solace they can in cakes and ale and fits of temper. Bartleby chooses not to continue working.[13]

MULTICULTURAL CRITICISM

Multicultural criticism is particularly concerned with bringing to light the artistic and literary contributions of ethnic and minority groups; moreover, the critic taking this approach may reveal cultural distinctions and insights

that the mainstream public is unaware of or unexposed to. For example, John Cullen Gruesser discusses how mystery writer Walter Mosley strikes a "balance between genre conformity and genre subversion"[14] in his "signifying" character Ezekiel "Easy" Rawlins. Applying Henry Louis Gates, Jr.'s theory of signifying, based on an indigenously black discourse, Gruesser investigates Mosley's main tough guy in *Devil in a Blue Dress:*

> In Mosley's 1948 Los Angeles, a black man does not acquire a detective's license and hang a shingle advertising his services as a private investigator. With no models on which to pattern himself, Easy must invent a detective persona that will work in his milieu. When DeWitt Albright, a veritable Moby Dick of murderous whiteness, surfaces in Joppy's bar asking Easy to do some investigative work for him, Easy knows he is in deep, uncharted waters; nevertheless, the one hundred dollars Albright offers is too tempting for the recently unemployed Easy to refuse. Unlike Marlowe [Raymond Chandler's main tough guy], to survive and succeed Easy must invent a method for dealing with not only Albright, and the corrupt, white power brokers who employ killers like him, but also the violent, oppressed black community in which he lives. The method Easy chooses is based on the well-established African American strategy of signifying.[15]

Another type of cultural criticism, **postcolonial criticism,** examines the impact of colonizing nations on their colonies—how, for example, European and American settlers have affected native populations. A postcolonial critic might analyze a text produced in a country that has been, or still is, under the control of a colonial power, or perhaps a text written about a developing nation by an author from an industrialized nation. A landmark book by Edward Said, *Orientalism* (1978), focuses on Western images and myths of Eastern and Middle Eastern cultures, and how the colonizing world justifies its exploitation of the postcolonial world.

NEW CRITICISM

New criticism, which began with I. A. Richards's *Principles of Literary Criticism* and *Practical Criticism* in the 1920s, maintains that meaning is found in the text itself, not in the experience of the reader—as in reader-response criticism—nor in the intention of the author. Only a close reading of the text, focusing on elements such as imagery, irony, and symbols, will disclose the work's central idea or unifying theme.

The albatross in Coleridge's *Rime of the Ancient Mariner* might be interpreted as a symbol of life thrown out of balance when the bonds between humankind and the natural world are violated. You might observe that Gustave Flaubert's description of the countryside in *Madame Bovary* contributes to the theme of dullness and deadness that reflects Emma's feelings of entrapment. The ubiquitous cow might be seen as a figurative representation of the idea that Emma's romantic expectations and dreams are frustrated by a complacent husband, "rechewing his happiness,"[16] and a mundane bourgeois life from which she cannot escape.

John Holloway, writing about Thomas Hardy's *Tess of the d'Urbervilles*, focuses on figurative language, on the metaphor of the hunt:

> *Tess of the d'Urbervilles* has unity through a total movement, and the nature of this movement may be grasped through a single metaphor. It is not the taming of an animal. Rather (at least at the start) it is the hunting of one. Several remarks and incidents in the book make this explicit, notably Tess's letter to her absent husband when he has deserted her. ("I must cry to you in my trouble—I have no one else. If I break down by falling into some dreadful snare, my last error will be worse than my first.") So does the night she spends in the wood with the wounded pheasants which, of course, brings powerfully back to the reader that earlier night in the wood when she falls into the snare set for her by Alec. Throughout, Tess is harried from place to place at what seems like gradually increasing speed. Even the very start of her relation with Alec is relevant: "the handsome, horsey young buck" drives up early in the morning in his gig to fetch her. At the end, it is especially clear. When the hunt is over, Tess is captured on the sacrificial stone at Stonehenge, the stone where once, like the hart at bay, the victim's throat was slit with the knife.[17]

Notice that Holloway concentrates on a single literary element rather than on nineteenth-century attitudes toward class division, a woman's place in society, thematic connections with other works of literature, or details of Hardy's life.

NEW HISTORICISM

Unlike traditional historical critics, who view art and literature against the backdrop of historical events and texts, new historicism critics hold that contemporary perceptions and representations of the past are equally authoritative. In other words, the recording of an event by a Renaissance historian, revealing his own preferences and partiality, is no more valid than the account recorded by a modern historian who has reconceived the event. For example, a new historicism reading of Daniel Defoe's *Robinson Crusoe* may point to Defoe's attitudes, not simply as adventurer and storyteller, but as a man whose own iniquitous prejudices are given voice through his lead character.

Stephen Greenblatt reconsiders Thomas More's *Utopia* in the light of More's own conflicted inner and public life in a society in which he both served and suffered greatly. The following sentences introduce the concept of new historicism:

> Our reading of *Utopia* has shuttled back and forth between the postulate of More's self-fashioning and the postulate of his self-cancellation; both are simultaneously present, but as with Holbein's painting, interpretation depends upon one's position at any given moment in relation to the work.[18]

POSTMODERNIST CRITICISM

Postmodernism has broken down the barriers between high art and popular culture, and critics have found themselves appraising a whole new range of

creative output, from advertising to fashion and from performance art to visionary art. The stories and novels of Vladimir Nabokov, Jorge Luis Borges, Gabriel García Marquez, Thomas Pynchon, and Toni Morrison have been called postmodern for their playful immersion in language and intellectual conundrums, while at the same time addressing social, political, and cultural issues. Postmodern artists, such as Andy Warhol, Jasper Johns, Claes Oldenburg, and Robert Rauschenberg, have overthrown the exalted artist and the artist's singular vision by parodying images and styles from the past, expressing themselves through irony, paradox, and caprice. The challenge for postmodernist critics is keeping pace with the outbreak of ever more diverse and boundless artistic forms.

In an essay titled "Avant-Garde and Comics: Serious Cartooning," M. Todd Hignite discusses the evolution and the new sophistication of comic book art:

> Major achievements over the last decade have resulted from various techniques of narrative experimentation. Jaime Hernandez movingly weds multi-layered narratives, exploring Mexican-American culture and the Southern California punk milieu, with radical fissures of time, place and point of view. Conversations trigger entire histories, implied by the subtlest visual cues. Hernandez integrates an expansive tapestry of humanity: characters and locales imaginatively rendered through telling minutiae, and transcending mere realism to achieve truth through a snappy and increasingly pared down shorthand style that provides only the vital marks necessary to define characters. . . . Such richness was fully achieved in his multi-issue *Wigwam Bam* (originally serialized in the early 1990s), a panoramic meditation on absence also delving into ethnic and provincial stereotypes.[19]

POSTSTRUCTURALIST CRITICISM

Poststructuralist critics are not interested in a work's message or moral, but posit that the world is fragmented and essentially unknowable, and that language is particularly unreliable. As such, there is no underlying system, no centering principle, and no final structure that can be envisioned in a work. Despite specific differences, poststructuralist theorists Jacques Lacan, Michel Foucault, Roland Barthes, Julia Kristeva, and Jacques Derrida are in general agreement that the notion of a unified and governing structure is extirpated by what they see as a free play of relationships between signs or codes. No critical reading, therefore, whether Freudian, Marxist, or feminist, can account for the single secret truth in a work. The critic might enter the text from any direction, across disciplines, not to discover meaning but to experience the indefinite and impenetrable text.

A poststructuralist reading of *Othello* might demonstrate that what the *signifier* signifies is not reliable. The handkerchief is a signifier. To Desdemona, it signifies fealty and allegiance to her husband, but to Othello, it points to his wife's adultery. Iago sees the handkerchief as a prop to carry out his nefarious plan, but to Emilia it is an object that will momentarily please her malcontent husband.

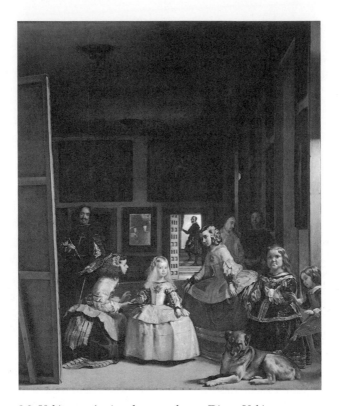

8.3 Velázquez's visual conundrum. Diego Velázquez,
Las Meninas, 1656. Oil on canvas. © Museo Nacional Del
Prado, Madrid.

In *The Order of Things: An Archaeology of the Human Sciences,* Foucault discusses the impenetrability of Velázquez's *Las Meninas* in "a language inevitably inadequate to the visible fact."[20]

> In appearance, this locus is a simple one, a matter of pure reciprocity: we are looking at a picture in which the painter is in turn looking out at us. A mere confrontation, eyes catching one another's glance, direct looks superimposing themselves upon one another as they cross. And yet this slender line of reciprocal visibility embraces a whole complex network of uncertainties, exchanges, and feints. The painter is turning his eyes towards us only in so far as we happen to occupy the same position as his subject. We, the spectators, are an additional factor. Though greeted by that gaze, we are also dismissed by it, replaced by that which was always there before we were: the model itself. But, inversely, the painter's gaze, addressed to the void confronting him outside the picture, accepts as many models as there are spectators; in this precise but neutral place, the observer and the observed take part in a ceaseless exchange. No gaze is stable, or rather, in the neutral furrow of the gaze piercing at a right angle through the canvas, subject and object, the spectator and the model, reverse their roles to infinity.[21]

Psychoanalytical Criticism

The theories of Sigmund Freud, and later of French theorist and linguist Jacques Lacan, are the basis of psychoanalytical criticism—that is, interpreting a work as a reflection of the author's or the character's subconscious mind. Critics have argued that Hamlet's actions are motivated by an Oedipus complex—Freud's theory that a son subconsciously seeks sexual fulfillment with his mother.

Krin Gabbard and Glen O. Gabbard critique Ridley Scott's 1979 science fiction film *Alien* using as a critical framework Austrian psychoanalyst Melanie Klein's studies on early childhood fantasies and aggressions. The following paragraph is about Kane, a crew member who has disturbed an egg while investigating a deserted spaceship; an alien erupts from the egg, affixing itself to Kane's face.

> When Kane is returned to the *Nostromo*, diagnostic studies reveal that it is impossible to remove the creature from his face. One X-ray study reveals that the monster has extended an appendage down the throat of Kane and is keeping him alive. This particular state of affairs can be understood in terms of the vicissitudes of early infantile development. The ego undergoes splitting and projects that part of itself which contains the aggressive instinct, or the death instinct in Kleinian terms, into the original external object, the mother's breast. The breast is then felt to be bad, resulting in a feeling of persecution on the part of the infant. The terrifying but life-sustaining creature in Alien represents the bad persecuting breast: it is the recipient of the first projection of the child's internal aggressive drives, while at the same time, it performs the traditional nourishing function.[22]

Reader-Response Criticism

In reader-response criticism, the reader is the key element and the work itself is judged in terms of its effect on the reader. The text is interpreted according to the dictates of personal identity and proclivities. For example, if you have negative feelings about the way in which the mentally ill are treated in modern establishments, you might read Ken Kesey's *One Flew over the Cuckoo's Nest* as an indictment of institutional violence. If your impression or experience of institutions for the mentally ill is positive, or at least benign, you may read Kesey's novel as a clash between law and anarchy.

Evan Carton, in his essay "Complicity and Responsibility in Pandarus' Bed and Chaucer's Art" offers a glimpse of the reader in the text—the reader as participant in Chaucer's *Troilus and Criseyde*. The narrator of Chaucer's poem, sometimes liberally offering his opinions and other times distancing himself, suggests in Book I that Criseyde is pretending not to know of Troilus's passion for her. The critic responds with an immediacy that is key to reader-response criticism:

> We have no reason to suspect Criseyde of feigning ignorance of Troilus' love, and never would have suspected her; now we must take responsibility for re-

jecting a notion that, at least temporarily, we have been guilty of entertaining. Throughout the poem, the narrator specifies things that he cannot or will not say and leaves us to decide whether or not they have been said and, if so, by whom. Our decisions, whatever they are, become part of the poem and give us a stake in it and a share of the responsibility.[23]

STRUCTURALIST CRITICISM

Structuralism is an approach to linguistics originally developed by Swiss linguist Ferdinand de Saussure, who saw language as a system of arbitrary signs. In analyzing literary texts, the structuralist critic looks beyond the individual work to its underlying and unifying structure. The significance of the whole text is understood only by analyzing its parts and the interaction of textual elements, such as plot, characterization, style, imagery, rhythm, rhyme, figures of speech, and symbols. You might see a relationship between structuralist criticism and formalist art criticism, in which the artwork's formal elements take precedence over the artist's thematic concerns. The structuralist pays particular attention to textual details to uncover the meaning of the whole and to appreciate the embedded values, attitudes, and biases of its language system.

Structuralists often note that the world is structured of and by *binary oppositions*, such as black and white, sanity and madness, civilization and barbarity. Oppositions structure meaning. You might explore black and white as binary opposites in *Othello.* Look at how the words *black* and *white* are used in the play. The woods and the village might be seen as binary opposites in Robert Frost's poem "Stopping by Woods on a Snowy Evening." Critic Anna Makolkin examines a predatory female character, Miss Reid, as well as Miss Reid's chaste male shipmates, in Somerset Maugham's story "Winter Cruise":

> Men on board the ship are pictured as faithful partners to their absent wives whom they do not dare to betray. Moreover, they seem not to manifest any sexual desire at all. Miss Reid is surrounded by some mythical, asexual males who have to be forced into a relation with a woman. The young radio operator who is used as a sex therapist for Miss Reid does it unwillingly, upon Captain's orders, out of fear for his job. Consequently, the gender in Maugham's representation is semiotically arranged like this:

man	woman
asexual	sexual
representatives of culture	representatives of nature
pure	sinful
societal, duty-minded	erotically minded
work-oriented	pleasure-oriented[24]

Another structuralist approach is to examine the text as metonym or metaphor. A **metonym** is a figure of speech in which an attribute or detail is used to represent the thing itself, for example, saying "the White House" to mean the entire executive branch of the government. In Glaspell's play *Trifles,* the character Minnie Wright never appears physically on stage, yet she is defined

metonymically through details: her pots and pans, rocking chair, jar of pre-serves, quilt, and apron. These details represent her. The structuralist's focus is not on the discovery of meaning—what the author intended the kitchen items to signify—so much as on how the interplay of encoded linguistic facts imparts meaning.

A **metaphor** is a figure of speech involving the direct comparison of two objects. A lyric poem by Giovanni Battista Marino, "While His Lady Combs Her Hair," in which he compares the lady's hair to the sea, her comb to a ship, and his heart to a shipwreck, is a veritable exercise in decoding language and understanding conventions. You might write an essay that shows how the details of a story, poem, play, film, or work of art that you are analyzing func-tion metonymically or metaphorically.

You may find that critical theories overlap; for example, Marxist and fem-inist criticisms, or postmodern and psychoanalytical criticisms, often work together because they are dealing with similar social and philosophical issues. Familiarizing yourself with these approaches to criticism may, at the very least, spark ideas and offer possibilities for getting started, developing points, and advancing positions in your humanities essays.

HANDBOOK

Once you have drafted and revised your essay, the next step is to edit it. This step is best saved for last; it would be a waste of time to edit the material before you are certain that it is properly organized or before you have thought through your thesis, points of proof, and supporting facts and details.

No matter how interesting and insightful the content of your paper, your reader's interest will flag if there are distracting errors in sentence structure, grammar, usage, punctuation, and mechanics. This section of *Thinking and Writing in the Humanities* is designed as a reference manual to assist you in alleviating such errors. Throughout this handbook, incorrect sentences are marked with an **X**.

CHOOSING WORDS

CHOOSING VERBS

One way to improve your writing is to choose your verbs carefully. **Verbs** are words that express an action or a state of being.

ACTIVE VERSUS PASSIVE VERBS

Use active verbs rather than passive verbs whenever possible. Active constructions create direct, vigorous sentences. Passive constructions tend to be tedious and tend to create awkward shifts in structure. In an **active con-**

struct**ion,** the subject of the verb is doing the acting. In a **passive construction,** the subject is being acted on.

To spot the passive voice in your paper, be on the lookout for

- sentences with forms of the verb *be* (*be, am, is, are, was, were, being, been*) followed by a past participle (verbs ending in *-ed, -en,* or *-t*)
- *by* phrases, sure signs of passive construction.

ACTIVE: Niki de Saint Phalle completed her *Black Venus* in 1967.

PASSIVE: *Black Venus* was completed by Niki de Saint Phalle in 1967.

Use active construction for economy of expression.

ACTIVE: Niki de Saint Phalle's sculpture *Black Venus* celebrates the joys of sensual freedom. [13 words]

PASSIVE: The joys of sensual freedom are celebrated by Niki de Saint Phalle's sculpture *Black Venus.* [15 words]

STRONG VERBS VERSUS WEAK VERBS

Choose simple, active verbs. Go through your paper and find all of the forms of *be, have,* and *do* and replace them with a simple version of the same verb or with another verb altogether.

Weak	Strong
is constructing	constructs
is looking closely at	examines
does a dance	waltzes
has the opinion that	believes

Rather than qualify a verb with an adverb, search for a stronger verb.

Weak	Strong
runs quickly	sprints
walks slowly	ambles
cries bitterly	sobs
knows somehow	intuits

VERB TENSES

Generally, write in the present tense when you are describing sculptures, paintings, buildings, plays, novels, poems, or films. Use the present tense when speaking of the creator's work, even if he or she is no longer with us, as in the following example:

Untitled (1964) by Donald Judd challenges the viewer to see the object as pure shape, unencumbered by notions of traditional aesthetics, significance, or function.

For events that happened only once, such as a concert, you may write in the past tense, as in the following example:

Cynthia Lawrence electrified her audience last night performing Richard Strauss's *Four Last Songs.*

Subject–Verb Agreement

A verb must agree with its subject in number. If the subject is singular, the verb must also be singular. Likewise, if the subject is plural, the verb must also be plural.

> subject verb
> John Chamberlain's sculpture *Debonair Apache* reminds us of the proliferation of transitory and disposable products in modern society.

> subject verb
> John Chamberlain's sculptures remind us of the proliferation of transitory and disposable products in modern society.

Words that come between the subject and its verb can confuse writers.

> subject verb
> **X** John Chamberlain's sculptures, along with other assemblage work, reminds us of the proliferation of transitory and disposable products in modern society.

The subject of the verb "reminds" in the above sentence is "sculptures." You would not write "sculptures reminds," but "sculptures remind."

Subject–verb disagreements often occur when the subjects are singular, indefinite pronouns. The following indefinite pronouns are singular and thus require a singular verb.

one	anyone	everybody	something
no one	anybody	everything	each
nobody	anything	someone	either
nothing	everyone	somebody	neither

The subject and verb in the following sentence disagree:

> **X** No one attending the sessions on neoclassical sculptures have time to see the Claes Oldenburg soft sculpture exhibition.

Choosing Pronouns

A **pronoun** is a word that takes the place of a noun. A **first-person** pronoun (such as *I, me, us, we*) refers to the speaker. A **second-person** pronoun (such as *you, yours*) refers to the person being spoken to. A **third-person** pronoun (such as *he, she, it, they, them*) refers to the person or thing being spoken about.

Avoiding I

Although using first-person pronouns in essays is not wrong, it is wrong to write more about yourself than about the sculpture, painting, or poem that you are examining. The following example is more focused on the author than on the sculpture.

X Last spring, when I went on a tour of England with my school, we visited the Tate Modern in London. I chose to write about Mona Hatoum's *Incommunicado,* a metal construction that looks like a child's crib. In some ways, it looked like my little brother's crib, but then I noticed that it had no mattress, no pillow, and no stuffed animals. In fact, it looked really uncomfortable, and that is when I noticed that the base of the cot was strung with wires that looked like they could cut a person into sections.

PRONOUN CASE

Pronouns have three cases: *subjective* (or *nominative*), *objective,* and *possessive.* Choose a subjective pronoun when your verb needs a subject or a subject complement, an objective pronoun when your verb or preposition needs an object, and a possessive pronoun when you need to show possession.

When you have a compound subject or object, the easiest way to be sure you are using the correct pronoun is to cross off all of the words in the group except the pronoun in question.

> The influence of Michelangelo on Auguste Rodin may not be immediately obvious, but ~~both Michelangelo and~~ he sculpted the quintessence of human contemplation.

> To ~~both Michelangelo and~~ him, the sculpted figure is cerebrally and viscerally involved in the process of thinking.

A pronoun working as a *subject complement* (a word that follows a *linking verb,* usually a form of the verb *be*) should be in the subjective case.

> *The Thinker* reveals, by his facial expression and body position, that it is he who carries the full burden of humankind's puzzlement.

Choose *who* when the pronoun will serve as the subject for a verb.

> It was Michelangelo who sculpted the pensive *Lorenzo de' Medici, Duke of Urbino.*

Choose *whom* if the pronoun will serve as an object.

> In whom is the spirit of Michelangelo more apparent: Auguste Rodin or Jean-Baptiste Carpeaux?

PRONOUN–ANTECEDENT AGREEMENT

Pronouns usually refer to some specific noun. That noun is the pronoun's **antecedent.**

> antecedent pronoun
> Each figure in Marisol Escobar's *Women and Dog* reveals her affinity for urban life and contemporary fashion.

Pronouns must agree with their antecedents in three ways:

- number (singular or plural)
- gender (masculine, feminine, or neuter)
- person (first, second, or third)

Mistakes occur most often when the antecedent is a singular, indefinite pronoun. The following sentence suffers from pronoun–antecedent disagreement:

> **X** In Marisol's *Women and Dog*, everyone expresses their sophistication.

The following sentence is grammatically correct, because the word "everyone" is singular and all the characters in *Women and Dog* are feminine.

> In Marisol's *Women and Dog*, everyone expresses her sophistication.

But what if a singular, indefinite pronoun refers to both men and women?

> **X** Every person wishes they could dress as smartly as Marisol's urbanites.

You might correct the sentence as follows:

> Every person wishes he or she could dress as smartly as Marisol's urbanites.

Or:

> All people wish they could dress as smartly as Marisol's urbanites.

The indefinite pronouns *each, either,* and *neither* are often followed by prepositional phrases that begin with *of.* Any pronoun referring to these indefinite pronouns must be singular, even if the object of the preposition *of* is plural.

> **X** Each of the women reveals their own individual style.

> Each of the women reveals her own individual style.

In short, the words *they, them, their,* and *themselves* must refer to some specific word. Find that word. If that word is singular, do not use any form of the word *they* in reference to it. You can change the pronoun or change the antecedent, but the two words must agree in number, gender, and person. Another excellent option is to avoid the use of pronouns whenever possible.

UNCLEAR PRONOUN REFERENCES

A pronoun must refer to something specific. The pronouns *this* and *it* are most often the culprits in an unclear reference.

> **X** In Marisol's *Children Sitting on a Bench*, most of the children have their hands folded in their lap. This creates a sense of lassitude.

The pronoun "this" in the previous sentence refers to an idea conveyed in the sentence that precedes it, but not to any specific word. You might correct this sentence as Follows:

> In Marisol's *Children Sitting on a Bench*, most of the children have their hands folded in their lap. The placement of the hands creates a sense of lassitude.

WORDINESS

Your writing should be terse, free of unnecessary words. Wordiness is not related to sentence length. Many long sentences are terse; many short sentences are wordy. To proofread for wordiness, look for redundancies and unnecessary prepositional phrases.

Wordy	Better
yellow in color	yellow
shaped like an octagon	octagonal
overexaggerate	exaggerate
basic fundamentals	basics (or fundamentals)
form of media	medium
in the article, it says	the article says

Repetitiousness is another cause of wordiness.

X Louise Nevelson's box assemblages are often monochromatic and painted a uniform color.

X Duane Hanson fabricates lifelike sculptures that are amazingly realistic.

Passive and weak verbs cause wordiness, as does the *there is/are* construction.

X Ready-mades were composed of everyday objects put together in an unconventional manner by Marcel Duchamp.

X There is a sensuous appeal to viewers everywhere in Henry Moore's reclining figures.

Another step you can take to eliminate wordiness is to delete the word *very* every time it occurs. If you are left with a weak word or phrase, change it to a strong one; for example, change *very large* to *massive* or *huge*, *very many* to *numerous*, and *very many times* to *often* or *frequently*. Never write *very unique*. If a thing is unique, it is one of a kind and cannot be made more unique by adding *very*. Eliminate the words *basically* and *totally* as well. Other culprits are *kind of*, *sort of*, and *just*, *great*, *suddenly*, *somehow*. Strunk and White call them *bankrupt* words. Ursula LeGuin calls them *weasel words*.

NEEDLESS PHRASES

Remove all announcements of your intentions and statements of purpose. You can make your point without announcing it.

X In this essay I will show that . . .

X The purpose of this essay is to . . .

NONSEXIST LANGUAGE

Use *humanity, humankind,* or *people* instead of *man* or *mankind*. Refer to the hypothetical doctor, nurse, lawyer, astronaut, or secretary as *he or she* (or *she or*

he). However, because the overuse of *he or she* can be distracting, avoid using pronouns whenever possible.

If the gender of the individual being referred to is known, use the appropriate pronoun. You may also assign a hypothetical person a gender, so long as it is clear that you are not automatically assigning the masculine gender to those in power and the feminine gender to those without power.

TONE

If you are writing or speaking informally, you may say anything you want. If you are writing or speaking formally, however, there are correct and incorrect choices. If *whom* is correct, use it, even if it sounds stilted. Also, avoid clichés and overworked phrases such as "all in all," "to make a long story short," "easier said than done," and "better late than never."

Choose vivid, specific words. You can "make a sculpture," or you can "sculpt a cube balanced on its point." Which is more vivid? You may write, "Noguchi makes use of geometric shapes in many of his public sculptures." Or you may write, "Noguchi's 28-foot-high steel red cube appears to float in front of Marine Midland Bank in New York, suggesting permanence in a fleeting event." Which description is more interesting? Which description gives the reader a clearer sense of the sculpture?

Most important, avoid words or phrases that dictionaries label informal, slang, colloquial, archaic, illiterate, nonstandard, obsolete, or substandard. The word *butt*, for example, is a coarsened version of *buttocks* and is not considered polite language. Think of your audience as a reader of newspapers such as the *New York Times* or magazines such as *Art Papers*. Such a reader has heard, read, and may occasionally use coarse language but is not accustomed to finding it in tasteful reading material. Such words lower the tone of your essay and distract your reader.

SENTENCE STRUCTURES

SENTENCE FRAGMENTS

Sentence fragments are word groups that pose as complete sentences but are incomplete because they are missing one or more essential parts—usually a subject or a verb. Although they are deliberately used at times for creative effect, they are usually mistakes in essays and should be eradicated.

Length is not the issue when it comes to fragments. A very short word group may be a complete sentence, and a very long word group may be a fragment. For example,

COMPLETE SENTENCE: The Romans were innovative builders.

FRAGMENT: Roman architecture, which is characterized by technical ingenuity and grand spatial design, accommodating the needs of a population exceeding one million people.

A frequent cause of fragments is to mistake a dependent clause for an in-dependent clause. **Dependent clauses** are word groups that contain a subject and a verb but that cannot stand alone as sentences. They must be attached to independent clauses.

> **X** Although the Colosseum seated fifty thousand people, compared to the Circus Maximus that held two hundred thousand spectators.

Another frequent cause of fragments is to mistake participles for verbs. Participles are verb forms that are being used as adjectives, not verbs.

> **X** For example, the Pantheon, clearly inspired by Greek architecture, featuring a portico with sixteen Corinthian columns.

Fragments are often easy to identify in isolation. However, when they are positioned inside a paragraph, they are harder to spot because the paragraph sounds correct when it is read quickly.

> **X** Roman architects inherited knowledge from the Greeks and Etruscans. For example, the Pantheon, clearly inspired by Greek architecture, featuring a portico with sixteen Corinthian columns.

You could repair this fragment simply by attaching it to the previous sentence or by giving it its own subject and verb.

Run-On Sentences

Run-on sentences are a common but crucial mistake. Like fragments, run-ons reveal a fundamental problem in writing—the failure to realize where a sentence begins and ends. No matter how sophisticated your ideas, your writing will seem immature as long as it contains run-on sentences.

Run-on sentences consist of two or more independent clauses that have been incorrectly joined. There are two types of run-on sentences: fused sentences and comma splices.

Fused sentences join independent clauses without the benefit of any punctuation.

> **X** Domes and foliage patterns on stone capitals characterize the exteriors of Byzantine architecture mosaics and frescoes decorate the interiors.

Comma splices join independent clauses with only a comma.

> **X** Domes and foliage patterns on stone capitals characterize the exteriors of Byzantine architecture, mosaics and frescoes decorate the interiors.

There are many ways to repair a run-on sentence, but the following four are the easiest:

■ Separate the two independent clauses into separate sentences.

> Domes and foliage patterns on stone capitals characterize the exteriors of Byzantine architecture. Mosaics and frescoes decorate the interiors.

- Separate the two independent clauses with a comma plus a coordinating conjunction. The **coordinating conjunctions** are *but, or, yet, for, and, nor, so.* (Remember the acronym BOYFANS).

 Domes and foliage patterns on stone capitals characterize the exteriors of Byzantine architecture, and mosaics and frescoes decorate the interiors.

- Separate the two independent clauses with a semicolon.

 Domes and foliage patterns on stone capitals characterize the exteriors of Byzantine architecture; mosaics and frescoes decorate the interiors.

- Convert one of the independent clauses to a dependent clause.

 Whereas domes and foliage patterns on stone capitals characterize the exteriors of Byzantine architecture, mosaics and frescoes decorate the interiors.

A frequent cause of run-on sentences is to connect independent clauses with adverbs like *however* instead of with coordinating conjunctions.

 X Domes and foliage patterns on stone capitals characterize the exteriors of Byzantine architecture, however, mosaics and frescoes decorate the interiors.

Another frequent cause of run-on sentences is to force a pronoun into the same sentence as the noun to which it refers.

 X The Byzantine Empire reigned during the fifth century, its architecture is characterized by domes and foliage patterns.

Awkward Sentence Constructions

Misplaced and Dangling Modifiers

A **misplaced modifier** is an adjective, adverb, or modifying phrase or clause that is in the wrong place in the sentence.

 X A Gothic cathedral, the arches are pointed rather than rounded, which extends the height of Notre Dame.

The sentence should be arranged as follows:

 The arches are pointed, rather than rounded, which extends the height of Notre Dame, a Gothic cathedral.

Another faulty sentence construction arises from the **dangling modifier,** a more subtle problem. In this construction, the word the modifier is supposed to modify (or describe) is missing from the sentence, leaving the modifier "dangling."

 X Featuring the high interior spaces and stained glass windows, a feeling of soaring upward as if to meet God is realized.

This sentence gives no clue what noun is doing the "featuring."

FAULTY PREDICATION

Faulty predication is the term for a sentence that claims someone or something is being or doing something unlikely or impossible.

X Gothic architecture is supported by the flying buttress.

FAULTY COMPARISON

One common mistake in making comparisons is the incomplete comparison. A reader may well ask, "Than what?" in response to the following sentence:

X The cathedral at Chartres is more fragile looking.

Another mistake is to compare incomparable things.

X The Gothic style in Italy is less dramatic than the Gothic cathedrals of Germany.

FAULTY DEFINITIONS

The most common faulty definition incorrectly defines a thing as a place or a time.

X An example of naturalism in Gothic sculpture is where the sculptured figures' robes fall naturally rather than uniformly.

Simply avoid the *is when* or *is where* construction unless the thing you are defining really is a time or a place.
Another common but faulty construction is the *is because* construction.

X The reason the High Gothic cathedrals appear weightless is because the flying buttresses allow for such height and light.

The sentence above would be correct if it used the word "that" instead of "because."

UNNECESSARY SHIFTS

Be consistent in the use of pronoun person.

X Visitors to Notre Dame cathedral in Paris feel a sense of being pulled upward. You get a feeling of reverence.

It is also a mistake to shift verb tense, voice, or mood midway through your sentence or paragraph.

X Gargoyles adorn the exterior of Notre Dame cathedral in Paris. The monsters were not symbolic but purely decorative.

Avoid shifting from the imperative mood (a command) to the indicative mood (an assertion).

X Read about Notre Dame, and then you should visit it.

MIXED CONSTRUCTIONS

Sometimes beginning writers start a sentence one way and end it another way.

> X Gothic architecture asks us to examine our spirituality and what do we believe.

> X By using flying buttresses allowed Gothic architects a new freedom in design.

PARALLEL CONSTRUCTION

Parallelism adds elegance and rhythm to your sentences. The idea is to present two or more similar items in the same grammatical form. The following sentence could be improved by using parallel construction:

> X Stained glass windows let in the light, depict scenes from the Scriptures, and they represent the inspiration of Abbot Suger of St.-Denis.

PUNCTUATION

COMMA

Four basic rules, if followed, will usually result in the correct use of the comma.

RULE 1

Use a comma after an introductory modifying phrase or adverb clause.

> In Greek mythology, the nine daughters of Zeus and Mnemosyne preside over the arts and sciences.

Do not place a comma after a noun clause or phrase serving as the subject of a verb. It is a mistake to separate a subject from its verb with a comma.

> X What Pythagoras describes as the *music of the spheres,* is harmony produced by the movement of celestial bodies.

RULE 2

Use commas between words, phrases, and clauses that appear in a series of three or more. Be sure to use a comma before the word *and* that introduces the final item in the series.

> Buddhist chants are often accompanied by drums, cymbals, bells, and gongs.

RULE 3

Use a comma before a coordinating conjunction—*but, or, yet, for, and, nor,* and *so*—that links independent clauses. An independent clause can stand alone as a complete sentence.

> The troubadours and *trouvères* composed lyrics in the vernacular, and they performed their poems about chivalry and courtly love for the French nobility.

Do not place a comma before a coordinating conjunction that is not linking independent clauses.

> **X** Troubadour poetry owes a debt to Islamic verse, and is often a joyful response to nature and physical pleasure.

RULE 4

Set off nonessential words, phrases, and clauses with commas. A word, phrase, or clause is **nonessential** if the sentence retains its complete meaning without the word, phrase, or clause.

> The Buddhist monk's recitation of Sanskrit prayers, no less than the Muslim muezzin's call to supplication, conveys a deep faith in a higher order to guide the actions of humankind.

Clauses beginning with *that* are essential and are not set off with commas.

> The style of Western plainsong (Gregorian chant) suggests that the Catholic Church emphasized the liturgy above all else.

Adjective clauses beginning with *which* are nonessential and are set off with commas.

> The *Play of Herod*, which dramatizes King Herod's order to put to death all children in Bethlehem under the age of two, is known as liturgical drama.

Adjective clauses beginning with the words *who, whom,* or *whose* can be essential or nonessential. If the adjective clause refers to a specific person, it is nonessential and should be set off with commas.

> Pérotin, who was a member of the Notre Dame School in Paris, wrote some of the earliest polyphonic compositions for the Christian Mass.

If the adjective clause does not refer to someone specific, the clause is essential and should not be set off with commas.

> Anyone who hears a polytextual motet begins to appreciate the flowering of polyphonic music in the thirteenth century.

When quoting, consider the acknowledgment phrase—the phrase that tells who is speaking or writing—as nonessential and set it off with commas.

> In reference to *La Finta Pazza Licori,* the first great opera composer Monteverdi writes to the Chancellor of the Duke of Mantua, "There will be a dance for every act, all different and fantastic."

Consider *yes, no,* mild interjections, terms of direct address, interrogative tags, and sharply contrasting elements as nonessential.

Yes, Monteverdi's contemporary was the eminent German composer Heinrich Schütz.

No, Schütz was not a pupil of Monteverdi.

Oh, Schütz was a pupil of Giovanni Gabrieli.

Students, listen to Monteverdi's opera *Orfeo* before next class.

We like the aria "Vi recorda, o boschi ombrosi," don't you?

Monteverdi, not Gabrieli, was called the "prophet of music."

SEMICOLON

Use a semicolon to separate independent clauses not joined by a coordinating conjunction. Think of the semicolon as a weak period.

> Johann Sebastian Bach's various posts within the Lutheran church inspired his composition of chorales, motets, cantatas, and oratorios; in his last decade, however, he explored the baroque contrapuntal style in more abstract compositions.

COLON

A colon separates a summary or series from an independent clause.

> Bach was a master of many musical forms: the prelude, fugue, passacaglia, chaconne, sonata, suite, concerto, chorale, motet, cantata, and oratorio.

In accordance with this rule, it is a mistake to use a colon to separate a summary or series from a word group that is not an independent clause.

> X Among the musical forms that Bach mastered are: the prelude, fugue, passacaglia, chaconne, sonata, suite, concerto, chorale, motet, cantata, and oratorio.

Another use of the colon is to introduce a quotation that follows an acknowledgment phrase that is an independent clause.

> Bach wrote his pledge of service to the Leipzig Town Council: "I shall set the boys the good example of an honorable, disciplined way of life, watch zealously over the school, and faithfully instruct the boys."

DASH

Think of the dash as a strong comma. It has two main uses. The first is to set off a short summary or elaboration after a complete main clause.

> One of Mozart's operas most certainly challenged his aristocratic audience and bewildered the Viennese public—*Don Giovanni*.

The second use of the dash is to set off an appositive phrase that consists of items in a series separated by commas.

> Three women in *Don Giovanni*—Donna Anna, Donna Elvira, and Zerlina—fall prey
> to the notorious libertine.

Your computer keyboard probably does not have a dash key, as such. To create a dash, simply press the hyphen twice. Some word processing programs will automatically convert such keystrokes into a dash.

APOSTROPHE

Apostrophes have two main uses. The first is to create contractions such as *don't, can't, they're,* and *it's.* Contractions are two words condensed. The apostrophe stands for the omitted letters. Avoid using contractions in formal writing.

The second use of the apostrophe is to show possession. The following examples show how to make nouns possessive:

- If the noun is singular, add 's.

 > Donna Anna discovers her father's body and swears to avenge his death.

- If the noun is plural and does not end in *s,* add 's.

 > The women's distinct reactions to their seducer render the opera more than
 > *opera buffa.*

- If the noun is plural and ends in *s,* simply add an apostrophe.

 > The three trombones' appearance with the full orchestra to herald the commandant's statue creates a chilling moment.

The personal possessive pronouns—*hers, ours, theirs, yours, whose,* and *its*—do not contain apostrophes.

QUOTATION MARKS

Copy quoted material exactly, including the internal punctuation. Some adjustments can be made, however, to the end marks and to capitalization.

DOUBLE QUOTATION MARKS

Place double quotation marks around direct quotations:

> "Inheriting the classical concerto from Mozart, Beethoven responded with all the
> force of his dramatic temperament to the opposition between soloist and orchestra," writes Joseph Machlis in *The Enjoyment of Music.*

Do not put quotation marks around indirect quotations or paraphrases—usually signaled by the word *that.*

> Joseph Machlis writes that art offered Beethoven the happiness that life withheld.

Place quotation marks around the titles of songs, short stories, essays, poems, and articles in newspapers and magazines. In general, underline or italicize titles of plays, books, magazines, newspapers, journals, movies, television programs, and works of art. In short, put quotation marks around the titles of smaller works, and underline or italicize the titles of larger works.

> In an article in the *New York Times* titled "The Very Model of Musicianship," soloist-conductor Joseph Silverstein comments on the difference ten years of concert experience can make between recordings of Beethoven's Violin Concerto in D.

Quotation marks may enclose words intended in a special or ironic sense. Use this option sparingly.

> I have a picture of the "disheveled" genius sitting on my piano.

SINGLE QUOTATION MARKS

Use single quotation marks for quoted material inside other quoted material.

> Burnett James, in *Brahms: A Critical Study,* says, "Part of the trouble lay with the warring factions in Leipzig, with the 'conservatives' who considered Brahms a dangerous revolutionary and the 'progressives' who thought him a deserter from the cause of the 'new music.'"

CAPITALIZATION IN QUOTATIONS

Capitalize the first word of a complete quotation but not the first word of a partial quotation (that is, a quotation that is not a complete sentence).

> Brahms wrote to his friend, the violinist Joachim, "So now I am to send my *Marienlieder* to Rieter, and though I used to enjoy hearing them, they mean no more to me now than a blank sheet of paper."

> Brahms wrote to his friend Joachim that he was sending his *Marienlieder* to the publisher Rieter, but that he no longer enjoyed hearing them and they meant no more to him than a "blank sheet of paper."

USING OTHER PUNCTUATION MARKS WITH QUOTATION MARKS

Commas and periods always go inside the closing quotation marks, whether they are part of the quoted material or not.

> Michael Steinberg, in his book *The Symphony,* praises Antonín Dvořák's *Symphony No. 6 in D Major:* "And what lovely scoring it is: effortlessly ample, not aggressive, neither blaring nor thick."

> "And what lovely scoring it is," writes Michael Steinberg of Dvořák's *Symphony No. 6 in D Major.*

Question marks and exclamation marks go inside the closing quotation marks when they are part of the quoted material.

Dvořák wrote in a letter to his father, "Who could have thought that far across the sea, in this enormous London, I should one day celebrate triumphs such as few foreign artists have known?"

Question marks and exclamation marks go outside the closing quotation marks when they are not part of the quoted material.

Would you agree with Donald Francis Tovey that Dvořák's *Seventh Symphony* is "among the greatest and purest examples of this art form since Beethoven"?

Colons, semicolons, and dashes are placed outside the closing quotation marks.

Gustav Mahler wrote to his friend Friedrich Löhr, "If a thoroughbred is harnessed to a cart with oxen, the best he can do is to sweat and haul with them"; clearly, his orchestra failed to meet his high standards.

Quotations may be introduced with an acknowledgment phrase followed by a comma. However, if the acknowledgment phrase is an independent clause, it is followed by a colon.

Michael Steinberg describes Mahler's restless attitude toward conducting: "He loved and detested conducting; that is, he loved the opportunity to shape musical objects according to his penetrating vision and hated the constant compromise and the friction with musicians less possessed than himself."

Indent quoted passages of four or more lines. Notice that the indented material is double spaced and that there are no quotation marks around the quoted material. Indentation takes the place of quotation marks. Refer to the research paper on the Elgin Marbles in Chapter Seven to see how indented material should look on the page.

ALTERING QUOTATIONS

Sometimes, you will have occasion to leave out parts of quotations or to clarify their contents. You may use ellipsis dots or brackets for these tasks.

Original passage by Stravinsky
In composing the *Sacre,* I had imagined the spectacular part of the performance as a series of rhythmic mass movements of the greatest simplicity, which would have an instantaneous effect on the audience, with no superfluous details or complications such as would suggest effort.

Ellipsis dots show that you have omitted material from a quoted passage. Use three dots when omitting material at the beginning or in the middle of a sentence. Space once before the first dot and once after each dot.

"In composing the *Sacre,*" writes Stravinsky, "I had imagined the spectacular part of the performance as a series of rhythmic mass movements of the greatest simplicity [. . .] with no superfluous details or complications such as would suggest effort."

If your paper is written MLA-style, place brackets around your ellipses.

Use an end punctuation mark and three dots when leaving out material at the end of the sentence.

> Stravinsky writes, "In composing the *Sacre*, I had imagined the spectacular part of the performance as a series of rhythmic mass movements of the greatest simplicity, which would have an instantaneous effect on the audience. [. . .]"

Use brackets to add clarifying words or to substitute clear words for unclear ones.

> Stravinsky writes, "In composing the *Sacre* [*du Printemps*], I had imagined the spectacular part of the performance as a series of rhythmic mass movements of the greatest simplicity, which would have an instantaneous effect on the audience, with no superfluous details or complications such as would suggest effort."

NOTES

INTRODUCTION

[1] *The Epic of Gilgamesh,* ed. and trans. N. K. Sanders (Baltimore: Penguin Books, 1964), 99.

[2] Omar Khayyám, "The Rubáiyat," trans. Edward Fitzgerald, *Poetry: A Thematic Approach,* ed. Sam H. Henderson and James Ward Lee (Belmont: Wadsworth Publishing, 1968), 253.

CHAPTER ONE

[1] *Bartlett's Familiar Quotations,* 16th ed., ed. Justin Kaplan (Boston: Little, Brown, 1992), 146.

[2] Martha Chew, "Flannery O'Connor's Double-Edged Satire: The Idiot Daughter versus the Lady Ph.D.," *Southern Writers* 1973: 17–25.

[3] Ezra Pound, "Robert Frost (Two Reviews)," *Literary Essays of Ezra Pound* (New York: New Directions, 1968), 382–86.

[4] Ann Barzel, "Cowboys, Lovers, and Rockers in Chicago," *Dance* Aug. 2002: 53–55.

[5] Lee Siegel, "Eyes Wide Shut: What the Critics Failed to See in Kubrick's Last Film," *Harper's* Oct. 1999: 76.

[6] *Ibid.,* 80.

[7] Bridget Riley, "Piet Mondrian," *Writers on Artists* (New York: Dorling Kindersley, 2001), 184–95.

[8] Michael Steinberg, *The Symphony: A Listener's Guide* (New York: Oxford University Press, 1995), 43.

[9] X. J. Kennedy, "Who Killed King Kong?" *Dissent* Spring 1960: 272.

[10] Roger Shattuck, *Forbidden Knowledge: From Prometheus to Pornography* (New York: St. Martin's Press, 1996), 19.

[11] Jim Frederick, "We Are, Like, Poets," Reprint, *The Compact Reader,* 5th ed., eds. Jane E. Aron (Boston: Bedford Books of St. Martin's Press, 1990), 94.

[12] Robert MacNeil, "Wordstruck," Reprint, *The Rinehart Reader,* 3rd ed., eds. Jean Wyrick and Beverly J. Slaughter (Fort Worth: Harcourt Brace College Publishers, 1999), 51.

[13] Joseph Campbell, *Mythic Image* (Princeton: Princeton University Press, 1974), 359.

[14] Justin Kaplan, "Essayists on the Essay," *The Best American Essays, College Edition,* 2nd ed., ed. Robert Atway (Boston: Houghton Mifflin, 1990), 12.

[15] Walter Kerr, *Tragedy and Comedy* (New York: Simon & Schuster, 1967), 266.

[16] Virginia Woolf, "If Shakespeare Had Had a Sister," *A Room of One's Own,* Reprint, *The Rinehart Reader,* 216.

[17] George Orwell, "Charles Dickens," *George Orwell: A Collection of Essays* (San Diego: Harcourt Brace, 1981), 103–04.

[18] *Good Advice on Writing,* eds. William Safire and Leonard Safir (New York: Simon & Schuster, 1992), 210.

[19] Peter Elbow, *Writing Without Teachers,* 2nd ed. (Oxford: Oxford University Press, 1998), 49.

[20] William Strunk and E. B. White, *The Elements of Style* (Boston: Allyn & Bacon, 1979), 23.

CHAPTER TWO

[1] Michel de Montaigne, "Of the Art of Discussion" *The Complete Essays of Montaigne,* trans. Donald M. Frame (Stanford: Stanford University Press, 1958), 704.

[2] "The Ancient Coffer of Nuri Bey," *Tales of the Dervishes,* ed. Idries Shah (New York: Dutton, 1970), 189–90.

CHAPTER THREE

[1] Mark Strand, "Hopper: The Loneliness Factor," Reprint, *Writers on Artists,* ed. Daniel Halpern (San Francisco: North Point, 1988), 257–58.

[2] Aristotle, *The Poetics,* trans. L. J. Potts, *Types of Drama,* 2nd ed., eds. Sylvan Barnet, Morton Berman, and William Burto (Boston: Little, Brown, 1972), 303–04.

CHAPTER SIX

[1] Richard Hornby, "The London Theatre, Summer 1987," *Hudson Review* Winter 1988: 642–44.

[2] "Marilyn at the Met," *Time* 16 Mar. 1970: 69.

[3] Charles Isherwood, "Oedipus," *Variety* 19 Oct. 1998: 84.

[4] David Dillon, "Drama of Nature and Form," *Architecture* May 1988: 150–52.

[5] Robert Hofler, "Princess Turandot," *Variety* 11 Dec. 2000: 30.

[6] Peter Schjeldahl, "Dead-End Kids," *The New Yorker* 11 Dec. 2000: 126.

[7] Edwin Denby, *Dance Writings* (New York: Alfred A. Knopf, 1986), 254–55.

[8] Aaron Copland, *Copland on Music* (New York: W. W. Norton, 1963), 188.

[9] Marc Bridle, "Stravinsky: Rite of Spring," *Music on the Web UK* (2000), 30 Aug. 2001 <http://www.Len@musicweb.force9.co.uk>.

[10] Christopher Bowen, "Renewed Brittania," *Dance Magazine* Feb. 1998: 97.

[11] Lee Parsons, "The Force of Giacometti," *World Socialist Web Site* (1998), 26 Aug. 2001 <http://www.wsws.org>.

[12] Pauline Kael, "Tango," *The New Yorker* 28 Oct. 1972: 134.

[13] Marty Rosen, "Exuberant Night of Bop," *The Courier-Journal* (2001), 23 Aug. 2001 <http://www.louisvillescene.com>.

[14] Christopher Andreae, "Sarah-Jane Selwood's Porcelain Vessels," *Ceramics* 37 (1999): 17.

[15] David Bonetti, "Natural Selection: Ansel Adams' Lesser-Known Nature Photography at SFMOMA," *San Francisco Chronicle* (2001), 4 Aug. 2001 <http://www.sfchronicle.com>.

[16] Christopher Knight, "Flat-Out Profound," *Los Angeles Times* (2001), 23 Aug. 2001 <http://www.calendarlive.latimes.com>.

[17] David Bonetti, "Photographs as Beautiful as Paintings," *San Francisco Chronicle* (2001), 12 Apr. 2001 <http://www.sfchronicle.com>.

[18] Pauline Kael, *I Lost It at the Movies* (Boston: Little, Brown, 1965), 143.

[19] Gene Santoro, "Paul Simon's *Graceland*," Reprint, Douglas Hunt, *The Riverside Guide to Writing* (Boston: Houghton Mifflin, 1991), 345.

[20] Wes Blomster, "Poet Laureate Joins Takács," *Boulder Daily Camera* (2001), 9 Jan. 2002 <http://www.thedailycamera.com>.

[21] Andrew Druckenbrod, "Chamber Music Soars at Warhol," *Pittsburgh Post-Gazette* (2001), 23 Aug. 2001 <http://www.post-gazette.com>.

[22] Roger Ebert, *Roger Ebert's Movie Home Companion* (Kansas City: Andrews, McMeel, & Parker, 1985), 184.

[23] Frank Rich, *Hot Seat: Theater Criticism for the New York Times, 1980–1993* (New York: Random House, 1998), 245.

[24] Catherine Slessor, "Digitizing Düsseldorf," *Architecture* Sept. 2000: 118.

CHAPTER SEVEN

[1] David Rudenstine, "Did Elgin Cheat at Marbles?" *The Nation* 29 May 2000: 31.

CHAPTER EIGHT

[1] Ana María Barrenechea, Foreword, *Borges The Labyrinth Maker* (New York: New York University Press, 1965), viii.

[2] Northrop Frye, *Anatomy of Criticism* (New Jersey: Princeton University Press, 1971), 12.

[3] *Ibid.*, 190.

[4] William Blake, *Complete Writings,* ed. Geoffrey Keynes (London: Oxford University Press, 1969), 118.

[5] "Befall," *Compact Edition of the Oxford English Dictionary,* (London: Oxford University Press, 1979), 191.

[6] Bernard Berenson, *The Passionate Sightseer* (New York: Thames, 1960), 29.

[7] Patricia Hart, "Magic Feminism in Isabel Allende's *The Stories of Eva Luna,*" *Multicultural Literatures through Feminist/Poststructuralist Lenses,* ed. Barbara Frey Waxman (Knoxville: University of Tennessee Press, 1993), 107.

[8] *Ibid.*, 107.

[9] Richard F. Brown, "Impressionist Technique: Pissarro's Optical Mixture," *Impressionism in Perspective,* ed. Barbara Ehrlich White (New Jersey: Prentice Hall, 1978), 116–17.

[10] Robert K. Martin, *The Homosexual Tradition in American Poetry* (Iowa City: Iowa University Press, 1998), 19, 21.

[11] Walter Friedlaender, *David to Delacroix* (Cambridge, Mass.: Harvard University Press, 1952), 115.

[12] *Ibid.*, 123–24.

[13] Louise K. Barnett, "Bartleby Is Marx's Alienated Worker," *Studies in Short Fiction* 11.4 (1953): 379.

[14] John Cullen Gruesser, "An Un-Easy Relationship: Walter Mosley's Signifyin(g) Detective and the Black Community," *Multicultural Detective Fiction: Murder from the "Other" Side,* ed. Adrienne Johnson Gosselin (New York: Garland, 1999), 236.

[15] *Ibid.*, 241.

[16] Gustave Flaubert, *Madame Bovary*, trans. Paul de Man (New York: W. W. Norton, 1965), 24.

[17] John Holloway, "Unifying Metaphors in *Tess of the d'Urbervilles*," Thomas Hardy, *Tess of the d'Urbervilles*, ed. Scott Elledge (New York: W. W. Norton, 1965), 444–45.

[18] Stephen Greenblatt, *Renaissance Self-Fashioning: From More to Shakespeare* (Chicago: University of Chicago Press, 1980), 58.

[19] M. Todd Hignite, "Avant-Garde and Comics: Serious Cartooning," *Art Papers* Jan.–Feb. 2002: 18.

[20] Michel Foucault, *The Order of Things: An Archaeology of the Human Sciences* (New York: Pantheon, 1970), 9.

[21] *Ibid.*, 4–5.

[22] Krin Gabbard and Glen O. Gabbard, "The Science Fiction Film and Psychoanalysis: *Alien* and Melanie Klein's *Night Music*," *Psychoanalytic Approaches to Literature and Film* (New Jersey: Associated University Press, 1987), 176–77.

[23] Evan Carton, "Complicity and Responsibility in Pandarus' Bed and Chaucer's Art," *Critical Essays on Geoffrey Chaucer*, ed. Thomas C. Stillinger (New York: Hall, 1998), 229.

[24] Anna Makolkin, "Women as Id Signs," *Semiotics of Misogyny Through the Humor of Chekhov and Maugham* (UK: Mellen, 1992), 37–38.

INDEX